Drawing and Painting
Flowers
Problems and Solutions

TRUDY FRIEND

D&C
David and Charles

In memory of Byfrance

A DAVID & CHARLES BOOK
Copyright © David & Charles Limited 2007

David & Charles is an F+W Publications Inc. company
4700 East Galbraith Road
Cincinnati, OH 45236

First published in the UK in 2007
First UK paperback edition 2010

Text and illustrations copyright © Trudy Friend 2007

Trudy Friend has asserted her right to be
identified as author of this work in accordance
with the Copyright, Designs and Patents
Act, 1988.

A catalogue record for this book is available from
the British Library.

ISBN-13: 978-0-7153-2403-5 paperback
ISBN-10: 0-7153-2403-9 paperback

Printed in China by SNP Leefung
for David & Charles
Brunel House Newton Abbot Devon

Commissioning Editor Freya Dangerfield
Assistant Editor Louise Clark
Project Editor Ian Kearey
Art Editor Sarah Underhill
Designer Sarah Clark
Design Assistant Emma Sanquest
Production Controller Kelly Smith

Visit our website at www.davidandcharles.co.uk

David & Charles books are available from all good bookshops; alternatively you
can contact our Orderline on 0870 9908222 or write to us at FREEPOST EX2
110, D&C Direct, Newton Abbot, TQ12 4ZZ (no stamp required UK only); US
customers call 800-289-0963 and Canadian customers call 800-840-5220.

The *Problems and Solutions* series of books from David &
Charles grew out of a series of articles that Trudy Friend
wrote for *Leisure Painter* magazine. *Leisure Painter* was
first published in 1967 and is now the UK's most popular
painting magazine, helping beginners and amateur artists
to paint in all media. The magazine is available from all
good UK newsagents or direct from the publisher on
subscription. Write to: *Leisure Painter* magazine, Caxton
House, 63/65 High Street, Tenterton, Kent TN30 6BD; or
telephone 01580 763315. Further information is available
on the website at www.leisurepainter.co.uk

Contents

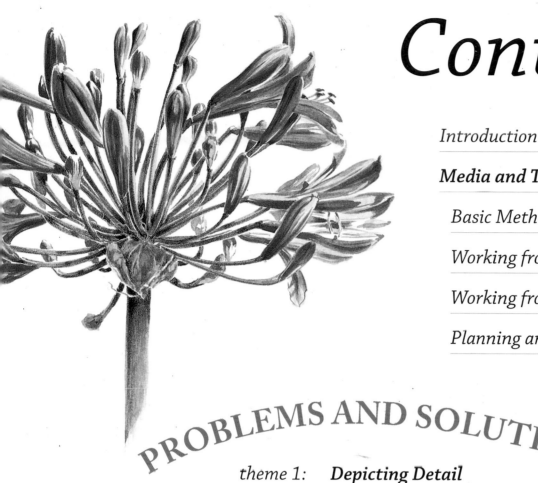

PROBLEMS AND SOLUTIONS

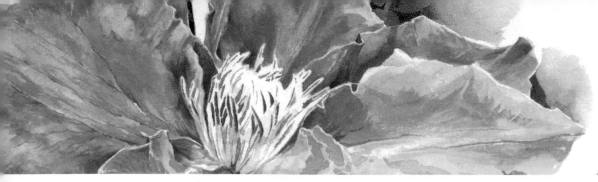

Introduction

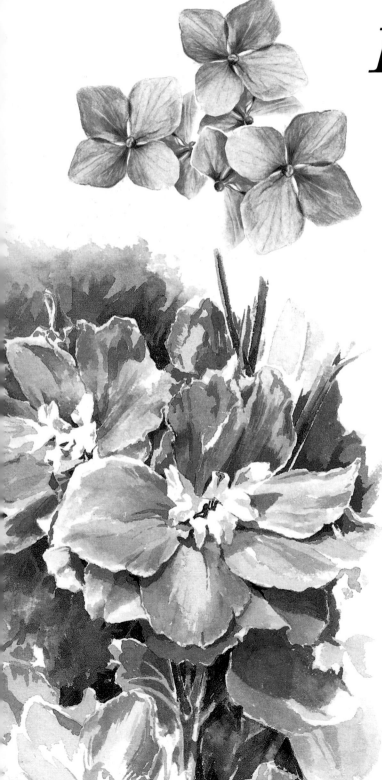

With this book I will be helping you…

to love your art,

to live your art

and see the world go by

as colour, texture, line and form

and with an 'artist's eye'.

Whether grown in pots, window boxes or gardens, flowers are a delight to the senses. Individual blooms can give as much pleasure as a bouquet containing a profusion of sprays. They are an important part of our lives as we marvel at their intricacies, enjoy their scents, touch the delicacy of their petals and are filled with incredulity at the limitless diversity of flowers and plants.

In a book like this I can only briefly mention a few species but, in doing so, I hope I can help you, as an artist, to appreciate them even more and entertain some new thoughts and considerations in their depiction.

Colour

It is probably the vast array of vibrant hues that attracts many artists to choose flowers as subject matter. Whether drawing with coloured pencils or painting using the application of delicate, translucent washes, there is a sense of fulfilment in portraying such beauty. It is not only the blooms that offer a colour-mixing challenge; we also need to develop our skills for capturing leaves and stems, which are not always green in colour.

Another consideration is tonal values – the way in which we depict cast shadows and rich, dark negative shapes, and use techniques such as the retention of white paper to achieve the all-important highlights; these elements play a vital part in bringing artwork to life.

Texture

It may be the texture we try to achieve when depicting a mass of tiny flowers making up a plant, or the texture of one flower head that possesses a massed formation of petals – either way, we need to have regard for the individual components and their relationship with each other, as well as for the whole image.

When achieving loose, free interpretations we still benefit from developing drawing and painting skills based upon close observation and detailed execution as a starting point.

Line

Lines can be seen in the form of veins and markings – many of which 'follow form' and help us depict the flower convincingly – but the use of outlines in our representations requires thought and consideration regarding how and why we are applying them.

Lines can be the result of on/off pressure upon the pencil or brush, and are always interesting when applied in this way. However, for some botanical and illustrative interpretations, a delicate line of even pressure may be what is required.

With the use of a nib pen or a brush, other varieties of linear drawing present themselves in a variety of narrow and wide strokes.

Form

Lines that 'find form' are often applied initially, following contours. When drawn close together they create areas of tone; and a mixture of line and tone, with regard for highlighted areas, helps us achieve a three-dimensional representation. We need to be aware of structure as well as form to avoid our images of flowers becoming flat and therefore uninteresting.

With an artist's eye

Looking beyond the obvious and putting something of ourselves into our interpretations, rather than just drawing what we see, is coupled with how we, as artists, see in a certain way.

Throughout this book, drawings and paintings demonstrate how I have been conscious of flowing forms and have imagined more than I can actually see in flower heads and their surrounding buds and leaves.

All these considerations, and many more, are presented within the following themes, and they combine to help us observe the world of flowers with an artist's eye.

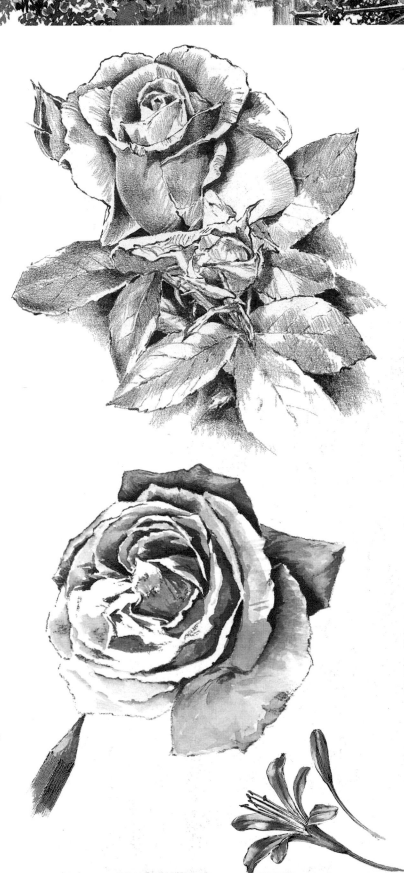

Media and Techniques

Pencils

From the hard H to the soft 9B, the graphite pencil is one of the most versatile media.

It is important to consider the surface: a soft pencil on soft paper produces considerable texture, particularly in gently toned areas. It also smudges easily and needs to be sprayed with fixative to hold the image fast.

A hard pencil on smooth paper enables you to draw fine detail, while drawing on a smooth surface with a soft 6B pencil allows you to achieve freedom of depiction, as seen in the examples below.

H pencil

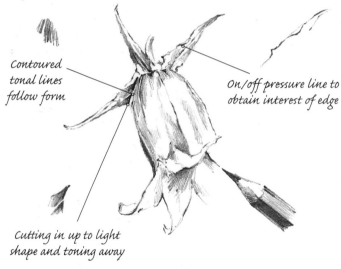

Contoured
tonal lines
follow form

On/off pressure line to
obtain interest of edge

Cutting in up to light
shape and toning away

6B pencil

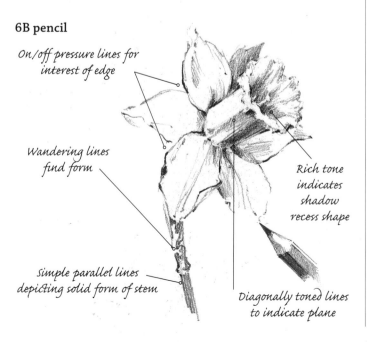

On/off pressure lines for
interest of edge

Wandering lines
find form

Rich tone
indicates
shadow
recess shape

Simple parallel lines
depicting solid form of stem

Diagonally toned lines
to indicate plane

Pen and ink

For the pen and ink example here, I have chosen a section of stem that displays a few buds. Drawn on lightweight Bockingford paper using a 0.3 fineliner pen, I grazed the pen lightly across the textured surface to achieve a soft impression. Two different strokes are shown here: contoured, to find form, and parallel, to give strength to the structure of the stem.

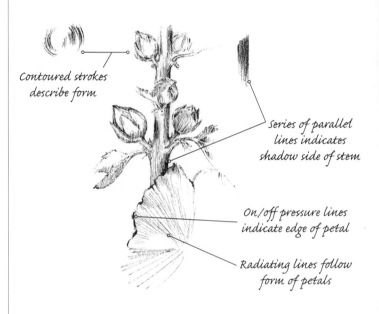

Contoured strokes
describe form

Series of parallel
lines indicates
shadow side of stem

On/off pressure lines
indicate edge of petal

Radiating lines follow
form of petals

Pen and wash

With the same pigment liner pen on the same surface, I drew a red hot poker plant section to demonstrate the pen and wash method, using directionally placed strokes in both pen and brushwork.

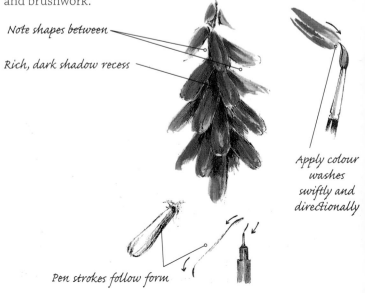

Note shapes between

Rich, dark shadow recess

Apply colour
washes
swiftly and
directionally

Pen strokes follow form

Coloured pencils

Moving from monochrome into colour, yet retaining the drawing approach, this study shows how zigzag strokes are used to achieve pattern effects. These can be contrasted with the fine line veins on the tissue-paper-thin protective 'sleeve' beneath.

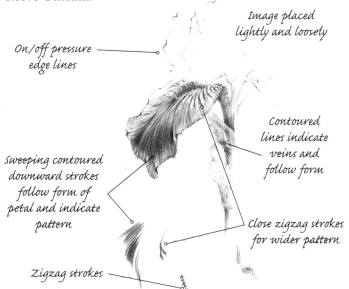

On/off pressure edge lines

Image placed lightly and loosely

Sweeping contoured downward strokes follow form of petal and indicate pattern

Contoured lines indicate veins and follow form

Close zigzag strokes for wider pattern

Zigzag strokes

Brush pens

The wide and slightly flexible brush pen can be used for both detailed and flat coverage. For the grape hyacinth here, the first stage is drawn in pale grey, followed by an overlay of blue and final enhancement of purple.

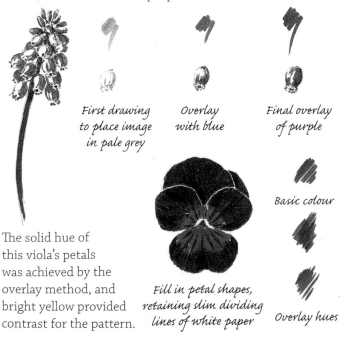

First drawing to place image in pale grey

Overlay with blue

Final overlay of purple

Basic colour

The solid hue of this viola's petals was achieved by the overlay method, and bright yellow provided contrast for the pattern.

Fill in petal shapes, retaining slim dividing lines of white paper

Overlay hues

Watercolour pencils

Reverting to a more detailed approach, a delicate hydrangea flower was used as an example for this versatile medium.

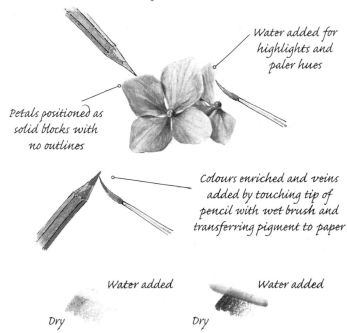

Water added for highlights and paler hues

Petals positioned as solid blocks with no outlines

Colours enriched and veins added by touching tip of pencil with wet brush and transferring pigment to paper

Water added

Dry

Water added

Dry

Watercolour

There are so many watercolour methods that I am able to include only a few on this page; you will see others in the themed sections.

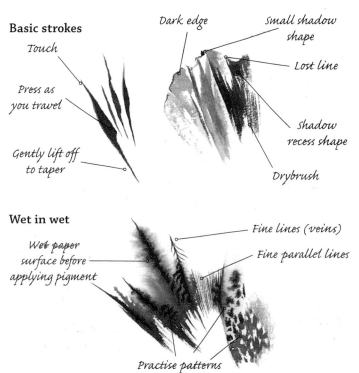

Basic strokes

Touch

Press as you travel

Gently lift off to taper

Dark edge

Small shadow shape

Lost line

Shadow recess shape

Drybrush

Wet in wet

Wet paper surface before applying pigment

Fine lines (veins)

Fine parallel lines

Practise patterns

Basic Methods

Bright colourful pansies – with varieties that flower in the winter as well as summer-flowering plants – can be captured effectively in many media. For this reason I have chosen a few cheerful pansy faces, all drawn and painted from life, to demonstrate some of the methods you will find in the themes that follow. In the examples on this page I used Bristol Board as a smooth surface support.

A hard H pencil is ideal for line drawing in the form of a simple bud; to tone for colour as well as tone, I used a softer B pencil for delicate directional strokes; softer pencil grades are ideal for quick sketches, and for this technique I used a 4B grade pencil.

Coloured pencils are effective for achieving bright hues, and I used the Derwent Studio range to demonstrate the use of two strong contrasting colours for petal and pattern respectively. Derwent Inktense and watercolour pencils can be used dry or wet, and opposite you can see the effect that can be achieved by adding water to the pigments.

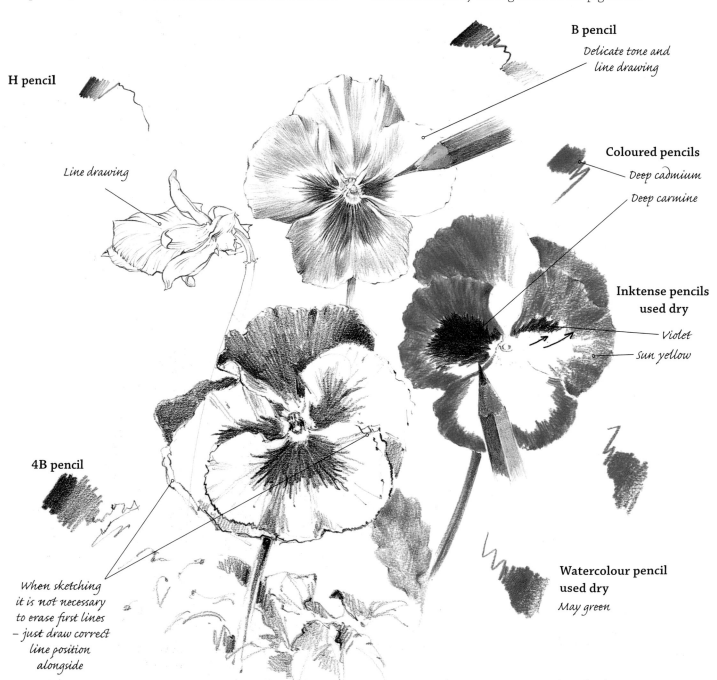

H pencil

Line drawing

B pencil
Delicate tone and line drawing

Coloured pencils
Deep cadmium
Deep carmine

Inktense pencils used dry
Violet
sun yellow

4B pencil

When sketching it is not necessary to erase first lines – just draw correct line position alongside

Watercolour pencil used dry
May green

Wet media

These studies show three painting media methods: Derwent Inktense pencils, watercolour pencils and pure watercolour.

Inktense pencils

You can either gently sharpen the pencil strip into a palette and add water to mix, or hold it over a palette well and, with a wet brush, pull the pigment into the well.

Watercolour pencils

You can draw the image dry on dry and then add a clear water wash; the colours will blend on the paper when you add water. I have done this here and, with the green areas, added a little red or violet to change the basic colour.

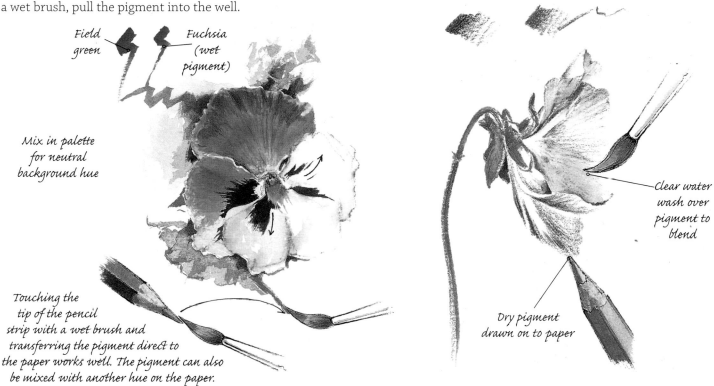

Field green

Fuchsia (wet pigment)

Mix in palette for neutral background hue

Touching the tip of the pencil strip with a wet brush and transferring the pigment direct to the paper works well. The pigment can also be mixed with another hue on the paper.

Clear water wash over pigment to blend

Dry pigment drawn on to paper

Watercolour

This study demonstrates the method of cutting in behind light forms and those that are dark yet possess light edges.

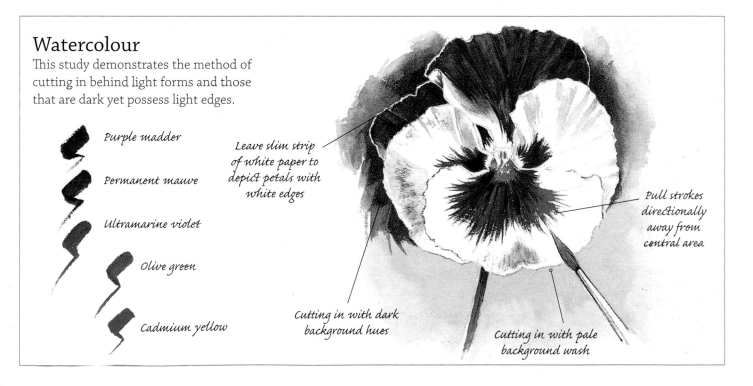

Purple madder

Permanent mauve

Ultramarine violet

Olive green

Cadmium yellow

Leave slim strip of white paper to depict petals with white edges

Pull strokes directionally away from central area

Cutting in with dark background hues

Cutting in with pale background wash

Working from Life

If you were to choose part of a garden as the subject matter for sketching, you might feel that there was so much to absorb visually that you would prefer to leave out certain areas. You can achieve this by simply not including them in your sketch – even though they are still visible in the scene before you.

In this demonstration I have gone one step further and physically removed parts of a pansy plant growing in a pot, so that the eye is not distracted in the final representation.

First sketch

Here I have sketched in everything, even the faded blooms. There was, however, such a profusion of flower heads, stems and leaves, that I decided to break some of them and remove them (to draw them as individual parts later). This left those that remained more clearly defined.

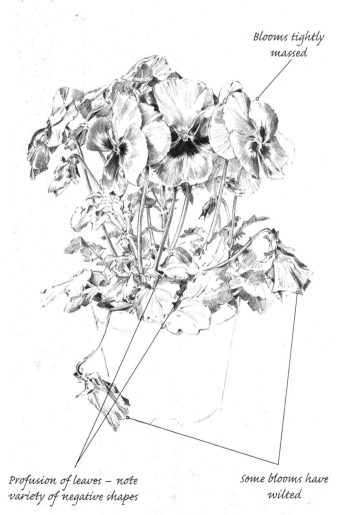

Blooms tightly massed

Profusion of leaves – note variety of negative shapes

Some blooms have wilted

Second sketch

Before making the second sketch I moved the blooms apart slightly. Remember that you can always twist the pot around a little in order to view the flowers from a different angle.

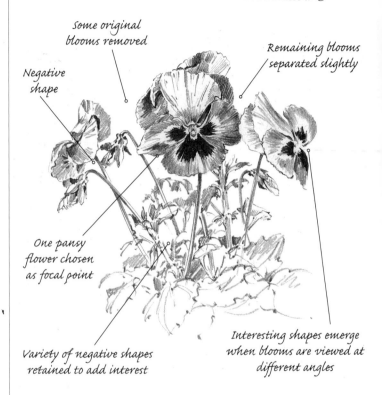

some original blooms removed

Negative shape

Remaining blooms separated slightly

One pansy flower chosen as focal point

Variety of negative shapes retained to add interest

Interesting shapes emerge when blooms are viewed at different angles

Ink tracing

A tracing is useful in that you can draw over your lines on the reverse of the paper and transfer them lightly on to the prepared surface prior to placing the first areas of colour. In this tracing the lower area was simplified, with some shapes edited out.

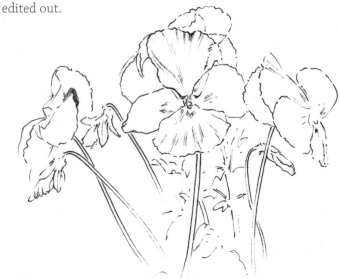

Using sketches

When you start painting you will have both the original sketch and the plant in front of you to refer to. This can be an advantage, as the plant may move slightly as you work if you are painting for any length of time. If it does move – and even a comparatively small amount of movement over a period of time can have a disconcerting effect – you will still have your sketch as a reference.

Blocking in colour

Before painting I prepared a sheet of Bockingford paper by placing a coloured flat wash upon the stretched surface; I used gouache in order to include white in my palette. In the painting I have indicated (a) the first, freely 'drawn' lines and areas of colour; (b) the second application, where hue and tone are intensified; and (c) the building of some initial areas of colour, upon which the final interpretation is placed.

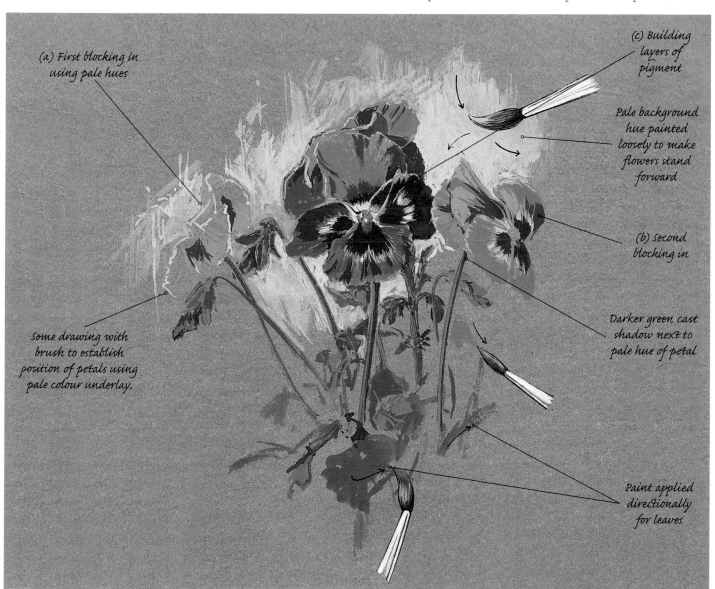

(a) First blocking in using pale hues

Some drawing with brush to establish position of petals using pale colour underlay.

(c) Building layers of pigment

Pale background hue painted loosely to make flowers stand forward

(b) Second blocking in

Darker green cast shadow next to pale hue of petal

Paint applied directionally for leaves

Observing details

There are many advantages to working from life, not least the fact that you can view specimens from various angles. You can also observe details and analyse further by removing individual parts to help you understand the plant's structure. You can hold a part in your free hand or place it on a flat sheet of paper, so you can observe and paint it from various angles.

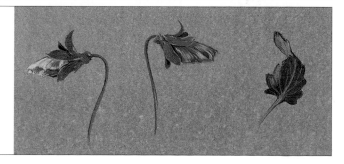

Working from Photographs

If you can obtain clear photographic reference of a plant that you are also able to observe from life, you have the best of both worlds. A two-dimensional image placed alongside your drawing or watercolour paper can be a great help; and to see the actual plant before you – where you can touch it, feeling the texture, and turn it to observe different angles – is an added bonus.

The first illustration shows some typical problems that may be experienced – even with the help of a photo – when beginners do not know how to suggest a three-dimensional form, or to follow that form with pencil or brushstrokes. Obtaining fluidity of pigment can also be a problem when using watercolour, and overcoming this is explained within some of the following themes.

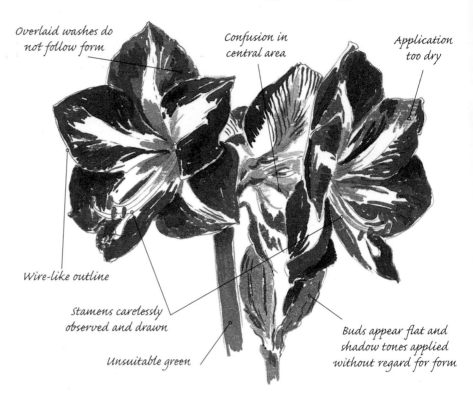

Overlaid washes do not follow form

Confusion in central area

Application too dry

Wire-like outline

Stamens carelessly observed and drawn

Unsuitable green

Buds appear flat and shadow tones applied without regard for form

Depicting detail

With the aid of a camera, you can record various stages of development of a plant such as this amaryllis, and can then use your photos to enable close observation of the intricacies of this fascinating plant, and its progression from bud to flower.

From the first tight bud, through its gentle opening into the revelation of four components emerging from one, these illustrations show in detail the variety of line and tone that combine to present these exciting forms.

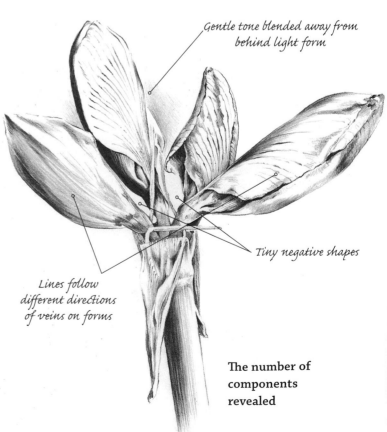

Gentle tone blended away from behind light form

Tiny negative shapes

Lines follow different directions of veins on forms

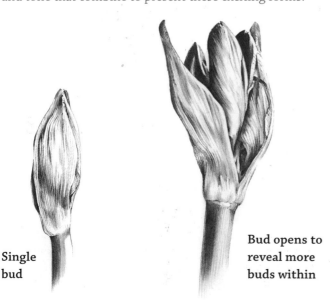

Single bud

Bud opens to reveal more buds within

The number of components revealed

Presenting the image in pen and ink

In this study I used a Profipen 0.5 to graze the surface of cartridge paper for the depiction of buds gradually opening.

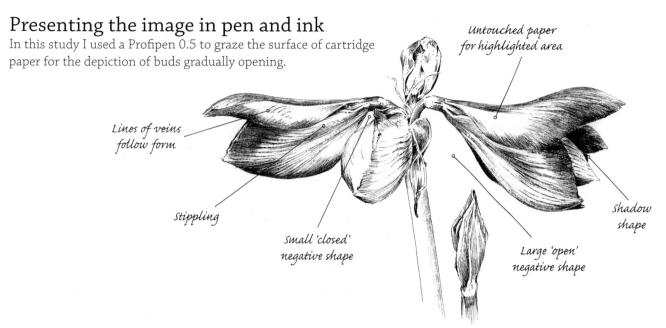

Untouched paper for highlighted area

Lines of veins follow form

Stippling

Small 'closed' negative shape

Large 'open' negative shape

Shadow shape

Working in colour

Watercolour pencils, enabling delicacy of interpretation, were the choice for the next stage, where the petals start spreading to reveal an array of stamens. Gently grazed across the paper's surface, these waxy-textured pencils can be overlaid dry on dry, establishing the image prior to the addition of water.

A great deal can be learnt and understood about plant structure and growth through an exercise like this, where the camera captures each stage of development. Intricately accurate representations using photographic references build a solid base from which we can later choose to move away into spontaneously loose impressions that are successful due to the depth of basic knowledge obtained in this way.

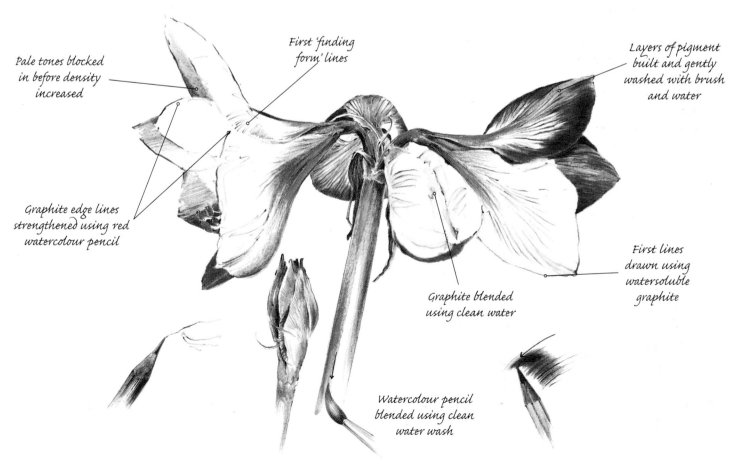

Pale tones blocked in before density increased

First 'finding form' lines

Layers of pigment built and gently washed with brush and water

Graphite edge lines strengthened using red watercolour pencil

Graphite blended using clean water

First lines drawn using watersoluble graphite

Watercolour pencil blended using clean water wash

Planning and Composition

There are a number of factors to take into consideration when planning your composition. On this page I have shown four format options within which you can plan your composition – portrait, oval, landscape and circular – and, on the opposite page, the less-used square format. Note the different considerations required for each format.

In Theme 7 (see pages 100–113) you can see a few of the problems that can arise in the drawings and paintings executed by beginners when they are unaware of the importance of planning the composition within which their flowers are to be presented. This theme also covers the subjects of editing in and editing out.

Modifying the portrait format

The simple arrangement of a bouquet of flowers in a portrait format can present problems regarding the treatment or inclusion of a background. These can be solved by using an oval format to contain the arrangement. You can guide the eye into your composition by placing the flowers in an S shape, shown here by the red contoured line.

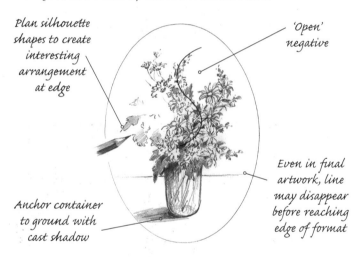

Plan silhouette shapes to create interesting arrangement at edge

'Open' negative

Even in final artwork, line may disappear before reaching edge of format

Anchor container to ground with cast shadow

Working off-centre

By placing the main object of interest slightly off-centre within a busy background, you can avoid the problem of blank, uninteresting areas.

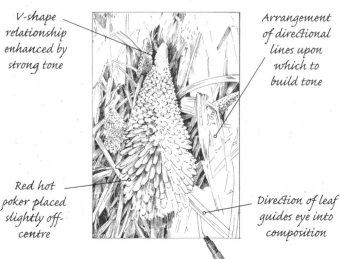

V-shape relationship enhanced by strong tone

Arrangement of directional lines upon which to build tone

Red hot poker placed slightly off-centre

Direction of leaf guides eye into composition

Landscape format

This format offers an opportunity to guide the observer's eye towards the main area of interest by the way the blooms are placed in relation to each other and their foliage background.

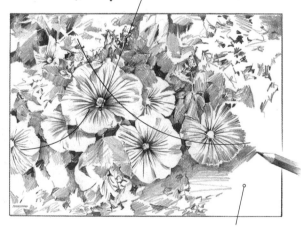

Eye is taken towards focal point of dominant bloom

Area has less content to rest the eye

Circular format

To make a simple circular format more interesting you can bring part of the composition out of the circle by drawing or painting the component on to the mount; if composing your picture within a drawn line, you can go beyond that edge.

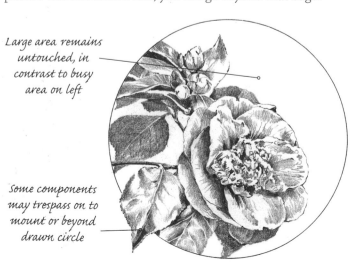

Large area remains untouched, in contrast to busy area on left

Some components may trespass on to mount or beyond drawn circle

Focusing in

Working from a photo reference, this exercise shows how you can change the composition and create more impact by moving in closer to a particular area.

In the first study I decided that the landscape format was being divided in a way that afforded too much consideration for foliage and too little for the splendid blooms of the poppies.

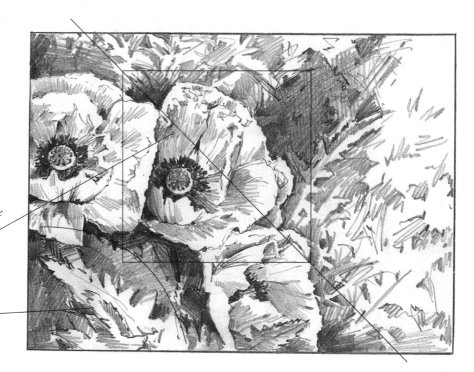

Composition cut in half diagonally

Arrangement of leaves in this area cuts corner off

To solve the problem I decided to concentrate upon one flower in particular, by observing it in close-up and relating it to the format of a square. This produced more interesting comparisons and contrasts of shapes and also limited the amount of green. (See page 102 for the first stages of building this image.)

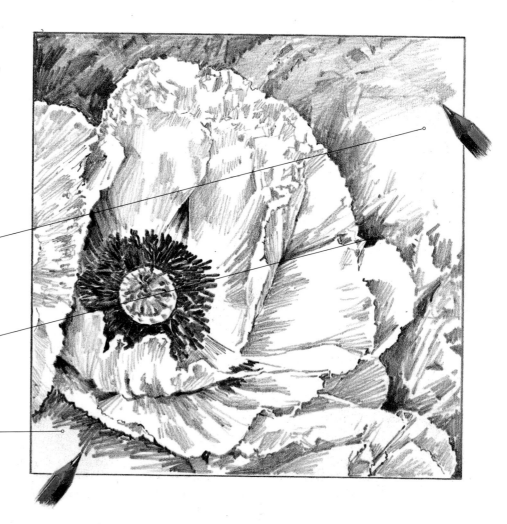

This area does not possess as much content and rests the eye

Cut in crisply – dark against light – to achieve interesting contrasts

Area will be in rich green for strong contrast against pale hue of poppy petal

Depicting Detail

Whether or not you wish to include in your work every detail you see, close observation of the forms of flowers, stems and leaves is essential. Even if you wish to paint or draw freely, expressing spontaneity and mastering a loose approach, time spent in mastering the basic discipline of sound observational drawing gives a good grounding for which there is no substitute. Without this, there will always be something lacking in freely executed work; with it you can be as free as you wish, and your drawings and paintings will still have conviction.

On the following pages, a variety of media have been used: coloured pencils, watersoluble Graphitint and graphite with watercolour overlay, as well as hard graphite F pencil on Bristol Board and B pencil on thin card. When sharpened to a fine point, a softer B pencil provides a delicacy that is suitable for executing smooth contoured tonal strokes.

Pencil exercises

To achieve exciting contrasts of tone it is essential to incorporate a variety of tonal values within your representations and to place the darkest darks directly against white paper (the lightest light). Practise drawing a very fine line first and then tone up to it, cutting in crisply, before toning away to blend into the paper.

The gentle blending involved may be a problem at first, but with practice in varying pencil pressure as you work, your skills will improve. These exercises relate to the methods used for the water lily on page 25.

Work across, lifting pressure all the time, and blend into paper

Start with firm, downward pressure, contoured strokes

Contoured on/off pressure stroke

Create contoured effect with gentle shadow lines

Gently build tone in certain areas to allow others to remain paler

Tone in shadow recess shape

Cut in with dark tone, leaving slim area of white paper

Cut in for crisp contrasts

Allow area of white paper to widen and tone lightly away from edge

These exercises relate to the cyclamen on page 28. It is important to be aware of which direction you need to tone in order to represent the relevant forms.

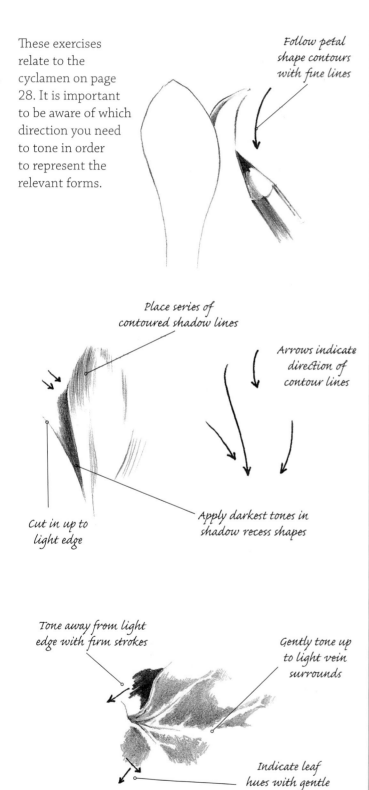

Follow petal shape contours with fine lines

Place series of contoured shadow lines

Arrows indicate direction of contour lines

Apply darkest tones in shadow recess shapes

Cut in up to light edge

Tone away from light edge with firm strokes

Gently tone up to light vein surrounds

Indicate leaf hues with gentle crosshatching

Toning exercise

This is a simple exercise to try if you have not yet mastered what I refer to as the 'up to and away' form of toning. For this exercise, draw a firm pressure guideline similar to a petal shape. Starting a little way from the line, use a zigzag movement of the pencil to tone towards (up to) the line. Cut in crisply against the line before toning with a similar movement away from the line. Allow your tone to blend out smoothly, either into another form or a background area. By leaving a strip of paper before doing the same on the other side, you will achieve the effect of a slim petal edge that has been highlighted.

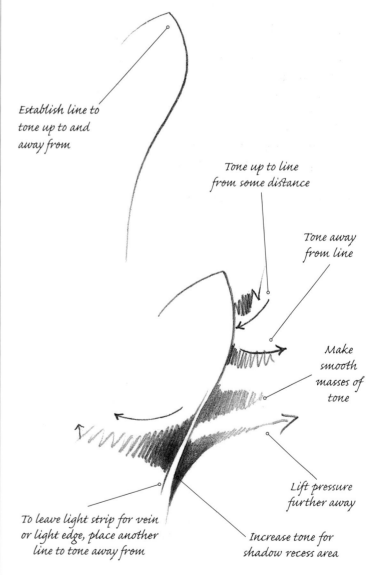

Establish line to tone up to and away from

Tone up to line from some distance

Tone away from line

Make smooth masses of tone

Lift pressure further away

Increase tone for shadow recess area

To leave light strip for vein or light edge, place another line to tone away from

Coloured pencil exercises

A natural progression from monochrome drawing is to introduce colour using the same techniques.

The exercises here demonstrate how delicacy of application can produce sensitive detail drawing and how retention of the white paper surface introduces effective highlights.

Starting with a pale underlay, you can gradually build stronger hue and tone in subsequent overlays to increase intensity as you describe the form with directional application of pigment.

Watersoluble pencil exercises

The foxglove study on page 81 was drawn using Graphitint watersoluble pencils, followed by the gentle application of water with directionally placed strokes. The subtle hues that result from such a technique – using pencil as both a wet and a dry medium – can be exciting to work with.

It is always a good idea to experiment with different paper surfaces before committing to one in particular. These examples were made on Saunders Waterford HP paper; other papers will produce different results.

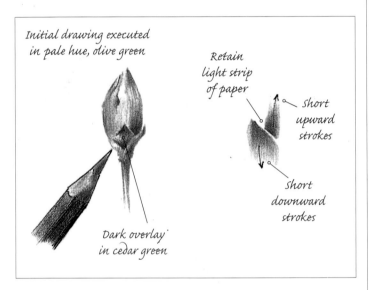

Initial drawing executed in pale hue, olive green

Retain light strip of paper

Short upward strokes

Short downward strokes

Dark overlay in cedar green

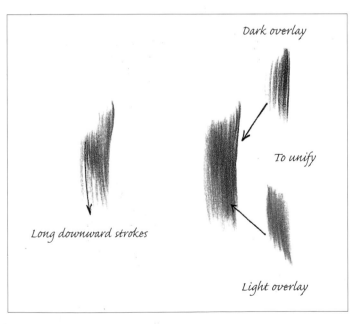

Dark overlay

To unify

Long downward strokes

Light overlay

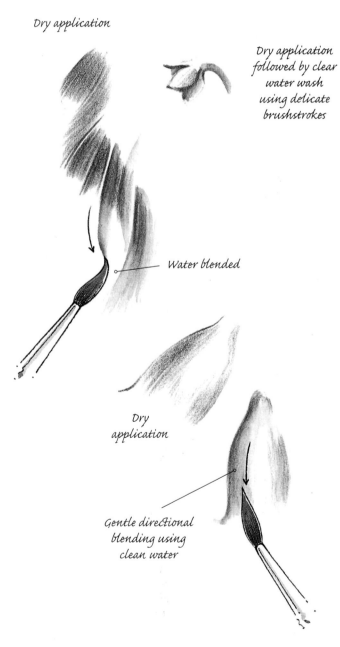

Dry application

Dry application followed by clear water wash using delicate brushstrokes

Water blended

Dry application

Gentle directional blending using clean water

Mixed media

A detailed graphite pencil drawing can be enhanced by the application of watercolour painted overlays, as shown on page 27. A smooth white paper surface was used here so that a fine detail drawing could be established before adding directionally placed watercolour wash overlays.

The pencil and brush movements are similar – with the exception of upward and downward pressure strokes with the brush, which produce wide brushstrokes that can be swept across areas of the paper to indicate the delicacy of veins and petals.

Be careful to mix enough water with your pigment and to make enough to last through the entire painting. When all washes have dried, you can add further pencil strokes to enhance the depth of tone in certain areas.

Brush movements

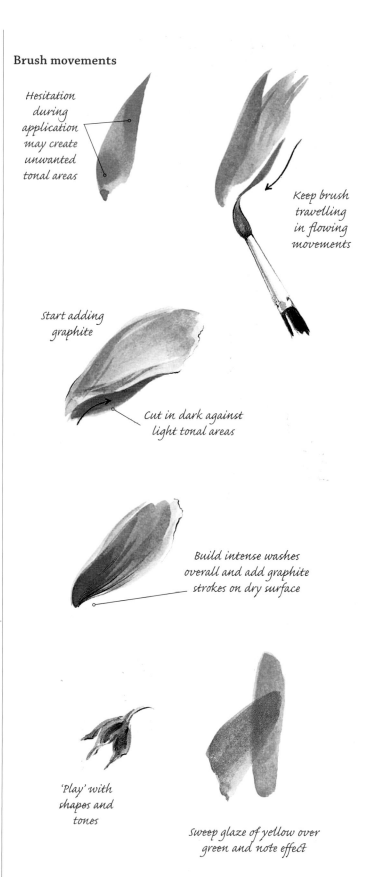

Hesitation during application may create unwanted tonal areas

Keep brush travelling in flowing movements

Start adding graphite

Cut in dark against light tonal areas

Build intense washes overall and add graphite strokes on dry surface

'Play' with shapes and tones

Sweep glaze of yellow over green and note effect

Pencil movements

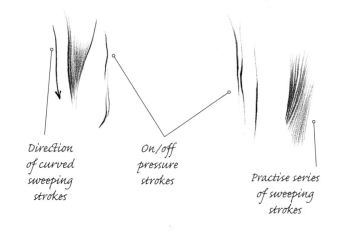

Direction of curved sweeping strokes

On/off pressure strokes

Practise series of sweeping strokes

Fine vein strokes

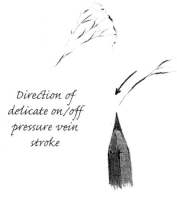

Direction of delicate on/off pressure vein stroke

Problems

Carnations

coloured pencils

Whether you are depicting the detail of a single spray of flowers or a few sprays taken from a larger bunch, it is not necessary to complete the arrangement in one sitting.

Giving some initial consideration to the placing of negative shapes between stems, blooms and leaves will allow you to draw, say, a flower head and part of the structure one day and continue with more the next day. It is when stems, leaves and flowers overlap – with some parts of the structure passing behind or across others – that problems can occur, resulting in a series of disjointed images.

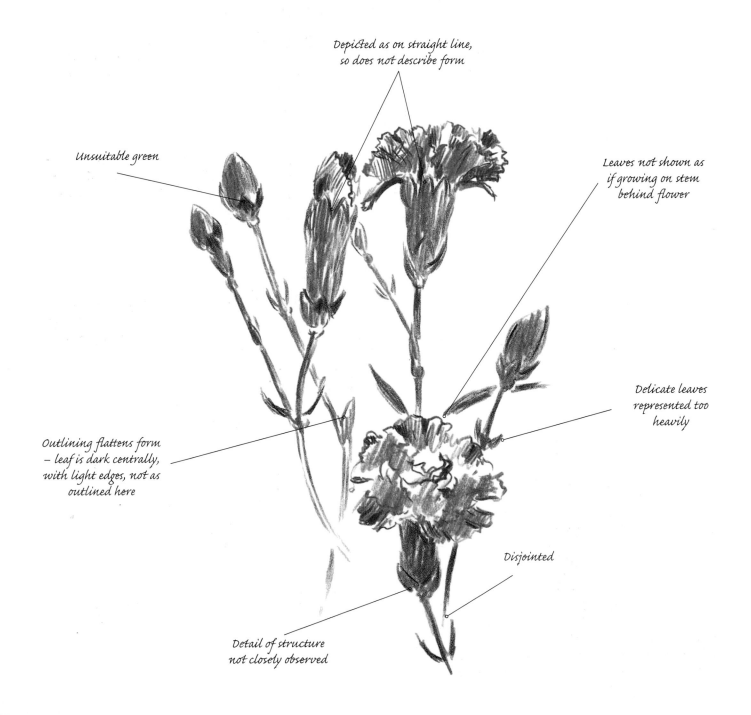

Depicted as on straight line, so does not describe form

Unsuitable green

Leaves not shown as if growing on stem behind flower

Delicate leaves represented too heavily

Outlining flattens form – leaf is dark centrally, with light edges, not as outlined here

Disjointed

Detail of structure not closely observed

Solutions

The problem of how to avoid wire-like outlining can be overcome simply by the placing of light and dark tones against each other. It is also wise to give some thought to the arrangement in advance.

Coloured pencils are ideal for this type of work when used upon HP watercolour paper. It is essential to work with carefully sharpened pencils in order to depict fine detail such as this – try to curb your enthusiasm and impatience to start immediately while you take time to prepare your pencils.

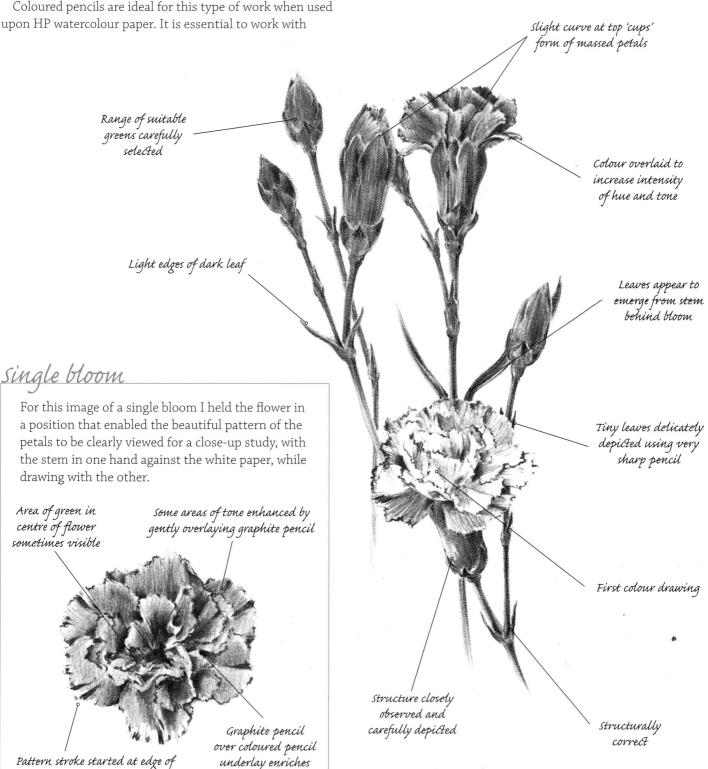

Slight curve at top 'cups' form of massed petals

Range of suitable greens carefully selected

Colour overlaid to increase intensity of hue and tone

Light edges of dark leaf

Leaves appear to emerge from stem behind bloom

Tiny leaves delicately depicted using very sharp pencil

First colour drawing

Structure closely observed and carefully depicted

Structurally correct

single bloom

For this image of a single bloom I held the flower in a position that enabled the beautiful pattern of the petals to be clearly viewed for a close-up study, with the stem in one hand against the white paper, while drawing with the other.

Area of green in centre of flower sometimes visible

Some areas of tone enhanced by gently overlaying graphite pencil

Graphite pencil over coloured pencil underlay enriches contrasts of dark in shadow areas

Pattern stroke started at edge of petal – widest part of marking – tapering towards centre of flower

Problems

Foxglove

watercolour

Foxgloves have many attributes that make them interesting subjects, and I have included them in three themes. On page 49 is a detailed interpretation in pen, ink and wash, emphasizing the importance of contrasts in drawings and paintings; on page 81 outlines come into play as we see more of the stem, with flowers represented at different angles to those on this spread; the study here looks at the detail of pattern within the bell-shaped blooms and how the pattern marks follow the shape of the flower.

Beginners sometimes experience problems when attempting to depict the interiors of these flowers and the way the pattern follows the contoured recesses.

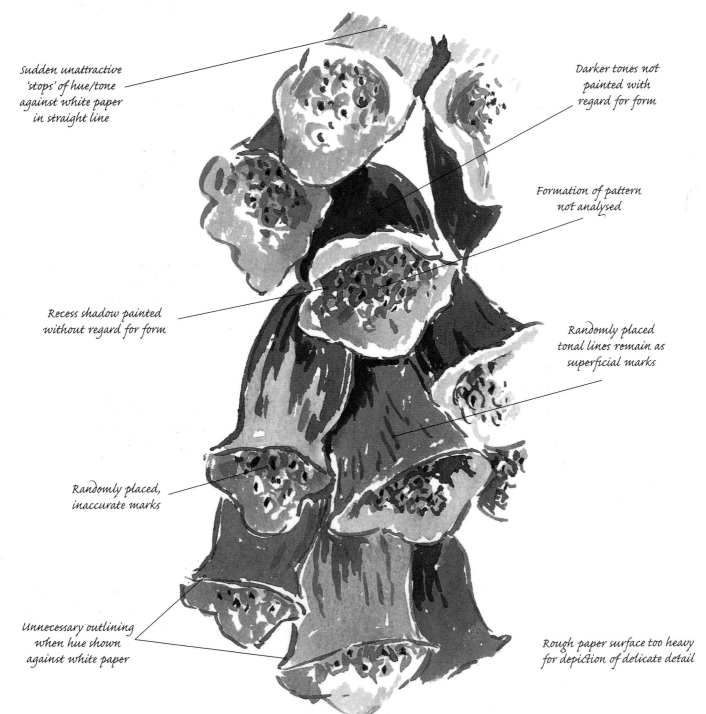

Sudden unattractive 'stops' of hue/tone against white paper in straight line

Darker tones not painted with regard for form

Formation of pattern not analysed

Recess shadow painted without regard for form

Randomly placed tonal lines remain as superficial marks

Randomly placed, inaccurate marks

Unnecessary outlining when hue shown against white paper

Rough paper surface too heavy for depiction of delicate detail

Solutions

I have chosen one main bloom to demonstrate in detail how the prolific pattern is arranged within the bell-shaped flower. It is helpful to treat a subject like this as a monochrome study, concentrating more fully upon tonal values, but I have introduced a blue (to mix with the purple madder) to help indicate shadow areas.

Tonal values in purple madder **Shadow tones**

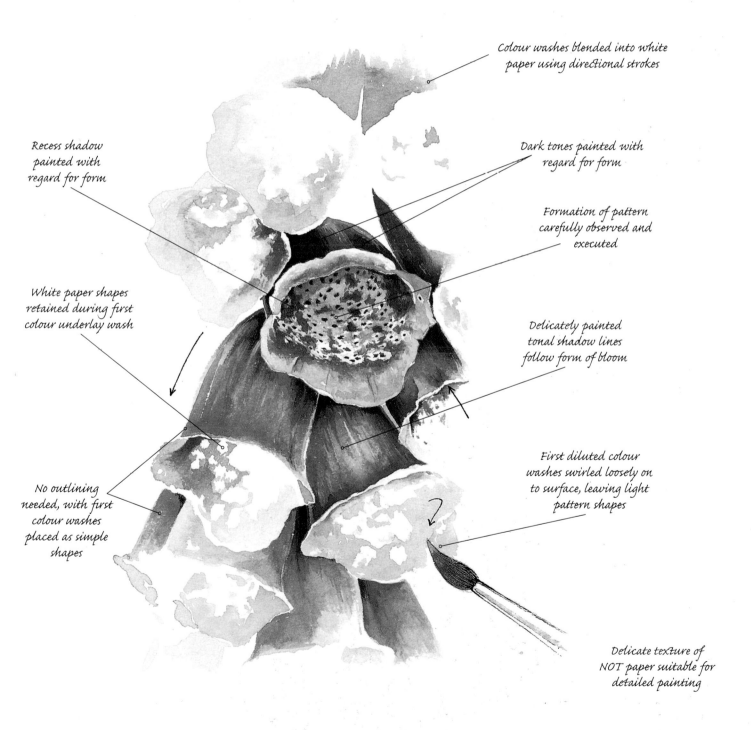

Colour washes blended into white paper using directional strokes

Recess shadow painted with regard for form

Dark tones painted with regard for form

Formation of pattern carefully observed and executed

White paper shapes retained during first colour underlay wash

Delicately painted tonal shadow lines follow form of bloom

No outlining needed, with first colour washes placed as simple shapes

First diluted colour washes swirled loosely on to surface, leaving light pattern shapes

Delicate texture of NOT paper suitable for detailed painting

Problems

Water Lily

pencil

This popular water plant, with its large floating leaves, allows the artist to make interesting comparisons between the two different forms of flower and leaf.

The numerous petals, which open out to reveal an array of tiny forms within, offer exciting contrasts to the large, flat leaves, floating above submerged shapes that can just be discerned below the water's surface.

Beginners may not be aware of the vast choice of materials available or how important it is to experiment in order to choose the most suitable combinations for their own style.

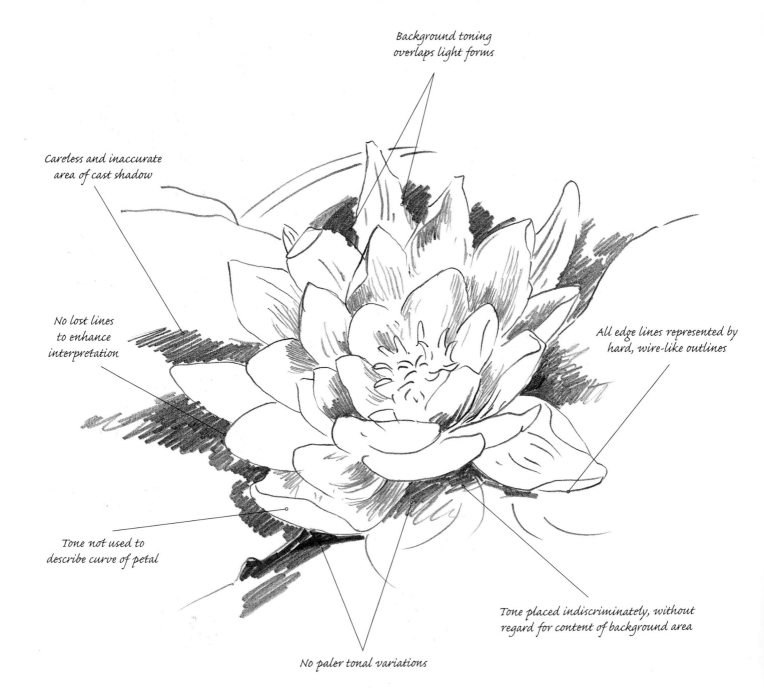

Background toning overlaps light forms

Careless and inaccurate area of cast shadow

No lost lines to enhance interpretation

All edge lines represented by hard, wire-like outlines

Tone not used to describe curve of petal

Tone placed indiscriminately, without regard for content of background area

No paler tonal variations

Solutions

Delicate application is essential for detailed drawings of this nature – to indicate tone or fine edge lines that describe the form. Some of the latter can subsequently be absorbed into the tonal areas, while others can be enhanced to add interest.

Highlighted petals contrasting with dark shadow recess shapes and areas of cast shadow can be depicted in detail using a finely sharpened graphite pencil; I used a hard F pencil on Bristol Board to achieve a smooth impression.

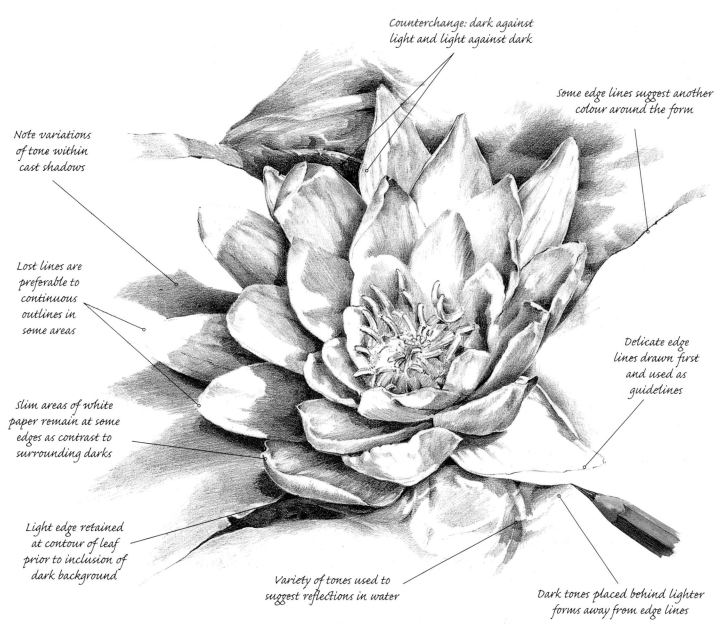

Counterchange: dark against light and light against dark

Some edge lines suggest another colour around the form

Note variations of tone within cast shadows

Lost lines are preferable to continuous outlines in some areas

Slim areas of white paper remain at some edges as contrast to surrounding darks

Delicate edge lines drawn first and used as guidelines

Light edge retained at contour of leaf prior to inclusion of dark background

Variety of tones used to suggest reflections in water

Dark tones placed behind lighter forms away from edge lines

Test a variety of pencils to discover which work best for you. These marks were made with Derwent Graphic pencils on Bristol Board.

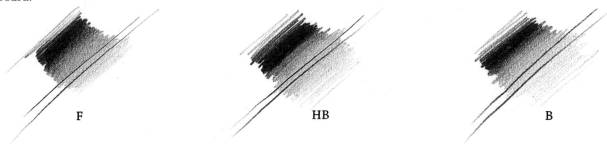

F HB B

Problems

Sweet Pea

pencil and watercolour pencils

The delicacy of a sweet pea plant can be captured using a detailed pencil drawing that has a tinted overlay painted with watersoluble pencils.

Problems can often arise when a paper is used that is unsuitable for this approach: lightweight drawing paper is inclined to cockle under the application of water, and even thin white card can often be preferable to the more textured surfaces of some drawing papers.

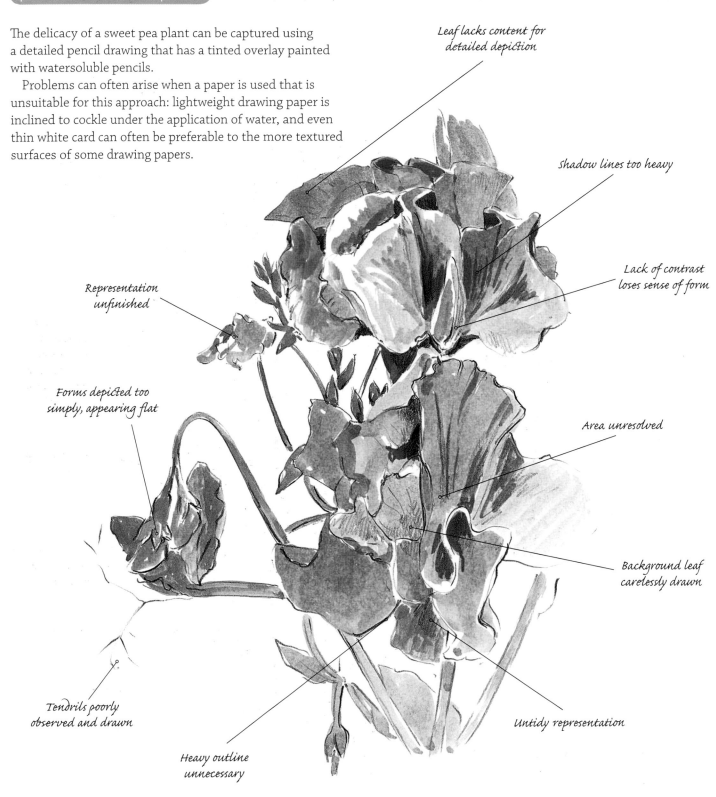

Leaf lacks content for detailed depiction

Shadow lines too heavy

Lack of contrast loses sense of form

Representation unfinished

Forms depicted too simply, appearing flat

Area unresolved

Background leaf carelessly drawn

Tendrils poorly observed and drawn

Heavy outline unnecessary

Untidy representation

Solutions

Derwent Inktense pencils were used as overlay pigment on the pencil drawing here, and both pencil and brushstrokes follow the contours of petals and leaves. Intensity of hue and tone were gradually built with wet-on-dry overlaid washes, which, although diluted, were not too wet to control. A smooth white paper surface combined with a relatively hard pencil – I used a 2B here – can help retain a crispness of drawing that is not lost with the introduction of a tint.

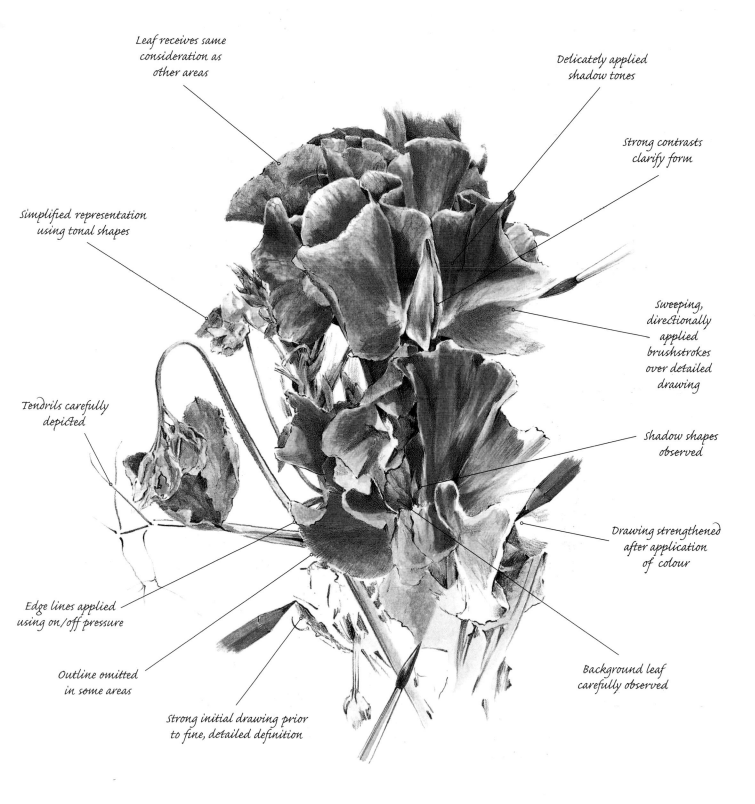

Leaf receives same consideration as other areas

Delicately applied shadow tones

Strong contrasts clarify form

Simplified representation using tonal shapes

Sweeping, directionally applied brushstrokes over detailed drawing

Tendrils carefully depicted

Shadow shapes observed

Drawing strengthened after application of colour

Edge lines applied using on/off pressure

Background leaf carefully observed

Outline omitted in some areas

Strong initial drawing prior to fine, detailed definition

Cyclamen

pencil

The close observation of detail provides an important starting point for drawing and painting flowers and plants. This aspect is also emphasized in the next theme and, although colour is included in all the themes, an awareness of tonal values is so essential that this first demonstration is executed in monochrome.

The water lily on page 25 possesses numerous petals in contrast to simple leaves; in this cyclamen, however, simple flower shapes rise above a sea of profusely patterned leaves of varied size. With both flowers an ability to execute pencil control, in order to place the fine strokes that represent gently toned contoured petals, is essential.

These illustrations show the development of a study from the initial investigative sketch, through the transference of the image on to good paper, to the final inclusion of all the minute tonal shapes required for a detailed representation.

Preliminary drawing

In the initial sketch, the components are placed showing their correct relationships to each other. Before starting to draw, turn the pot so that you view the flowers from a number of interesting angles, and make your choice from these.

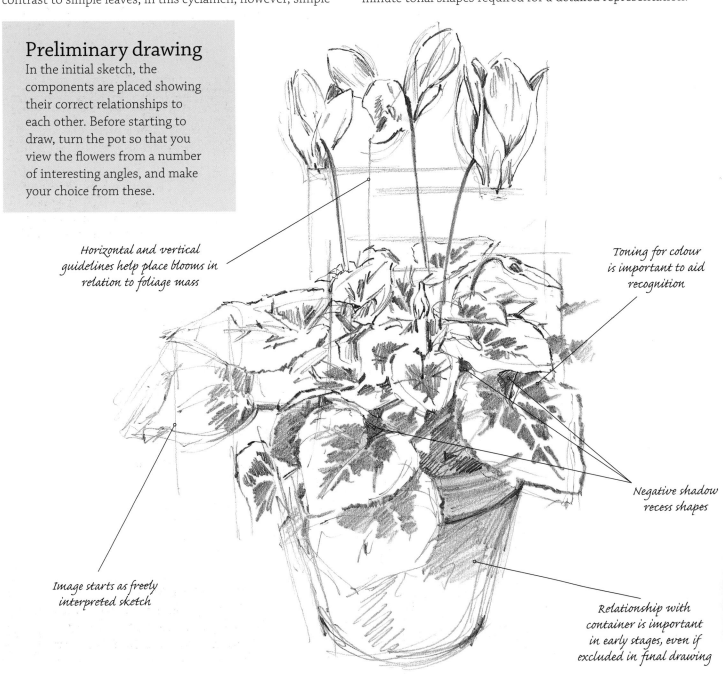

Horizontal and vertical guidelines help place blooms in relation to foliage mass

Toning for colour is important to aid recognition

Negative shadow recess shapes

Image starts as freely interpreted sketch

Relationship with container is important in early stages, even if excluded in final drawing

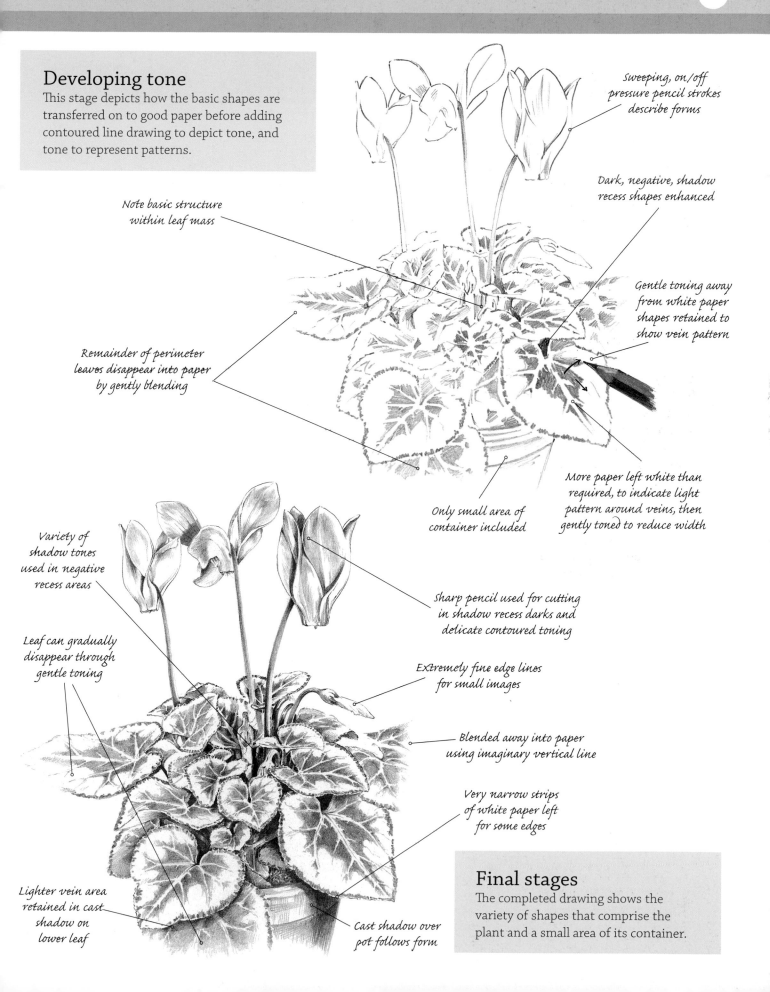

Developing tone

This stage depicts how the basic shapes are transferred on to good paper before adding contoured line drawing to depict tone, and tone to represent patterns.

Sweeping, on/off pressure pencil strokes describe forms

Dark, negative, shadow recess shapes enhanced

Note basic structure within leaf mass

Gentle toning away from white paper shapes retained to show vein pattern

Remainder of perimeter leaves disappear into paper by gently blending

More paper left white than required, to indicate light pattern around veins, then gently toned to reduce width

Only small area of container included

Variety of shadow tones used in negative recess areas

Sharp pencil used for cutting in shadow recess darks and delicate contoured toning

Leaf can gradually disappear through gentle toning

Extremely fine edge lines for small images

Blended away into paper using imaginary vertical line

Very narrow strips of white paper left for some edges

Lighter vein area retained in cast shadow on lower leaf

Cast shadow over pot follows form

Final stages

The completed drawing shows the variety of shapes that comprise the plant and a small area of its container.

Achieving Accuracy

Drawing exercises

This theme covers the importance of accurate observation and representation, established in preliminary drawings, where guidelines and negative shapes help in setting the relationship between components.

When working from photographs, guidelines are easy to use. When working from life, you may experience difficulties if the plant moves: in this situation, quick investigative sketches are an advantage. An example of this method of working is shown on page 42, where wandering lines and guidelines are worked alongside accurate observation of negative shapes and 'shapes between' to achieve a correct placing of blooms, stems and leaves.

Here I have drawn an arrangement of dahlia blooms presented at different angles, using just a few essential guidelines to place the flower heads in relation to each other, the leaves and stems. The pencil exercises relate to the strokes used for the dahlia on page 37.

Defining negative shapes

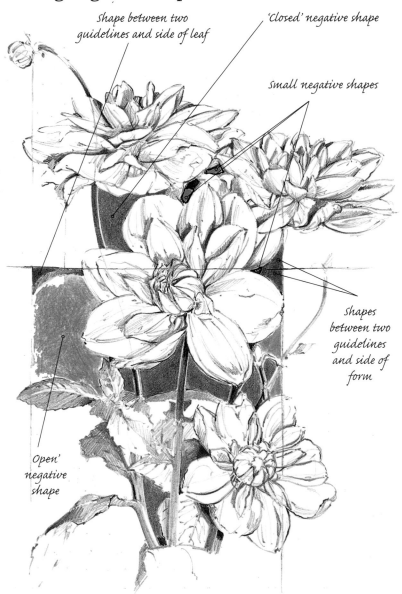

Shape between two
guidelines and side of leaf

'Closed' negative shape

Small negative shapes

shapes
between two
guidelines
and side of
form

Open'
negative
shape

Transferring the image to watercolour paper

You can place tracing paper over the initial pencil drawing – either at a window or using a lightbox – and trace on to the tracing paper using pen and ink. Next, place watercolour paper over the tracing paper and draw over your ink lines with pencil to imprint the image on to the paper. This method is quicker and more accurate than the method of using pencil on both sides of the tracing paper.

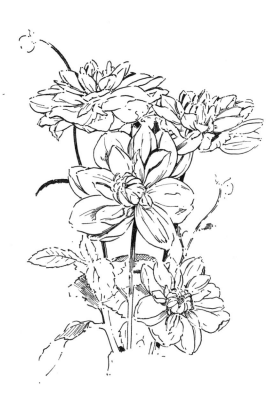

Pen and ink exercises

Stem

First stroke is
simple contour

Other side of
stem achieved
by series of
short strokes

Place short stroke
then go back over
end and extend to
produce next one

Petal

Long and short
contoured strokes
follow form

Practise series of strokes
placed side by side to indicate
tonal areas

Leaf

(b)

(a)
First strokes

Contoured series of short strokes,
similar to depicting steps

Graphite pencil exercises

These exercises relate to the image of the dahlia on page 37.

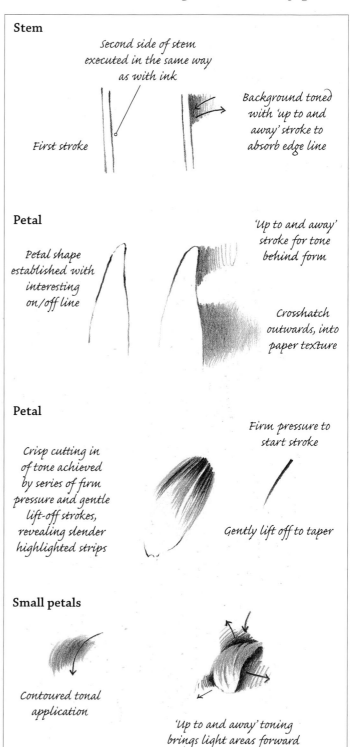

Stem

Second side of stem
executed in the same way
as with ink

First stroke

Background toned
with 'up to and
away' stroke to
absorb edge line

Petal

Petal shape
established with
interesting
on/off line

'Up to and away'
stroke for tone
behind form

Crosshatch
outwards, into
paper texture

Petal

Crisp cutting in
of tone achieved
by series of firm
pressure and gentle
lift-off strokes,
revealing slender
highlighted strips

Firm pressure to
start stroke

Gently lift off to taper

Small petals

Contoured tonal
application

'Up to and away' toning
brings light areas forward

Watercolour exercises

It is often helpful to use black-and-white photographic reference in order to understand tonal values, and once you are familiar with the method of overlaying washes of diluted pigment – wet over dry – you can have fun with them.

Monochrome mix

A useful neutral hue can be obtained by mixing two colours, and this example shows how it appears when gradated; it is presented here in abstract form, while on page 39 it is used in relation to a complex arrangement of leaves behind white daisy petals. Start with one of the paler tones and apply sweeping brushstrokes loosely in different directions. Allow to dry before crisscrossing subsequent strokes. Finally, fill in some really dark areas as shadow recess negative shapes – these will be the darkest darks of a background and will cut in against light petals, leaves and stems.

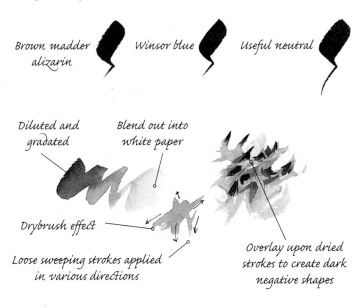

Brown madder alizarin

Winsor blue

Useful neutral

Diluted and gradated

Blend out into white paper

Drybrush effect

Loose sweeping strokes applied in various directions

Overlay upon dried strokes to create dark negative shapes

Two-colour overlays

Overlaying a limited palette of two colours produces more variety, as you can see on page 41. Practise building overlays using two colours; here I used purple madder and rose madder genuine.

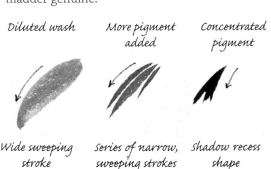

Diluted wash

More pigment added

Concentrated pigment

Wide sweeping stroke

Series of narrow, sweeping strokes

Shadow recess shape

Overlaying watercolour

Using the same colour throughout for blooms and leaves, various tones are produced by the overlay method. These tonal scales relate to the group of blooms on page 35.

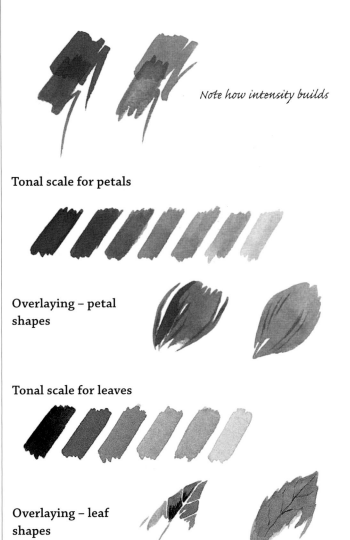

Note how intensity builds

Tonal scale for petals

Overlaying – petal shapes

Tonal scale for leaves

Overlaying – leaf shapes

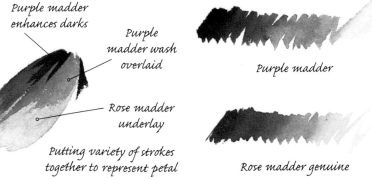

Purple madder enhances darks

Purple madder wash overlaid

Rose madder underlay

Putting variety of strokes together to represent petal

Purple madder

Rose madder genuine

Graphitint pencil

The delicate hues in the exercises shown here relate to the image on page 101.

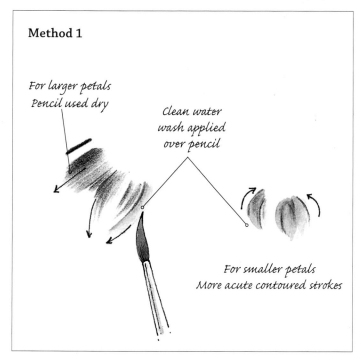

Method 1

For larger petals
Pencil used dry

Clean water
wash applied
over pencil

For smaller petals
More acute contoured strokes

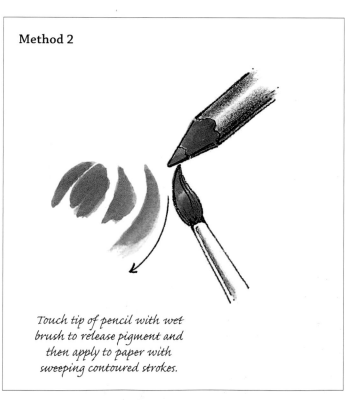

Method 2

Touch tip of pencil with wet
brush to release pigment and
then apply to paper with
sweeping contoured strokes.

Watersoluble coloured pencil with graphite pencil

Step 1

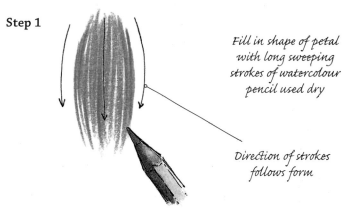

Fill in shape of petal
with long sweeping
strokes of watercolour
pencil used dry

Direction of strokes
follows form

Step 2

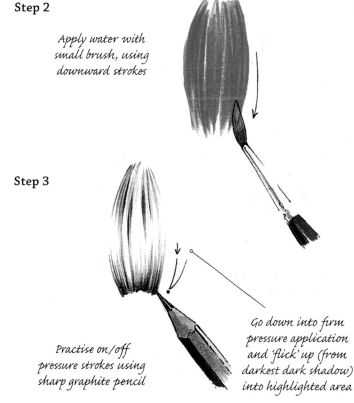

Apply water with
small brush, using
downward strokes

Step 3

Practise on/off
pressure strokes using
sharp graphite pencil

Go down into firm
pressure application
and 'flick' up (from
darkest dark shadow)
into highlighted area

Step 4

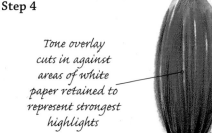

Tone overlay
cuts in against
areas of white
paper retained to
represent strongest
highlights

Pull down into
rich dark shadow
recess areas, with
regard for shape
against which
strokes are placed

Problems

Dahlias

watercolour

A group of dahlia blooms can present problems relating to composition, relationships and structural representation, as well as the method of execution in watercolour. The arrangement should be 'believable', and when flower heads are seen at different angles, difficulties can arise.

Petals within the flower heads, and leaves in relation to these and the stems, can easily appear disjointed; unless the negative shapes in the image have been observed closely and accurately, the components may appear to float, rather than be anchored structurally.

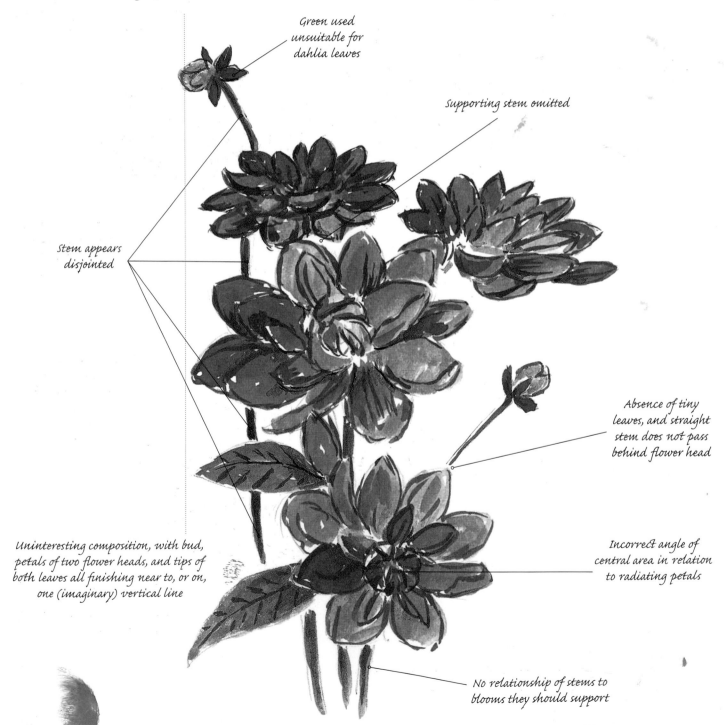

Green used unsuitable for dahlia leaves

Supporting stem omitted

Stem appears disjointed

Absence of tiny leaves, and straight stem does not pass behind flower head

Uninteresting composition, with bud, petals of two flower heads, and tips of both leaves all finishing near to, or on, one (imaginary) vertical line

Incorrect angle of central area in relation to radiating petals

No relationship of stems to blooms they should support

Solutions

Although it is the paint application that is all-important, a further consideration is the paper (support) upon which watercolour is applied. Unless they are chosen for a particular reason, cartridge papers, as used opposite, or rough-textured watercolour paper surfaces may not be the ideal choice for delicately executed interpretations. I used a smooth (HP) watercolour paper for this painting.

The four main stages of the painting, which show the build-up of delicate overlaid washes and linear work with the brush, are indicated below.

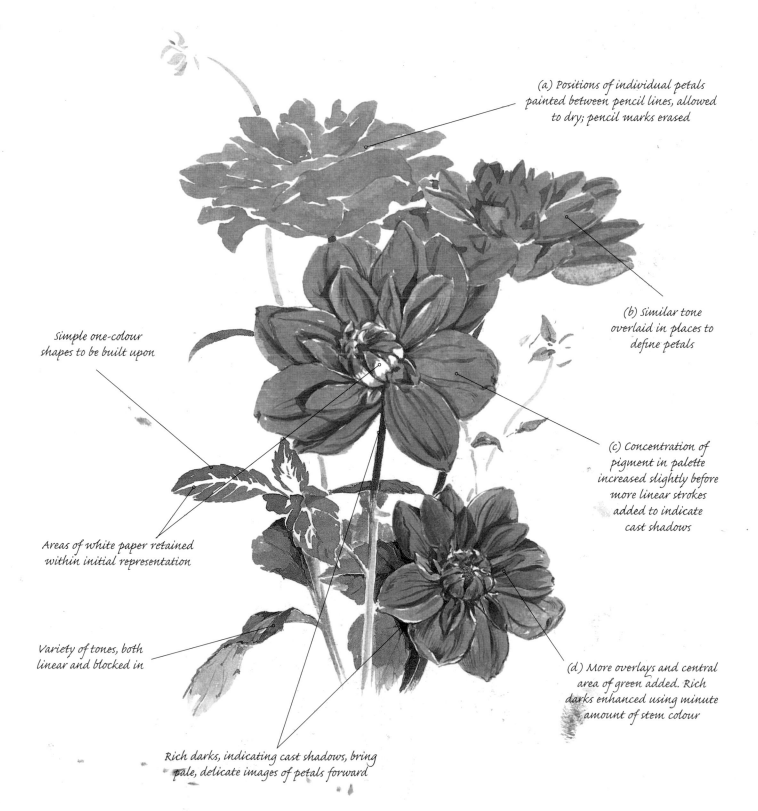

(a) Positions of individual petals painted between pencil lines, allowed to dry; pencil marks erased

(b) Similar tone overlaid in places to define petals

Simple one-colour shapes to be built upon

(c) Concentration of pigment in palette increased slightly before more linear strokes added to indicate cast shadows

Areas of white paper retained within initial representation

Variety of tones, both linear and blocked in

(d) More overlays and central area of green added. Rich darks enhanced using minute amount of stem colour

Rich darks, indicating cast shadows, bring pale, delicate images of petals forward

Problems

Dahlia Heads

pencil and watersoluble pencils

Pencil is an excellent medium for defining the delicate forms of petals accurately. Remaining with dahlias, two methods are shown here. The first uses pencil, gently overlaying tone upon tone to increase intensity; in the second example, watercolour pencil is overlaid with pencil.

Problems that may occur with both styles of representation, some of which are caused by lack of close observation or lack of understanding relating to plant formation, are illustrated on this page.

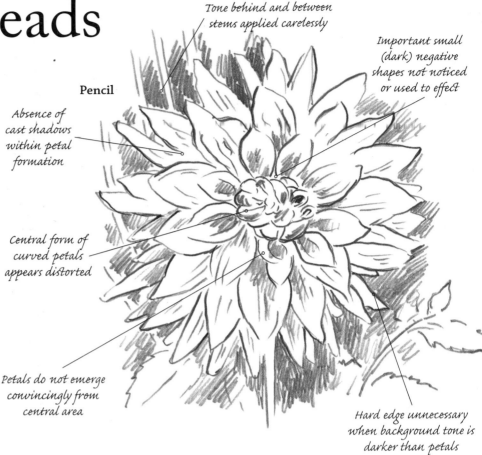

Pencil

Tone behind and between stems applied carelessly

Important small (dark) negative shapes not noticed or used to effect

Absence of cast shadows within petal formation

Central form of curved petals appears distorted

Petals do not emerge convincingly from central area

Hard edge unnecessary when background tone is darker than petals

Pencil and watersoluble pencils

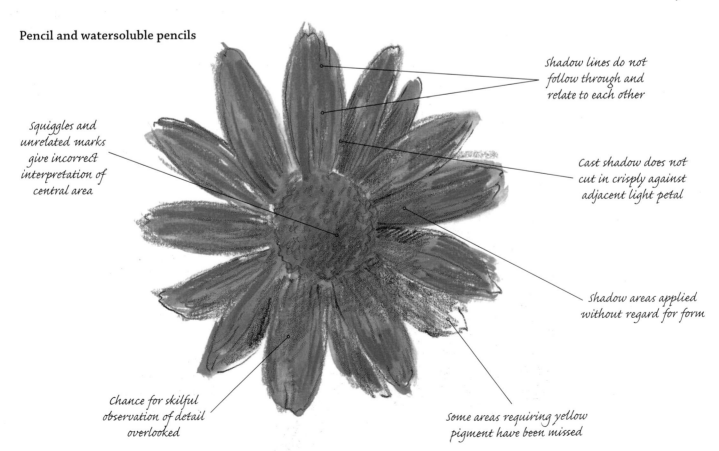

Shadow lines do not follow through and relate to each other

Squiggles and unrelated marks give incorrect interpretation of central area

Cast shadow does not cut in crisply against adjacent light petal

Shadow areas applied without regard for form

Chance for skilful observation of detail overlooked

Some areas requiring yellow pigment have been missed

Solutions

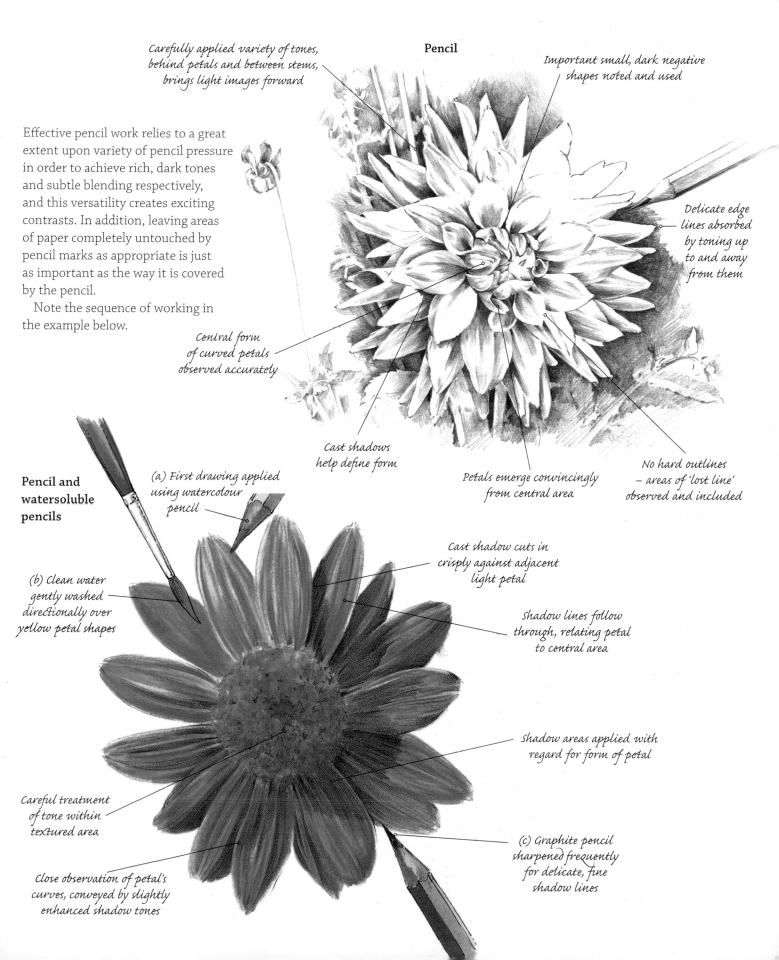

Pencil

Carefully applied variety of tones, behind petals and between stems, brings light images forward

Important small, dark negative shapes noted and used

Effective pencil work relies to a great extent upon variety of pencil pressure in order to achieve rich, dark tones and subtle blending respectively, and this versatility creates exciting contrasts. In addition, leaving areas of paper completely untouched by pencil marks as appropriate is just as important as the way it is covered by the pencil.

Note the sequence of working in the example below.

Delicate edge lines absorbed by toning up to and away from them

Central form of curved petals observed accurately

Cast shadows help define form

Petals emerge convincingly from central area

No hard outlines – areas of 'lost line' observed and included

Pencil and watersoluble pencils

(a) First drawing applied using watercolour pencil

Cast shadow cuts in crisply against adjacent light petal

(b) Clean water gently washed directionally over yellow petal shapes

Shadow lines follow through, relating petal to central area

Shadow areas applied with regard for form of petal

Careful treatment of tone within textured area

(c) Graphite pencil sharpened frequently for delicate, fine shadow lines

Close observation of petal's curves, conveyed by slightly enhanced shadow tones

Problems

Daisies

watercolour

Some of the problems encountered by beginners in their representation of background areas are experienced due to the inclusion of unnecessary outlines as they attempt to indicate each leaf in its entirety – resulting in a flat pattern effect. Lack of knowledge regarding tonal values, and failing to notice the numerous negative shapes in background areas, will result in confusion and can cause the artwork to be abandoned in frustration.

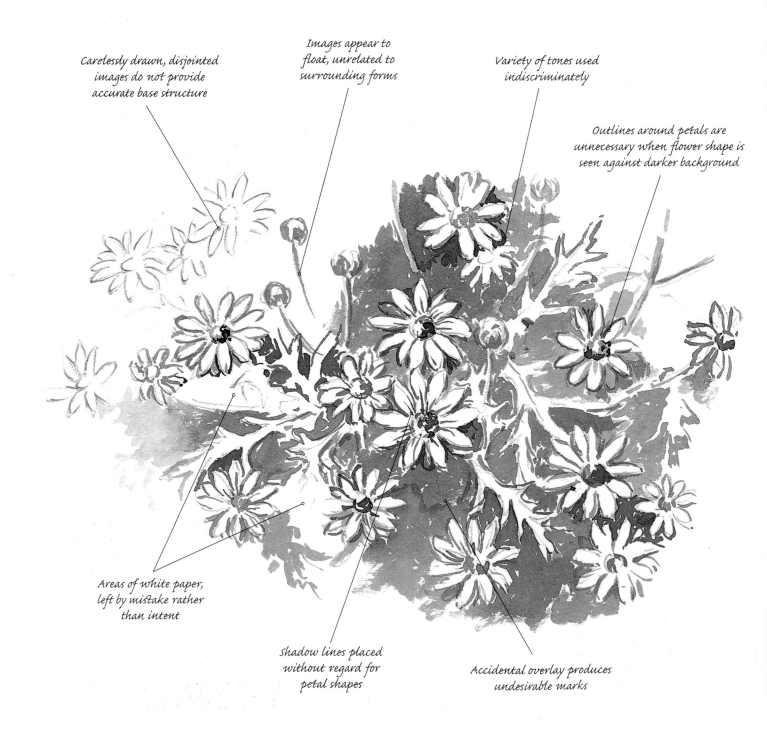

Carelessly drawn, disjointed images do not provide accurate base structure

Images appear to float, unrelated to surrounding forms

Variety of tones used indiscriminately

Outlines around petals are unnecessary when flower shape is seen against darker background

Areas of white paper, left by mistake rather than intent

Shadow lines placed without regard for petal shapes

Accidental overlay produces undesirable marks

Solutions

Here swiftly applied brushstrokes, overlaying tonal washes, combine with more considered strokes applied to negative shadow shapes between the leaves and the flower petals.

I am not trying to depict every leaf behind the blooms in detail, but aiming to achieve an overall impression of the foliage background to make the startling contrast of the white daisies apparent. The blooms are seen against a broad spectrum of tonal values that have been painted quite quickly and loosely, as a support to the main subject matter, the flower heads.

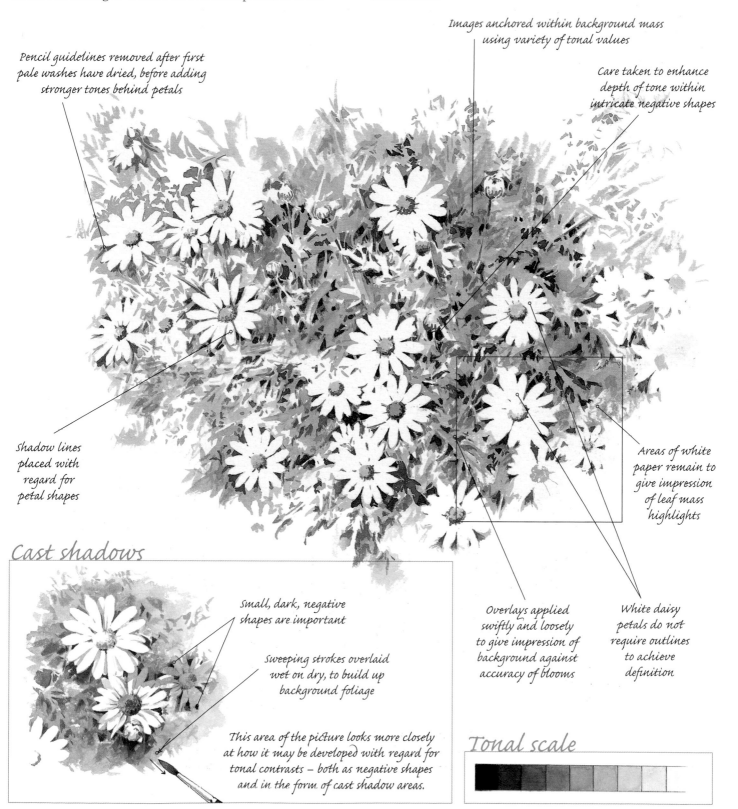

Pencil guidelines removed after first pale washes have dried, before adding stronger tones behind petals

Images anchored within background mass using variety of tonal values

Care taken to enhance depth of tone within intricate negative shapes

Shadow lines placed with regard for petal shapes

Areas of white paper remain to give impression of leaf mass highlights

Small, dark, negative shapes are important

Sweeping strokes overlaid wet on dry, to build up background foliage

Overlays applied swiftly and loosely to give impression of background against accuracy of blooms

White daisy petals do not require outlines to achieve definition

Cast shadows

This area of the picture looks more closely at how it may be developed with regard for tonal contrasts – both as negative shapes and in the form of cast shadow areas.

Tonal scale

Problems
Chrysanthemum

watercolour

Limiting a palette to only two colours allows you to concentrate fully upon tonal values and the method of paint application. If you divide your chosen colour into different strengths in separate palette wells, you can keep working and maintain flow without having to break off to re-mix paint. After the initial drawing has been transferred to watercolour paper, a diluted mix of the shadow colour can be applied within the shadow shape areas, leaving quite a lot of white paper. Beginners often experience problems by covering too much white paper and losing the opportunity to retain highlighted areas, resulting in a flat overall interpretation. There can also be problems with regard to the inclusion of rich dark shadow areas, resulting in lack of contrast and, again, a flat interpretation.

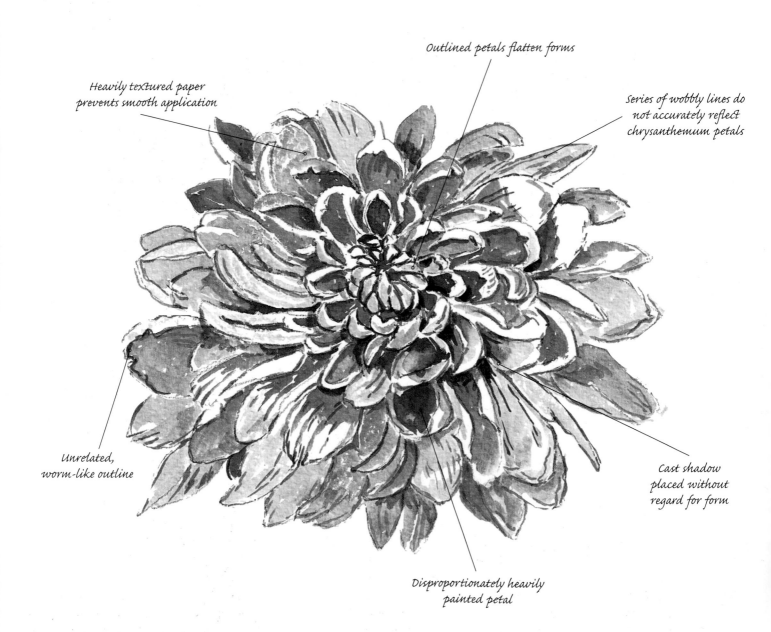

Outlined petals flatten forms

Heavily textured paper prevents smooth application

Series of wobbly lines do not accurately reflect chrysanthemum petals

Unrelated, worm-like outline

Cast shadow placed without regard for form

Disproportionately heavily painted petal

Solutions

By observing the shapes of shadows – both shadow recess shapes and cast shadow shapes – and forgetting the subject matter when you start the painting, you will be able to interpret an image accurately.

Here I started by depicting contoured shapes to establish the relationships of the petals and provide a base for the painting: I used guidelines to help place the petals (a), painted a first coat in the shadow tone areas (b), erased the pencil marks when the coat was dry (c), and washed over the petal shapes, retaining some of the untouched paper to represent highlighted areas (d). When this wash was dry, I applied a strong mix of the first colour to the dark areas (e), and lightly indicated the impression of other background blooms using sweeping brushstrokes (f).

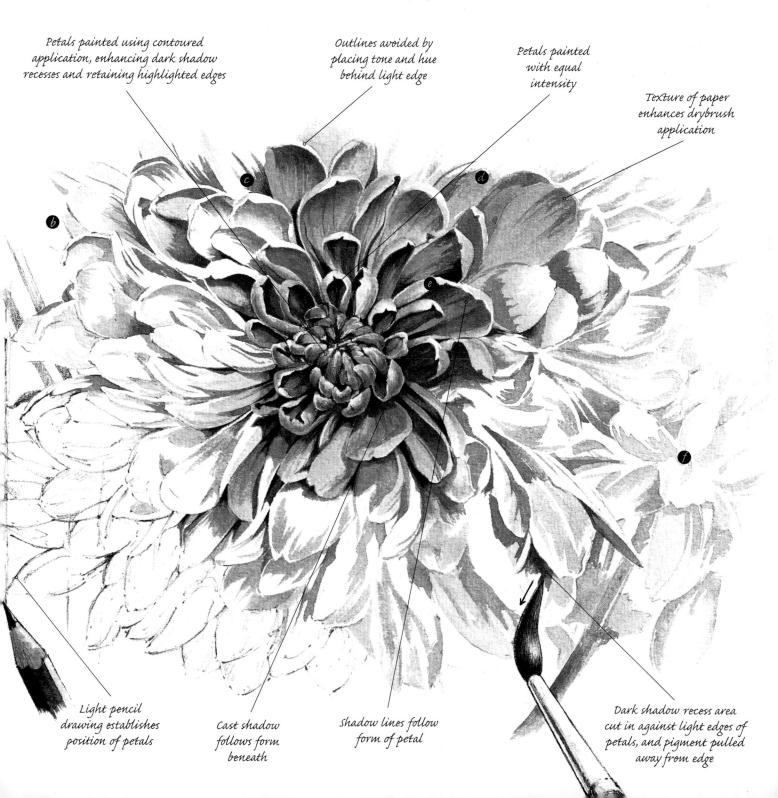

Petals painted using contoured application, enhancing dark shadow recesses and retaining highlighted edges

Outlines avoided by placing tone and hue behind light edge

Petals painted with equal intensity

Texture of paper enhances drybrush application

Light pencil drawing establishes position of petals

Cast shadow follows form beneath

Shadow lines follow form of petal

Dark shadow recess area cut in against light edges of petals, and pigment pulled away from edge

Pot of Chrysanthemums

gouache

Presented with a large pot of colourful plants, you have a number of choices: you may wish to depict the whole array of blooms or to isolate one of them; alternatively, you can select a few flower heads in relation to their surrounding greenery, which is the method demonstrated here.

The pot was rotated until a few flower heads presented themselves at interesting angles, and a curved petal, overlapping the central area of one head, caused a flutter of excitement, enhanced by the creation of a cast shadow when the pot was placed near a window.

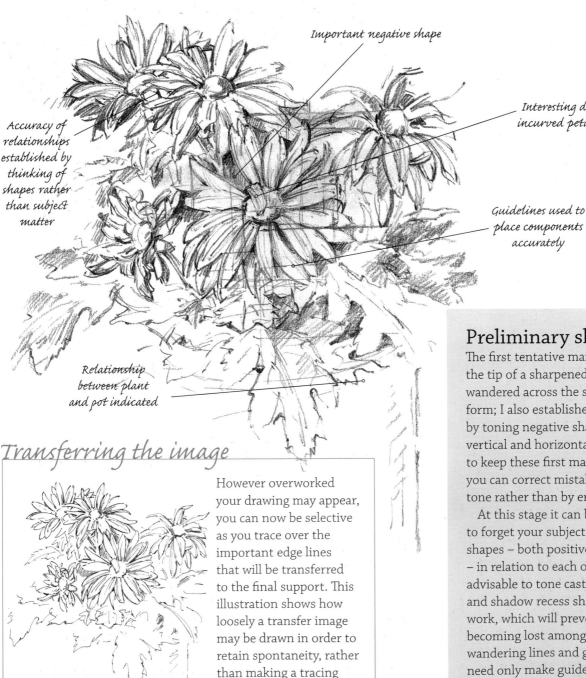

Important negative shape

Accuracy of relationships established by thinking of shapes rather than subject matter

Interesting detail of incurved petal noted

Guidelines used to place components accurately

Relationship between plant and pot indicated

Transferring the image

However overworked your drawing may appear, you can now be selective as you trace over the important edge lines that will be transferred to the final support. This illustration shows how loosely a transfer image may be drawn in order to retain spontaneity, rather than making a tracing using a wire-like outline.

Preliminary sketch

The first tentative marks were made as the tip of a sharpened carbon pencil wandered across the support, finding form; I also established relationships by toning negative shapes alongside vertical and horizontal guidelines. Try to keep these first marks pale, so that you can correct mistakes by increasing tone rather than by erasing.

At this stage it can be helpful to try to forget your subject and just look for shapes – both positive and negative – in relation to each other. It is also advisable to tone cast shadow shapes and shadow recess shapes as you work, which will prevent you from becoming lost among masses of wandering lines and guidelines. You need only make guidelines to place your components accurately.

First washes

The white-tipped chrysanthemum petals led me to choose a tinted surface upon which to work; and as I wanted to use white paint to full effect, my natural choice of medium was gouache.

Using the paint diluted as a watercolour wash, the first areas of colour were established within and around the pencil lines. These washes were then brushed out into the tinted paper, either as drybrush effects or gradated by the addition of more clean water.

It is not necessary to decide everything right at the beginning – happy accidents can often dictate the outcome and therefore allow more spontaneity of approach.

Neither is it necessary to depict each bloom or leaf in minute detail when working in this way – especially the blooms that turn away from the centre of interest.

Use your artist's licence and say what you want to say about your subject by emphasizing some areas and understating others.

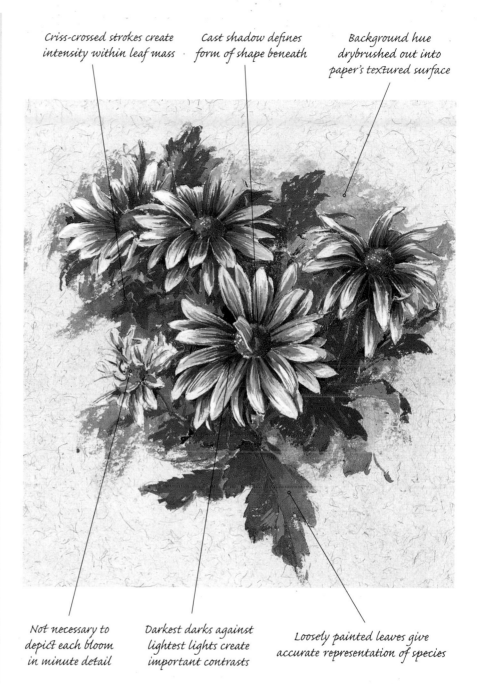

Criss-crossed strokes create intensity within leaf mass

Cast shadow defines form of shape beneath

Background hue drybrushed out into paper's textured surface

Not necessary to depict each bloom in minute detail

Darkest darks against lightest lights create important contrasts

Loosely painted leaves give accurate representation of species

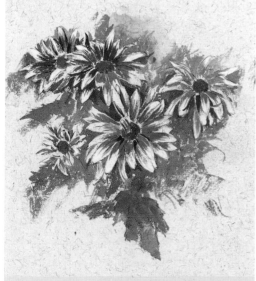

Colours painted loosely over lightly drawn images to establish feel of plant

Final stages

It is often difficult to know when to stop; I find it useful to stop before I feel the painting is complete – by doing this, you can leave the artwork for a while and return to it with a fresh eye at a later time. You may then discover that certain areas require just a little more attention and that understated parts of the image would benefit from remaining as they are.

It is advisable to under- rather than overdo, and knowing when to stop is just as important as knowing how to begin.

Contrasts

The use of contrast is an important consideration when representing plants and flowers. These may be contrasts of shape, structure, texture, media and application, contrasting viewpoints, contrasting colours and tone.

Shapes

In the study here, a series of contrasting silhouette shapes relates to the flowers used in this theme. All are shown full on, yet each flower shape in even this small selection is distinct from the others. Apart from the important silhouette shapes, you also need to consider contrasts within the negative shapes that you notice and choose to include. These are covered in other themes.

Structure

There are many fascinating contrasts of structure in the plant world, some of which can be seen in the plant forms depicted on pages 49 and 53 in this theme. Flowering plants may have a group of blooms at the top of one stem, a series of flower heads climbing a central stem, or single flowers on a number of slender stems, to give but three examples of the vast variety to be found.

Texture

From the velvety texture of a rose petal to the roughness of a hairy leaf or stem, and from a series of radiating flat petal shapes to a profusion of small petals within one flower head, there seems to be no limit to the diversity of flowering plants.

Media and application

Contrasting media, whether making a number of studies on the same sheet in different media, or using contrasts of media within the same study, is an exciting way to approach floral representation. In this theme alone I have used graphite pencil, watersoluble coloured pencils, ink and wash and pure watercolour; and further contrasts of media and techniques are presented in other themes.

Viewpoint

For explanations of contrasting viewpoints see pages 56 and 57, and compare the foxglove illustration on page 49 with that of the same type of plant on page 23.

Colour

Contrasting hues also play their part, and there is no better subject to supply us with an endless choice of vibrant colours than the plant world.

Tone

Successful use of tonal values within our drawings and paintings, using tonal contrasts to the full, is vital.

Using overlaid washes

Throughout the themes in this book there are frequent references to overlaid translucent watercolour washes. The study here, using pencils and watercolours, demonstrates how 'cutting in' with a dark hue or tone against light forms emphasizes the contrasts between the lightest lights against the darkest darks.

There are five stages of development: making pencil edge guidelines; applying the first pale colour washes to establish the shapes within the guidelines; allowing these washes to dry; erasing the pencil marks; and overlaying hue and tone (wet on dry and wet into wet as required) to build images.

On page 49 black ink gives depth to negative shadow recess shapes in background areas, bringing the lighter forms of the flowers forward. The studies on page 51 show how contrasts can be achieved using watercolour alone. Recognizing the scale of tonal values can make graphite pencil work exciting when cutting in (placing the dark tone behind light forms) for maximum contrast, as seen on page 53.

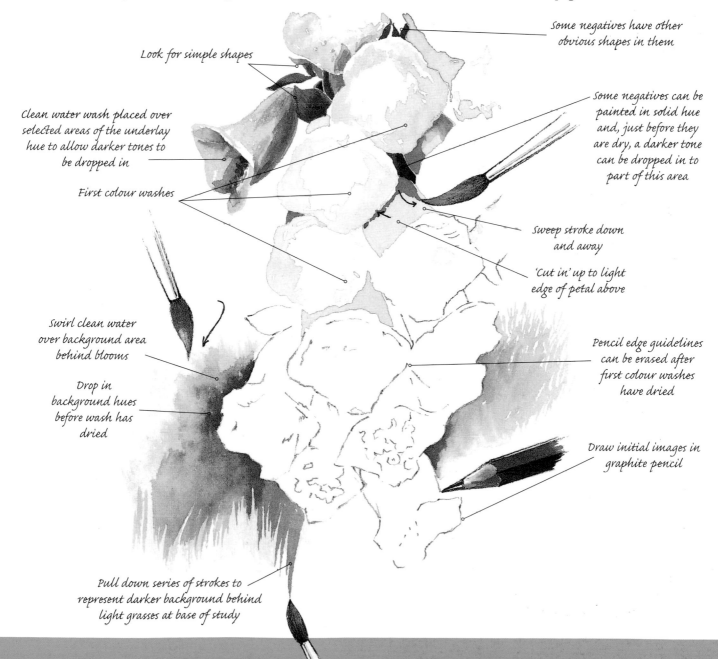

Look for simple shapes

Some negatives have other obvious shapes in them

Clean water wash placed over selected areas of the underlay hue to allow darker tones to be dropped in

Some negatives can be painted in solid hue and, just before they are dry, a darker tone can be dropped in to part of this area

First colour washes

Sweep stroke down and away

'Cut in' up to light edge of petal above

Swirl clean water over background area behind blooms

Pencil edge guidelines can be erased after first colour washes have dried

Drop in background hues before wash has dried

Draw initial images in graphite pencil

Pull down series of strokes to represent darker background behind light grasses at base of study

Pen and ink and pencil exercises

Although there are similarities between many of the strokes used for pencil work, pen and ink and watercolour painting, there will obviously be slight differences in application.

Profipen on NOT paper

Sweeping movements of the pen to produce contoured strokes are the same as those used with a pencil; in these pen and ink studies, for the image shown on page 49, I increased and decreased pressure upon the paper to achieve smoother transitions.

Working with pen and ink upon a textured surface, the aim is to enhance texture; this is achieved by gentle grazing on the paper's surface. Larger areas of tone are created by crosshatching with varied pressure (light to medium contact with the paper): this produces a variety of tones.

Pencil on HP paper

Sweeping on/off pressure strokes create the tonal 'creases' in the tissue-paper texture of a hollyhock's petals (see page 53). Smoothness of execution is essential for the effects desired to depict the many fine veins, and you may need to practise making a gentle transition from wide, firm strokes into 'lift pressure' departures from the paper's surface before using the technique on final artwork.

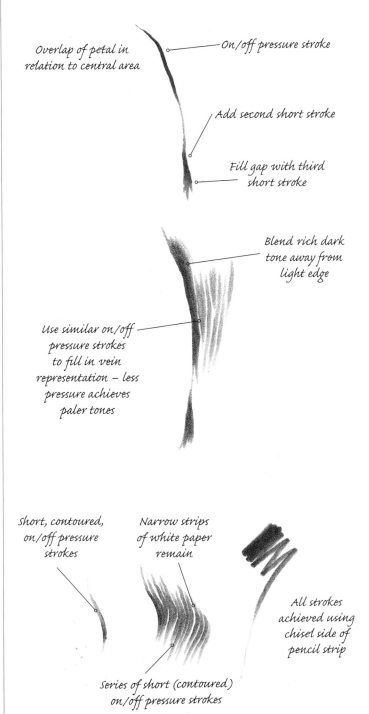

Overlap of petal in relation to central area

On/off pressure stroke

Add second short stroke

Fill gap with third short stroke

Blend rich dark tone away from light edge

Use similar on/off pressure strokes to fill in vein representation – less pressure achieves paler tones

Short, contoured, on/off pressure strokes

Narrow strips of white paper remain

All strokes achieved using chisel side of pencil strip

Series of short (contoured) on/off pressure strokes

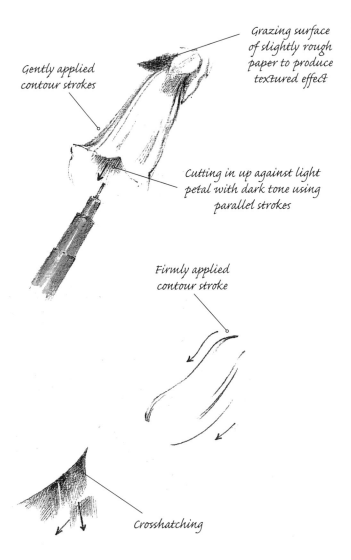

Gently applied contour strokes

Grazing surface of slightly rough paper to produce textured effect

Cutting in up against light petal with dark tone using parallel strokes

Firmly applied contour stroke

Crosshatching

Watersoluble pencil and watercolour brush exercises

Watersoluble pencils can be used to achieve watercolour effects, but in the exercises below the pencil marks remain recognizable, as they are shown as a contrast to the cast shadow watercolour brush exercises below right.

Watersoluble pencils on HP paper

Derwent Graphitint pencils respond in an exciting way when put in contact with water; they are also an ideal medium when presented mainly as a drawing, with only a little water content.

I used grey-green to provide a muted monochrome background representing tree mass. When applied to the smooth surface of the paper some very subtle effects can be achieved, as demonstrated here, where I have shown the three stages of development used to build the backdrop of the demonstration illustration on page 57.

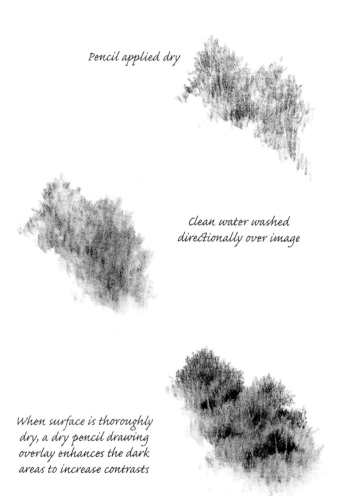

Pencil applied dry

Clean water washed directionally over image

When surface is thoroughly dry, a dry pencil drawing overlay enhances the dark areas to increase contrasts

Watercolour on NOT paper

Overlaying cast shadows can be achieved using the simplest of strokes – on page 51 a strong cast shadow is placed across white petals and over slender stems below petal edges.

This exercise demonstrates overlaying the background prior to placing a cast shadow stroke across the top of a stem; you will need to adapt the size and angle of your cast shadow strokes in your own paintings.

First contoured stroke for stem against petal

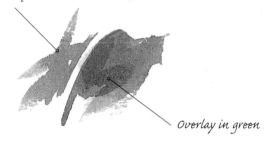

Place sweeping criss-cross strokes after leaving white paper to represent stem

Overlay in green

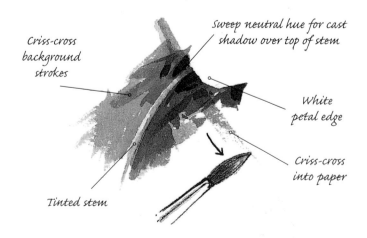

Criss-cross background strokes

Sweep neutral hue for cast shadow over top of stem

White petal edge

Criss-cross into paper

Tinted stem

Problems

Foxglove

watercolour and pen and ink

Numerous buds and blooms upon a single stem can be an exciting challenge for the artist. Many of the problems encountered by inexperienced artists, when they are unaware of how to apply areas of tone using pen and ink, can be solved by using a rough surface upon which the pen can be gently grazed to achieve a textured effect.

Light green placed over darker colour as opaque rather than translucent overlay

Muted grey from diluted black fails to suggest shadow recess area effectively

No clear shadow recess (negative) shapes within background area

No feeling for structure

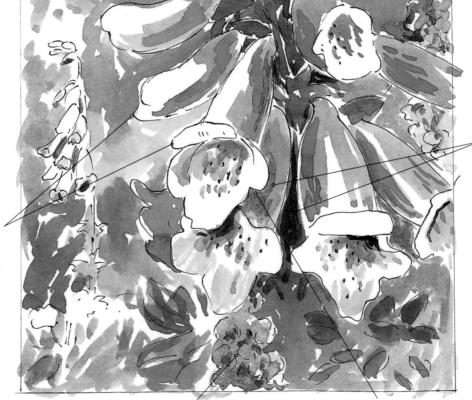

Black used to suggest shadows instead of mixing primaries to create neutral tints or making use of pen and ink

Each component outlined, with no indication of tone in pen and ink

Carelessly applied tonal strokes fail to indicate crispness of petals

Missed opportunity to produce rich, strong contrast between light part of flower and cast shadow

Solutions

A prolific background gives the opportunity to create effective mass impressions in pen and ink on Rough watercolour paper. Strong contrasts of light forms against their cast shadows and darker negative shadow recess shapes all combine to produce an intricate pen and ink interpretation.

This is an example of how to work up to predefined edges, arranging the composition within a frame. After drawing the plant using graphite pencil, your pen work can be selectively drawn – defining images and some of the dark shadow areas – before erasing the pencil and applying the first washes.

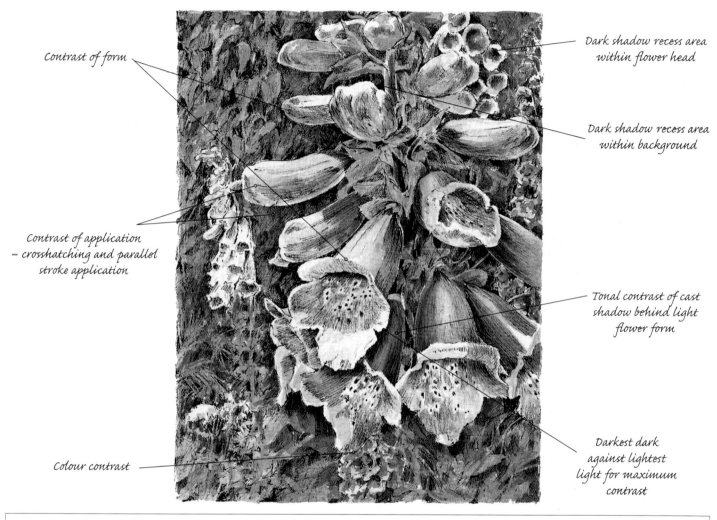

Contrast of form

Contrast of application – crosshatching and parallel stroke application

Colour contrast

Dark shadow recess area within flower head

Dark shadow recess area within background

Tonal contrast of cast shadow behind light flower form

Darkest dark against lightest light for maximum contrast

Method of working

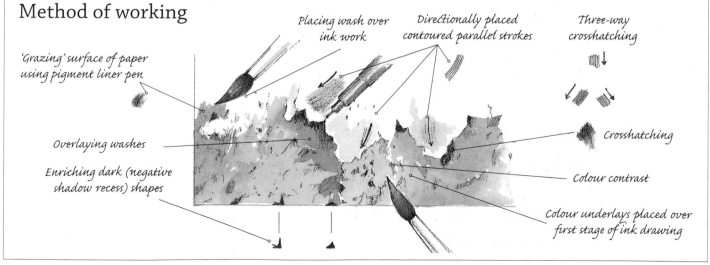

'Grazing' surface of paper using pigment liner pen

Overlaying washes

Enriching dark (negative shadow recess) shapes

Placing wash over ink work

Directionally placed contoured parallel strokes

Three-way crosshatching

Crosshatching

Colour contrast

Colour underlays placed over first stage of ink drawing

Problems

White Flowers

watercolour

The contrasting texture of a rough stone wall behind delicate white blooms and stems requires careful consideration when depicted in watercolour. Difficulties may arise for beginners if they are unable to understand methods of depicting white petals. Page 67 shows one way of approaching this problem, and the studies opposite demonstrate how to include background and thus make the use of an outline unnecessary.

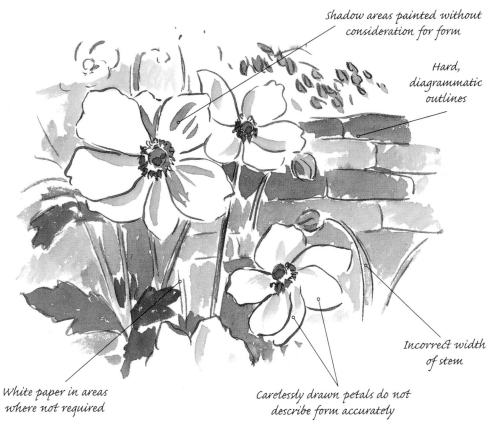

Shadow areas painted without consideration for form

Hard, diagrammatic outlines

Incorrect width of stem

Carelessly drawn petals do not describe form accurately

White paper in areas where not required

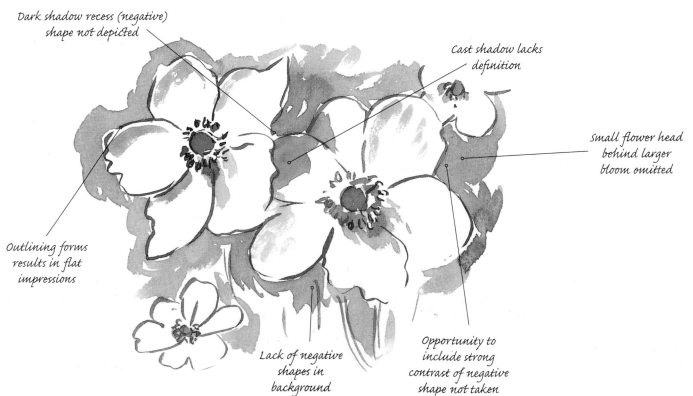

Dark shadow recess (negative) shape not depicted

Cast shadow lacks definition

small flower head behind larger bloom omitted

Outlining forms results in flat impressions

Lack of negative shapes in background

Opportunity to include strong contrast of negative shape not taken

Solutions

The two studies here began with a tonal underlay painting before building up tinted washes that increased the intensity of both tone and hue. For both the large flower heads and the contrasting slender stems I retained white paper shapes and strips respectively when placing the initial neutral shadow tone hue. This enables the delicate colours to be painted over a clean paper surface in the subsequent washes.

The upper study demonstrates contrasts of texture, line and form. The background textures and tonal contrasts against the white petals separate the two effectively. In the lower study placing massed, directionally applied strokes around light petal shapes achieves the same effect – the white blooms contrast strongly and are thrown forward. The scale is further contrasted by including two blooms not on the same plane.

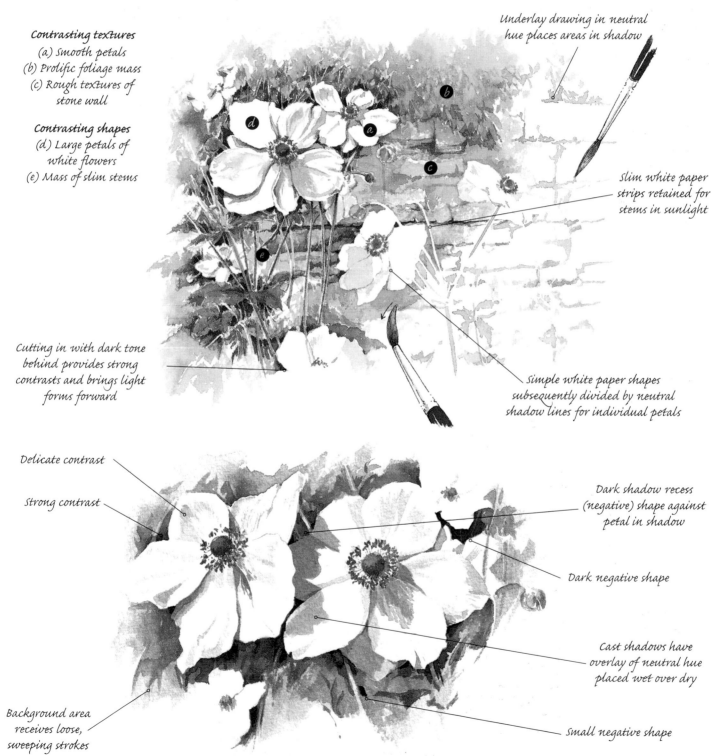

Contrasting textures
(a) *Smooth petals*
(b) *Prolific foliage mass*
(c) *Rough textures of stone wall*

Contrasting shapes
(d) *Large petals of white flowers*
(e) *Mass of slim stems*

Underlay drawing in neutral hue places areas in shadow

Slim white paper strips retained for stems in sunlight

Cutting in with dark tone behind provides strong contrasts and brings light forms forward

Simple white paper shapes subsequently divided by neutral shadow lines for individual petals

Delicate contrast

Strong contrast

Dark shadow recess (negative) shape against petal in shadow

Dark negative shape

Cast shadows have overlay of neutral hue placed wet over dry

Background area receives loose, sweeping strokes

Small negative shape

Problems

Hollyhock

pencil

In a fully open hollyhock bloom, apart from the contrasts of tonal shapes there are also contrasts of form – from the tightly closed buds above and below the bloom (and the opening ones at the sides) to the full glory of radiating veins, exposing the uneven central 'star' shape. There are so many contrasts to appreciate, even without colour.

Problems can arise when this diversity goes unnoticed. Representation in the form of a hard diagrammatic outline flattens the image and tonal areas are treated with disregard for the vital elements of cast shadows, shadow recess shapes and other considerations.

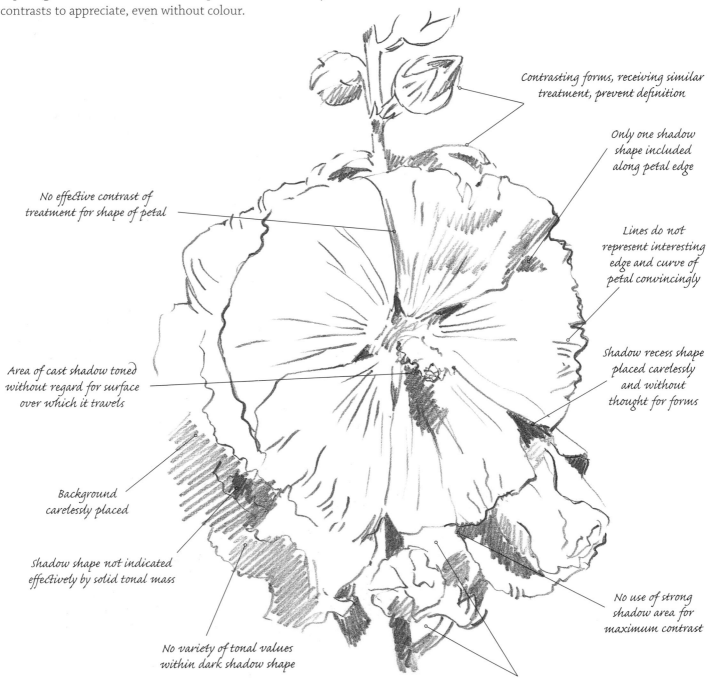

Contrasting forms, receiving similar treatment, prevent definition

Only one shadow shape included along petal edge

No effective contrast of treatment for shape of petal

Lines do not represent interesting edge and curve of petal convincingly

Area of cast shadow toned without regard for surface over which it travels

Shadow recess shape placed carelessly and without thought for forms

Background carelessly placed

Shadow shape not indicated effectively by solid tonal mass

No use of strong shadow area for maximum contrast

No variety of tonal values within dark shadow shape

Negative shapes lack interest

Solutions

The radiating veins of the open flower contrast beautifully with solid tonal blocks around the perimeter of the 'tissue-paper' petals. The latter, with their cast shadow shapes and shadow recess areas, allow the artist to make use of the full tonal value scale to achieve maximum contrasts that help towards the depiction of a three-dimensional image.

A particularly effective way of representing tonal contrasts is to use a graphite pencil on a suitable support: here I used a single 2B pencil on Saunders Waterford HP paper. Such a combination encourages full use of tonal values leading to maximum contrasts, whether these are shown as delicate lines or uneven areas of solid tone.

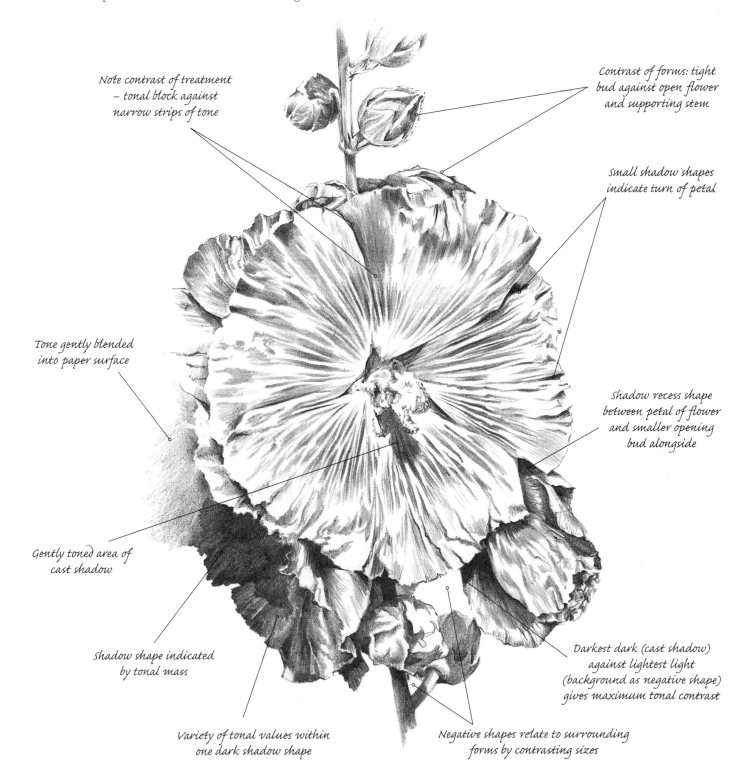

Note contrast of treatment – tonal block against narrow strips of tone

Contrast of forms: tight bud against open flower and supporting stem

Small shadow shapes indicate turn of petal

Tone gently blended into paper surface

Shadow recess shape between petal of flower and smaller opening bud alongside

Gently toned area of cast shadow

Shadow shape indicated by tonal mass

Darkest dark (cast shadow) against lightest light (background as negative shape) gives maximum tonal contrast

Variety of tonal values within one dark shadow shape

Negative shapes relate to surrounding forms by contrasting sizes

Problems

Garden Scene

pencil

Problems arise for beginners when the chosen format does not fit in with the view. Working in portrait rather than landscape format for a scene of this nature prevents full appreciation of the garden's layout – distortions may occur not only from lack of perspective knowledge but also from trying to squeeze in components on the edge of your vision.

In addition, problems in the portrayal of cast shadows may be encountered if you lack the confidence to place bold directional (shadow shape) tonal areas. Shadows can enhance or destroy the effects achieved within a pencil drawing and need careful consideration, not only in their placing but in the method of execution.

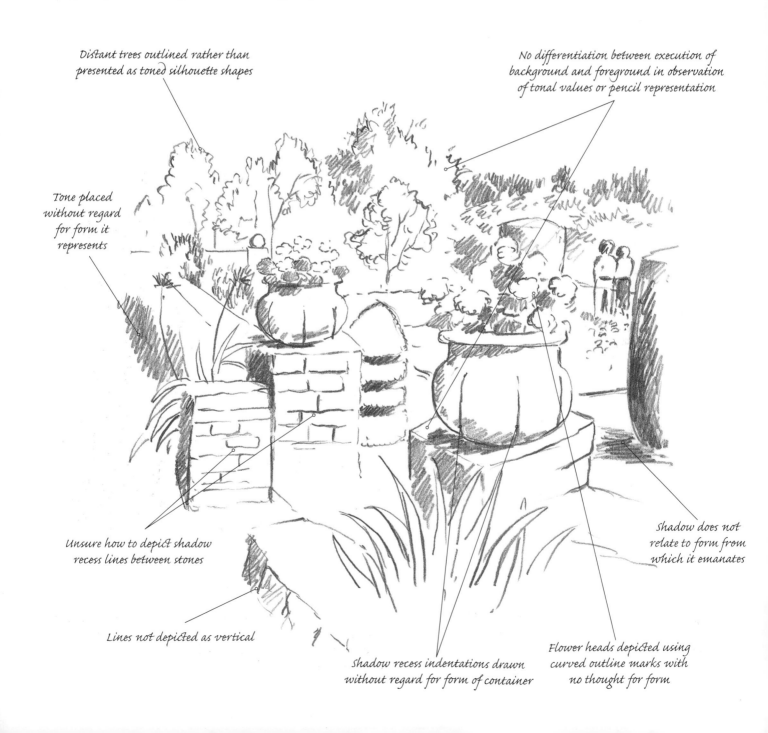

Distant trees outlined rather than presented as toned silhouette shapes

No differentiation between execution of background and foreground in observation of tonal values or pencil representation

Tone placed without regard for form it represents

Unsure how to depict shadow recess lines between stones

Lines not depicted as vertical

Shadow recess indentations drawn without regard for form of container

shadow does not relate to form from which it emanates

Flower heads depicted using curved outline marks with no thought for form

Solutions

The main aim in this drawing is to emphasize the importance of tonal values and the use of maximum contrast. This means that areas of rich dark against those that may remain as untouched white paper (representing highlights and surfaces in full sunlight, as well as white objects) take priority.

Remember to leave white paper (a) where you wish to indicate light negative shapes, such as sky visible through branches and leaf masses, and (b) where sunlight causes a surface to appear as the lightest light area. This may initially look as if there has been a fall of snow, which is resting along the top of the forms, but continue working down (placing the first areas of tone) until the 'undercoat' has been laid.

Lines may be sweeping, such as when depicting sword-shaped leaves in the foreground, or as on/off pressure lines such as those indicating joints in the stonework. The final stage comprises overlaying detail strokes.

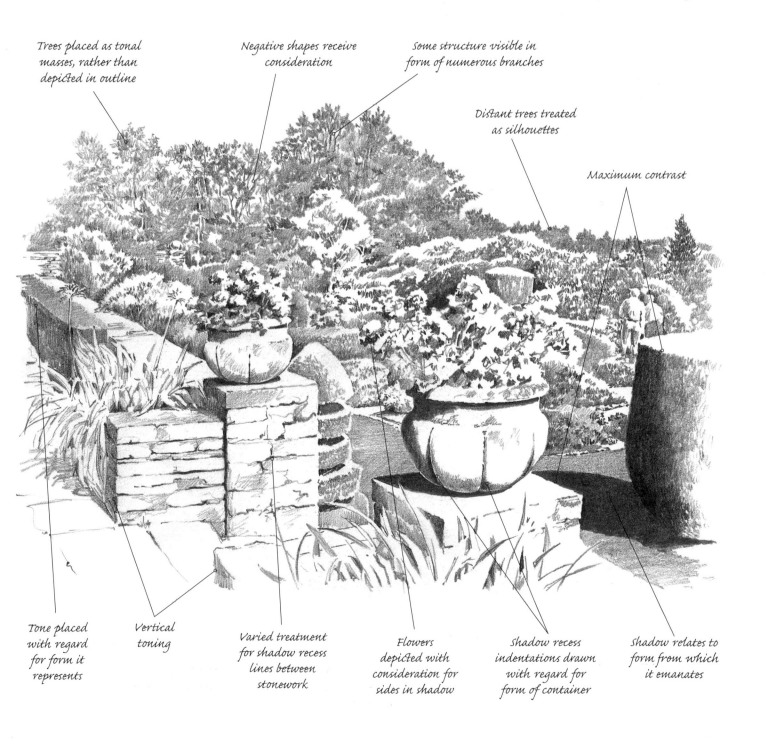

Trees placed as tonal masses, rather than depicted in outline

Negative shapes receive consideration

Some structure visible in form of numerous branches

Distant trees treated as silhouettes

Maximum contrast

Tone placed with regard for form it represents

Vertical toning

Varied treatment for shadow recess lines between stonework

Flowers depicted with consideration for sides in shadow

Shadow recess indentations drawn with regard for form of container

Shadow relates to form from which it emanates

Pots and Dahlias

pencil, Inktense and Graphitint pencils

In this demonstration you can find: a monochrome depiction of distant trees with colourful foreground representation; textures of trees, shrubs and plants against rough stonework, plus two figures; within the stonework forms, contrasts of curves (the containers) against the straight lines and sharp corners of walls; and a contrast of treatment, where close strokes depict distant masses of foliage, a looser application represents geranium plants in the containers and, in the foreground, much looser treatment suggests a profusion of dahlias. As the focal point is the pair of containers, I placed emphasis upon taking these to a more finished stage, in order to 'lead the eye' to them.

To capture the vibrant hues of the flowers I used Derwent Inktense pencils, with Graphitint pencils for the more muted areas of tone and colour, working on Saunders Waterford HP watercolour paper.

Preliminary drawings

The first consideration was the angle at which this area of the garden should be presented. Page 55 shows a larger expanse of the garden, concentrating upon contrasts of tone and texture as well as shape and form, such as trees and shrubs growing naturally and those that have been subjected to topiary.

Walking around your chosen area, you might wish to sketch smaller areas from a couple of different angles, one of which can then be taken further and developed into a final interpretation.

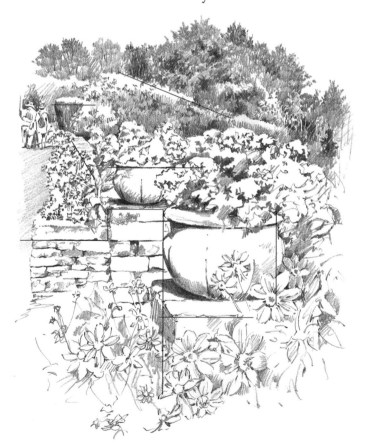

In this study there is more contrast of presentation than in the one below left, and the perspective angles of hedge and wall 'lines' (direction) contrast with verticals and horizontals, as well as with the curves of the containers.

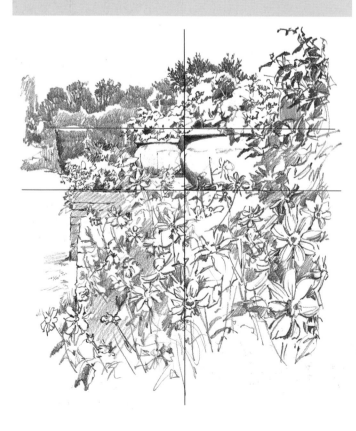

Although the sketch at left depicts a more unusual angle at which to view the containers, wall and dahlias, compositionally it does not work as well as the second sketch, from which the final painting developed. The superimposed vertical and horizontal lines show how this arrangement divides the picture evenly, and thus presents an uninteresting interpretation.

First colours

Having lightly transferred the image from sketch to watercolour paper, commencing with the top of the trees, I established the monochrome background, remembering to leave some areas of white paper to accommodate any white (highlights). In the central area I placed the geranium blooms and their leaves, containers and wall, and indicated the positions of the main flower heads.

Draw distant trees as monochrome study dry on dry

Wash clean water directionally over trees and hedge

Indicate positions of geranium heads and leaves, followed by foreground area

Note how much change in hue results from washing clean water over certain colours

Sweep strokes to follow direction of petal forms and veins

Final stages

Using clean water on a brush, I placed directional strokes that disturbed the pigment over different areas of the paper. When this was dry, I used dry pencils to enhance hue and tone and establish the darkest darks against the lightest lights, thus achieving maximum contrast.

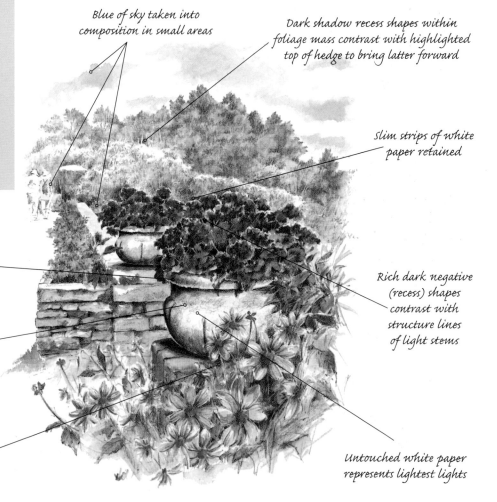

Blue of sky taken into composition in small areas

Dark shadow recess shapes within foliage mass contrast with highlighted top of hedge to bring latter forward

Slim strips of white paper retained

Rich dark negative (recess) shapes contrast with structure lines of light stems

Darkest darks against lightest lights for maximum contrast

Dry pencil overlays on white paper create texture

Light strips that trespass into areas of shadow tone retained and dark areas either side enhanced, to bring structure forward

Untouched white paper represents lightest lights

theme 4:
Monochrome and Colour Co-ordinated

Working in monochrome, in whatever medium you choose, encourages consideration for tonal values. This theme also covers toning for colour as well as tone, and demonstrates a combination of graphite pencil drawing as a background for watercolour painting. Working with a limited palette is to be encouraged as part of the learning process – see pages 63 (within a single plant) and 65 (a single species, but different coloured blooms), and in profusion of growth on pages 69 and 71. On page 65 I have also related monochrome toning to colour.

Pencil exercises

The white flowers on page 67 are drawn in monochrome, and it is with this that the exercises here start, showing how darker background drawing, behind light petals, encourages them to come forward.

Suggest central area and bring contoured lines out from this shape to represent petals

Apply pale linear toning directionally, following contours of petals

Tone in dark shadow recess shapes

Note shadow recess shape and its contrast with petals on either side

Cut in crisply between petals with darkest darks

Smoothly applied linear toning

Making studies

Preliminary studies can also take the form of exercises, and on page 63 you will see the painting that resulted from these two investigative sketches. When you have a plant that possesses numerous buds at the same time as open flowers, such as a lupin, it is a good idea to separate the two by executing detailed observational studies of the respective areas.

Preliminary monochrome sketches will help you understand the structure and formation of buds, blooms and leaves. All these then need to be considered in relation to each other and to the supporting stem.

Monochrome study showing tight formation of topmost buds

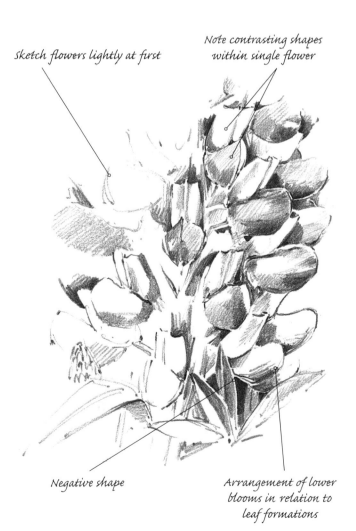

Sketch flowers lightly at first

Note contrasting shapes within single flower

Negative shape

Arrangement of lower blooms in relation to leaf formations

Hydrangea

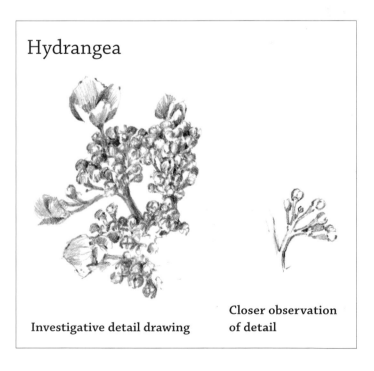

Investigative detail drawing

Closer observation of detail

Watercolour exercises

After the observational drawings on the previous pages, analysing the structure of individual parts, some simple brush exercises to help with the depiction of the plant are shown here.

One-stroke leaf shape

Leaves can be executed with sweeping strokes, and it is a good idea to loosen up by practising these brush movements before attempting to paint a finished study.

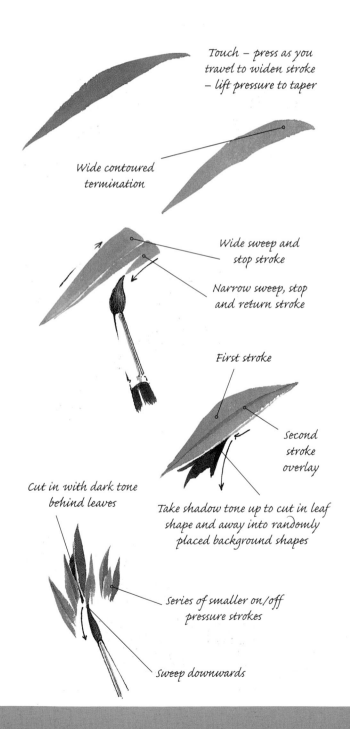

Touch – press as you travel to widen stroke – lift pressure to taper

Wide contoured termination

Wide sweep and stop stroke

Narrow sweep, stop and return stroke

First stroke

Second stroke overlay

Cut in with dark tone behind leaves

Take shadow tone up to cut in leaf shape and away into randomly placed background shapes

Series of smaller on/off pressure strokes

Sweep downwards

Directional tonal application

Short, sweeping strokes, applied in a different way to those used for lupin leaves, work together to create images of delicate sweet pea flowers, cutting in behind the forms.

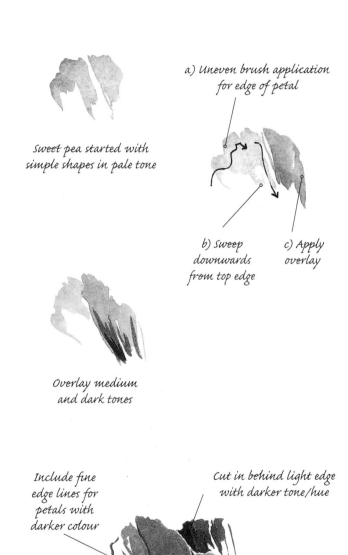

Sweet pea started with simple shapes in pale tone

a) Uneven brush application for edge of petal

b) Sweep downwards from top edge

c) Apply overlay

Overlay medium and dark tones

Include fine edge lines for petals with darker colour

Cut in behind light edge with darker tone/hue

Pull down swiftly

Retaining white paper

Many beginners experience problems with the method of initially leaving white paper within areas of profuse activity (shapes and colours) in order to paint in lighter hues as the picture progresses. Preliminary considerations and the method are explained on pages 69 and 71; in order to clarify this process further, here are a few exercises to try. I have simplified shapes and accentuated angles: the latter give strength to structure and crispness to images.

Two methods are demonstrated here in the form of simple brush exercises: (a) painting foliage hue around (and away from) the shapes you intend to paint in other colours; (b) painting flower shapes first in order to create a foliage mass effect behind. In both methods, some white paper is still retained to add sparkle and crispness to the execution.

Should you wish to reduce the effect of these areas, delicate overlays can be added in the final stages of the painting – but do not subdue them all if you wish to retain a lively effect.

Painting around flower shapes

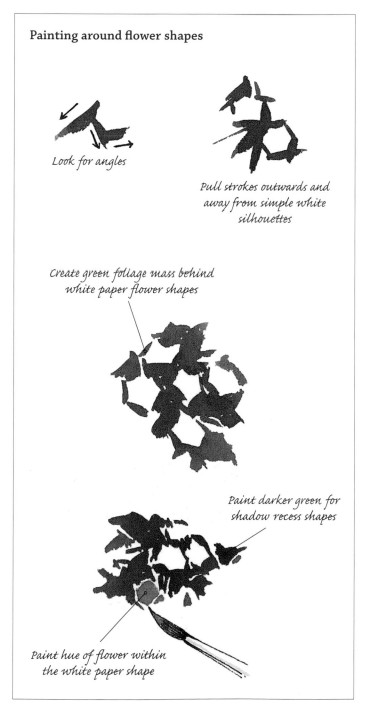

Look for angles

Pull strokes outwards and away from simple white silhouettes

Create green foliage mass behind white paper flower shapes

Paint darker green for shadow recess shapes

Paint hue of flower within the white paper shape

Flower shapes painted first

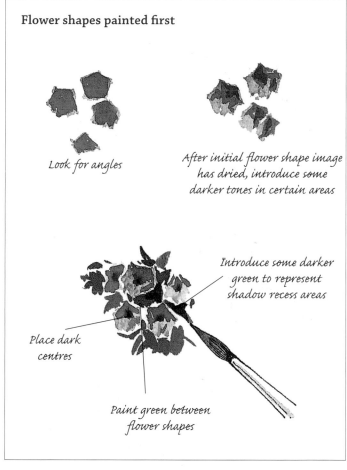

Look for angles

After initial flower shape image has dried, introduce some darker tones in certain areas

Introduce some darker green to represent shadow recess areas

Place dark centres

Paint green between flower shapes

Watercolour pencils and wash

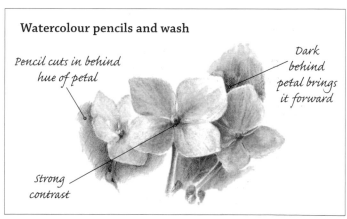

Pencil cuts in behind hue of petal

Dark behind petal brings it forward

strong contrast

Problems

Lupin

watercolour

Lupins comprise highly ornamental flower racemes or spikes.
The flowers are pea-like and have many colour variations,
some in contrasting colours.

Beginners can have problems when representing such
many-flowered plants, and these can include painting too
many outlines and painting them too heavily; negative
and background shapes can also be troublesome.

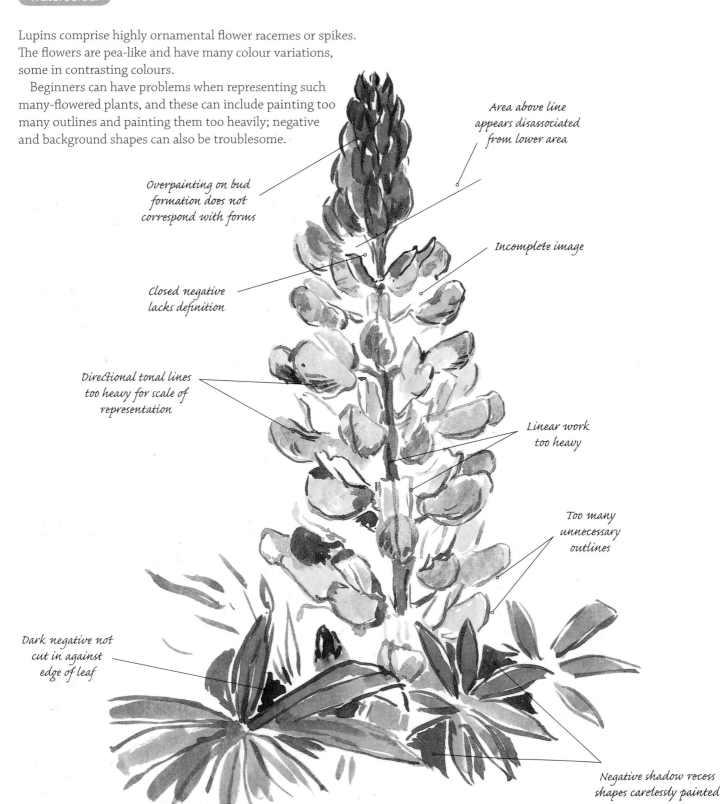

*Area above line
appears disassociated
from lower area*

*Overpainting on bud
formation does not
correspond with forms*

Incomplete image

*Closed negative
lacks definition*

*Directional tonal lines
too heavy for scale of
representation*

*Linear work
too heavy*

*Too many
unnecessary
outlines*

*Dark negative not
cut in against
edge of leaf*

*Negative shadow recess
shapes carelessly painted*

Solutions

Overlaying hue and tone in the form of translucent washes – wet over dry – with regard for directional application, helps define forms in relation to each other. A series of contoured arrows within the central area of this illustration shows how these forms developed.

Lightweight papers are suitable for small watercolour wash areas: this was executed on Saunders Waterford 180gsm (90lb) Rough paper.

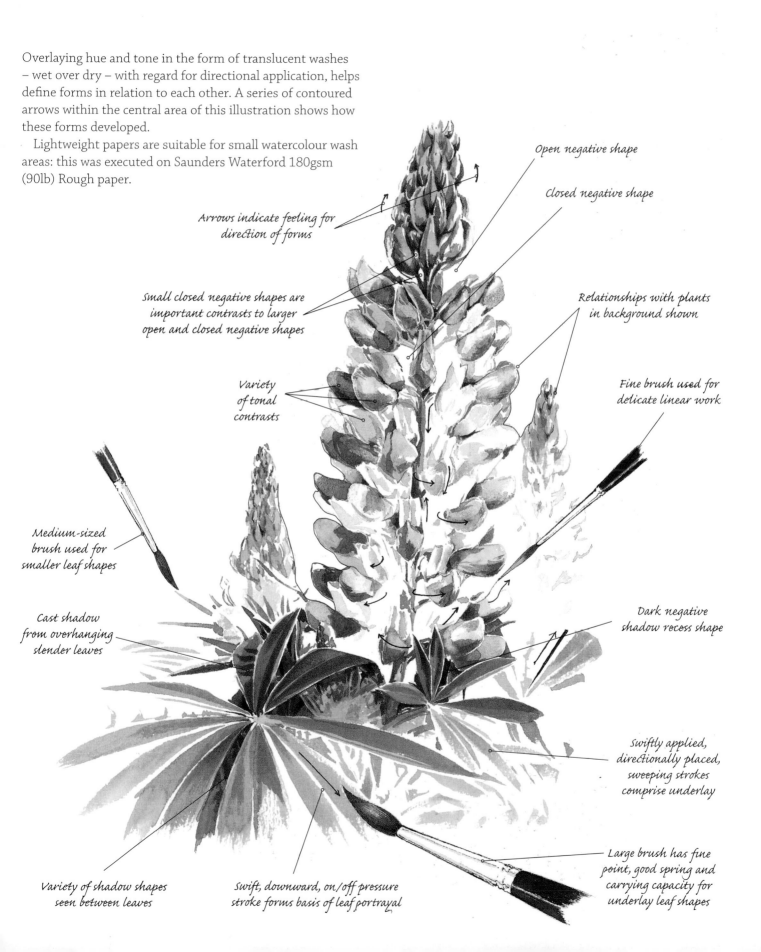

Open negative shape

Closed negative shape

Arrows indicate feeling for direction of forms

Small closed negative shapes are important contrasts to larger open and closed negative shapes

Relationships with plants in background shown

Variety of tonal contrasts

Fine brush used for delicate linear work

Medium-sized brush used for smaller leaf shapes

Cast shadow from overhanging slender leaves

Dark negative shadow recess shape

Swiftly applied, directionally placed, sweeping strokes comprise underlay

Variety of shadow shapes seen between leaves

Swift, downward, on/off pressure stroke forms basis of leaf portrayal

Large brush has fine point, good spring and carrying capacity for underlay leaf shapes

Problems

Sweet Peas

pencil and watercolour

These pea-shaped blooms demonstrate how a range of similar hues co-ordinates when flowers are displayed in a vase. Delicately curved petals vie with each other in swirls of visual movement, interspersed by contoured stems.

Monochrome studies lose clarity if consideration for colour and tone are omitted, and the artist needs to decide where to place tonal areas that indicate shadow recess and cast shadows, and where to apply tone that suggests one bloom is stronger, brighter or darker than another. These considerations frequently present problems for beginners, who find they are portraying a confusion, rather than a profusion, of blooms.

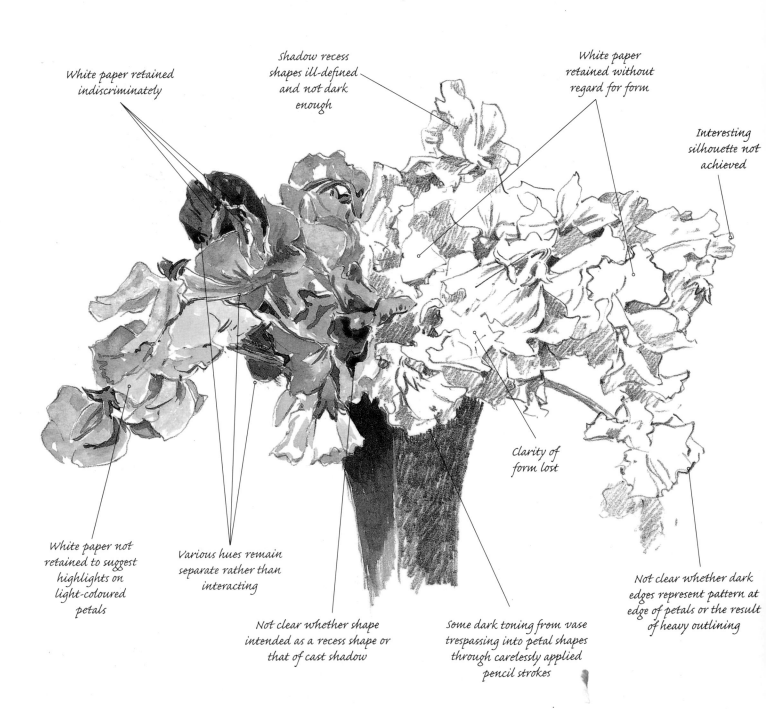

White paper retained indiscriminately

Shadow recess shapes ill-defined and not dark enough

White paper retained without regard for form

Interesting silhouette not achieved

White paper not retained to suggest highlights on light-coloured petals

Various hues remain separate rather than interacting

Not clear whether shape intended as a recess shape or that of cast shadow

Clarity of form lost

Some dark toning from vase trespassing into petal shapes through carelessly applied pencil strokes

Not clear whether dark edges represent pattern at edge of petals or the result of heavy outlining

Solutions

By combining colour and monochrome representation within a single study, you can incorporate both a regard for tonal values in a colour representation and a regard for colour within a tonal representation. This can be particularly rewarding and lead to rich, exciting results.

Whether you are portraying a number of sprays in a large container or a couple in a specimen vase, the same considerations apply: try to retain a sense of movement in the arrangement and use negative shapes – both dark and light – to hold the display together.

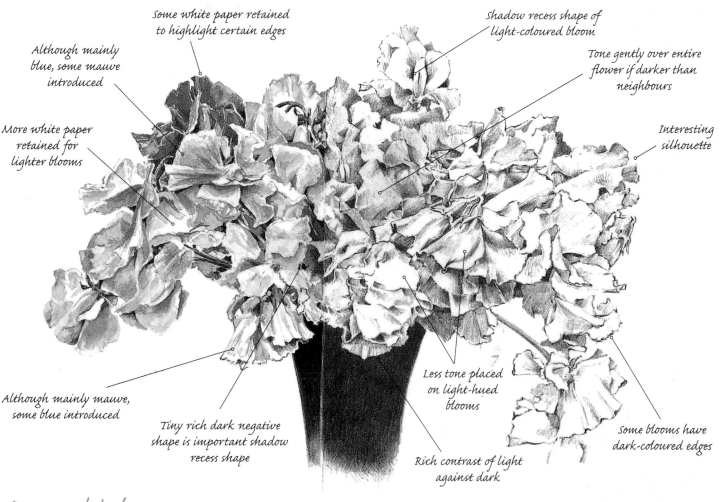

Some white paper retained to highlight certain edges

Shadow recess shape of light-coloured bloom

Although mainly blue, some mauve introduced

Tone gently over entire flower if darker than neighbours

More white paper retained for lighter blooms

Interesting silhouette

Although mainly mauve, some blue introduced

Tiny rich dark negative shape is important shadow recess shape

Less tone placed on light-hued blooms

Some blooms have dark-coloured edges

Rich contrast of light against dark

Pen and ink

Executed on a lightweight textured surface using a 0.1 pigment liner, this little study demonstrates how pen and ink can also be used with regard for colour – even when no colour is used.

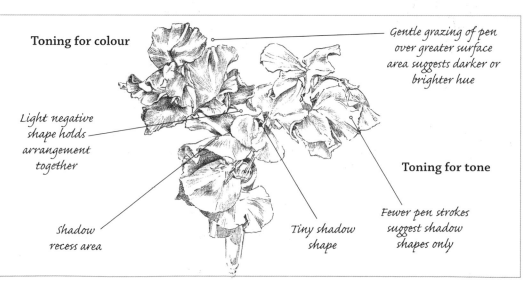

Toning for colour

Gentle grazing of pen over greater surface area suggests darker or brighter hue

Light negative shape holds arrangement together

Toning for tone

Shadow recess area

Tiny shadow shape

Fewer pen strokes suggest shadow shapes only

Problems

White Flowers

`pencil`

White flowers are ideal as subjects for monochrome representation, especially when viewed against a background of massed foliage, giving an opportunity to make full use of a variety of tonal values.

Beginners often experience difficulties with this type of representation – white petals against a background of

foliage – and consequently resort to the use of wire-like outlines around the former and even more unnecessary lines within the background foliage mass.

By practising the tonal scale in the form of gently shaded gradation, a familiarity with the different blending techniques can help to overcome this problem.

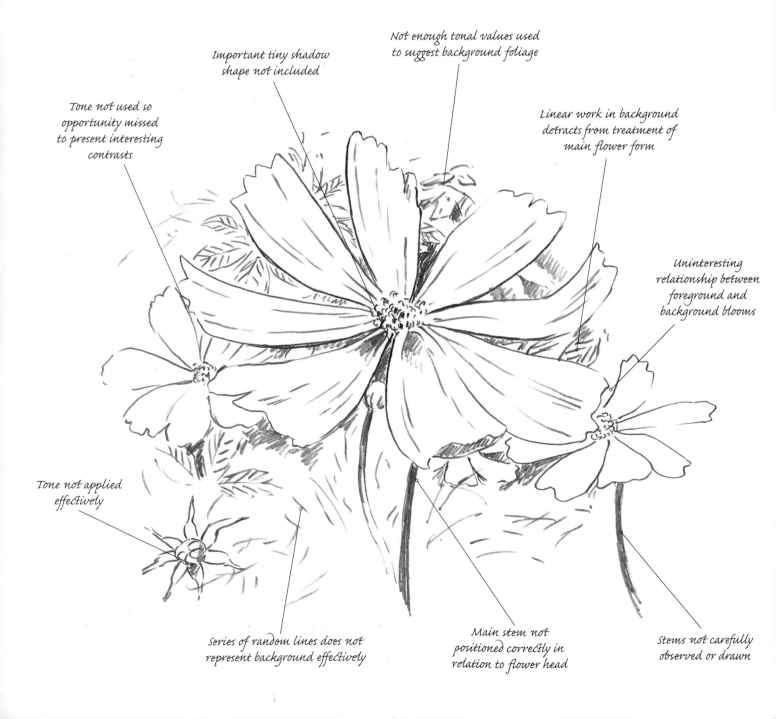

Important tiny shadow shape not included

Not enough tonal values used to suggest background foliage

Tone not used so opportunity missed to present interesting contrasts

Linear work in background detracts from treatment of main flower form

Uninteresting relationship between foreground and background blooms

Tone not applied effectively

Series of random lines does not represent background effectively

Main stem not positioned correctly in relation to flower head

Stems not carefully observed or drawn

Solutions

Long, slightly separated, petals encourage the use of the darkest tonal values against pure white paper, giving maximum contrast. By cutting in crisply with a very sharp pencil, clean edges make the pure white petals stand forward beautifully against the busy background tones.

The profusion of background shapes here has been executed with minimum use of line. Faint guidelines were placed initially in some areas, but these were soon absorbed by tonal block application.

The relationships between the large flower head in the foreground, smaller ones in the middle ground and massed foliage in the background, provide an interesting arrangement of shapes. In a monochrome drawing, consider the vast variety of tonal shapes and avoid hard outlining.

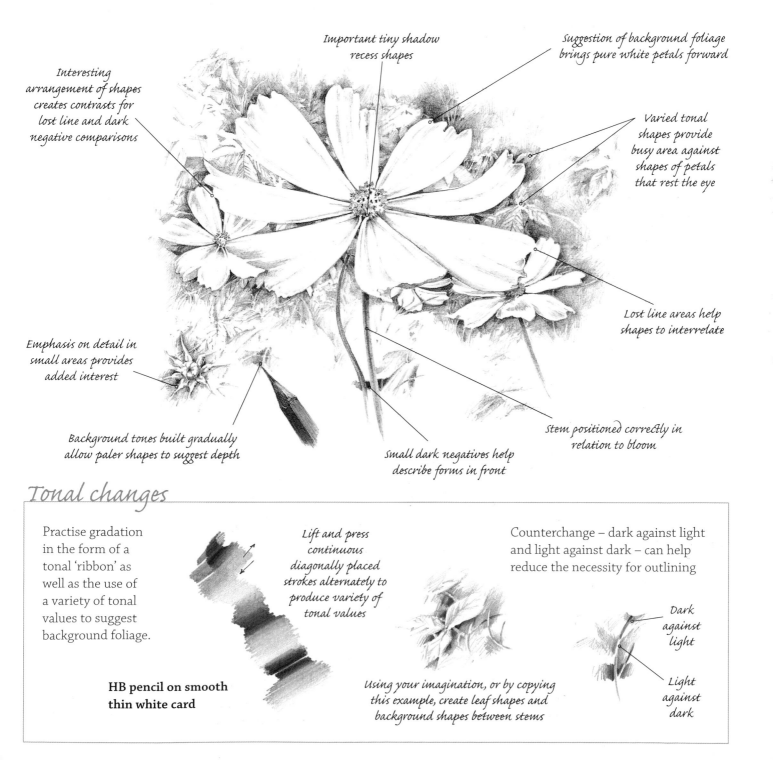

Important tiny shadow recess shapes

Suggestion of background foliage brings pure white petals forward

Interesting arrangement of shapes creates contrasts for lost line and dark negative comparisons

Varied tonal shapes provide busy area against shapes of petals that rest the eye

Emphasis on detail in small areas provides added interest

Lost line areas help shapes to interrelate

Background tones built gradually allow paler shapes to suggest depth

Small dark negatives help describe forms in front

Stem positioned correctly in relation to bloom

Tonal changes

Practise gradation in the form of a tonal 'ribbon' as well as the use of a variety of tonal values to suggest background foliage.

Lift and press continuous diagonally placed strokes alternately to produce variety of tonal values

Counterchange – dark against light and light against dark – can help reduce the necessity for outlining

HB pencil on smooth thin white card

Using your imagination, or by copying this example, create leaf shapes and background shapes between stems

Dark against light

Light against dark

Problems

Colourful Basket

pencil and watercolour

Some subjects can be represented effectively using a combination of monochrome background and colour. Here, the lack of hue in the graphite background allows the full effect of the watercolour paint to be appreciated, co-ordinating the pinks, blues, purples and mauves of the flowers and surrounding them with various foliage greens. Two main problems are noticeable in the study below, one being the perspective angles of the supporting building and the other the inclusion of white paper in areas where this is not required and does nothing to enhance the effect.

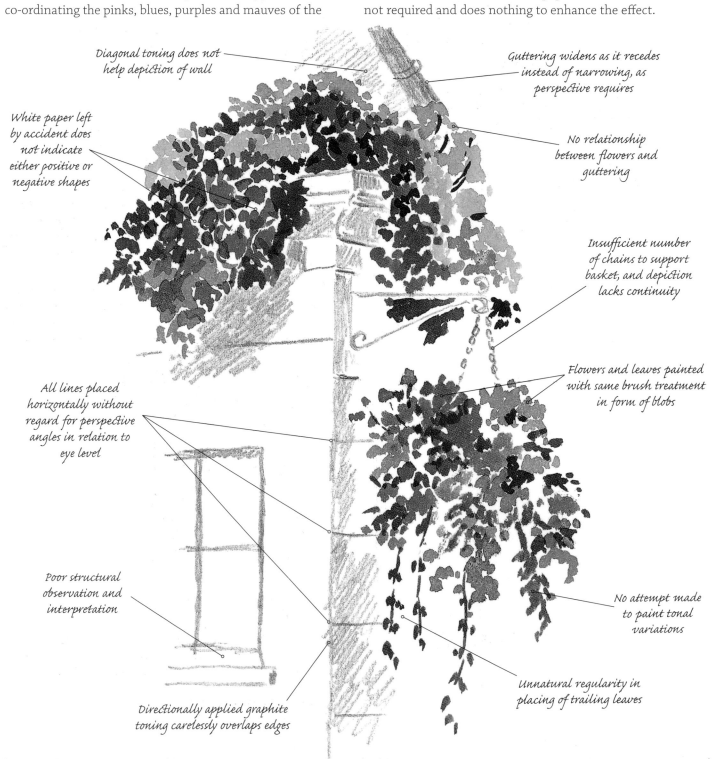

Diagonal toning does not help depiction of wall

Guttering widens as it recedes instead of narrowing, as perspective requires

White paper left by accident does not indicate either positive or negative shapes

No relationship between flowers and guttering

Insufficient number of chains to support basket, and depiction lacks continuity

All lines placed horizontally without regard for perspective angles in relation to eye level

Flowers and leaves painted with same brush treatment in form of blobs

Poor structural observation and interpretation

No attempt made to paint tonal variations

Directionally applied graphite toning carelessly overlaps edges

Unnatural regularity in placing of trailing leaves

Solutions

This study demonstrates how effective strong contrasts can be and how highlighted areas, when placed at the correct perspective angle (here, the corner of the building), add strength to the composition. Note how the flower heads comprise a variety of tonal shapes and values and how tonal contrasts have been used to full effect, within both the graphite monochrome drawing and the watercolour painting. I have taken the top area through to its conclusion but have left the hanging basket below unfinished so you can see how the painting was started.

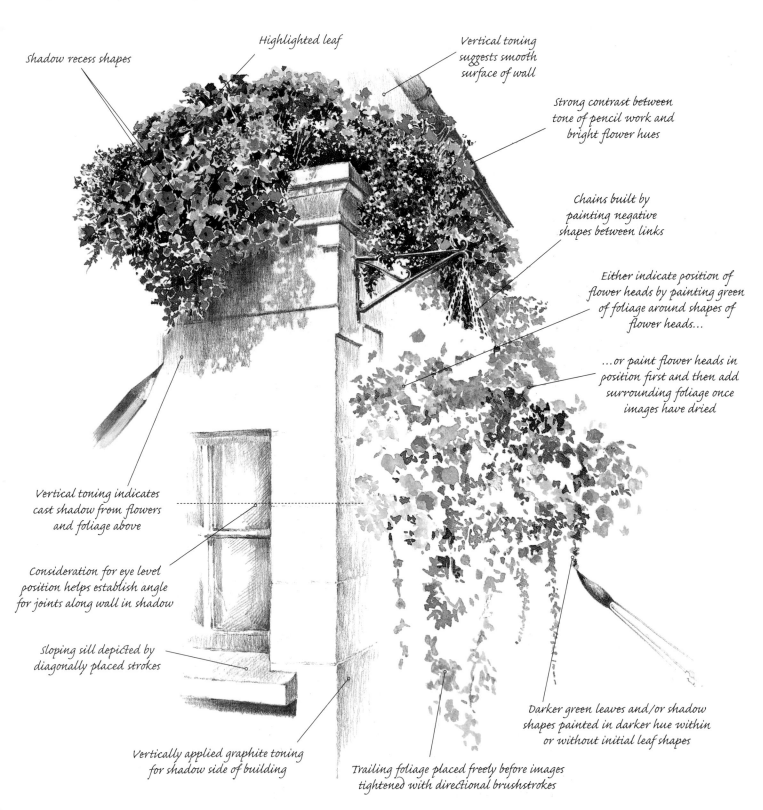

Shadow recess shapes

Highlighted leaf

Vertical toning suggests smooth surface of wall

Strong contrast between tone of pencil work and bright flower hues

Chains built by painting negative shapes between links

Either indicate position of flower heads by painting green of foliage around shapes of flower heads...

...or paint flower heads in position first and then add surrounding foliage once images have dried

Vertical toning indicates cast shadow from flowers and foliage above

Consideration for eye level position helps establish angle for joints along wall in shadow

Sloping sill depicted by diagonally placed strokes

Vertically applied graphite toning for shadow side of building

Trailing foliage placed freely before images tightened with directional brushstrokes

Darker green leaves and/or shadow shapes painted in darker hue within or without initial leaf shapes

Hanging Basket

watercolour

In this hanging basket some flowers grow up towards overhead light, some mass as they emerge from dense foliage, while others trail down on slender stems to present delicate heads at interesting angles. There is a profusion of colour and shapes – where the contrasts of rich, dark shadow recess areas cause the vibrant hues of numerous petals to become clearly defined within the diversity of leaf formations.

While green is the predominant colour, the other hues are co-ordinated so that they comfortably work together: warm reds, oranges and yellows are presented both in groups of flowers and as individual blooms.

I used loosely applied watercolour strokes to suggest an impression of all these elements, and some areas have been illustrated separately opposite as detail enlargements in order that you can see how the whole hanging basket image actually comprises simple shapes – nothing more. The key to success is the arrangement of these shapes with due regard to the plants' form and growth.

Preliminary drawing
For a relatively complex subject experiment with the placing of tonal shapes, using a soft pencil to establish the proportions of the flowers and foliage mass.

Exploratory drawing
This type of drawing, comprising wandering lines as well as tonal areas, can be executed in order to familiarize yourself with the subject matter.

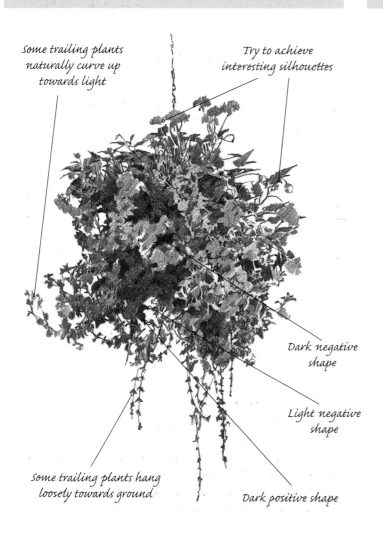

Some trailing plants naturally curve up towards light

Try to achieve interesting silhouettes

Dark negative shape

Light negative shape

Some trailing plants hang loosely towards ground

Dark positive shape

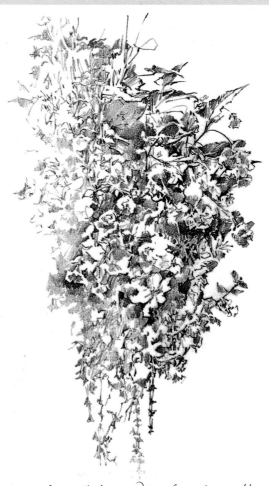

A soft pencil, sharpened to a fine point, enables crisp representation in line and tone

First washes

From the tonal sketch you can establish (and differentiate between) floral and foliage areas. A linear tracing around the main images can be used to transfer them on to watercolour paper – Saunders Waterford HP was used here – prior to painting in the basic colour shapes as simple flat areas, and a few darker hues can be added in some areas to overlay the colour/tone.

Depending upon variety some flowers mass, while others appear as individual blooms

Leaves painted as silhouettes, with narrow strips of white paper remaining for stems

Areas of paper untouched for white flowers

Pale underlay colours

Various shades of green painted loosely

Dark green areas represent negative shadow recess shapes and positive shapes of leaves in shadow

Negative shape looking through to what is beyond

Simple shadow shapes in neutral hue suggest form of white bloom

Untouched paper retained for white flowers

Negative shape within foliage mass

Dark recesses, enriched with overlaid washes, either side of light (stem) area

Shadow areas achieved by overlaid washes

Quick twists of brush suggest trailing foliage

Final stages

The main thing to remember is the importance of contrasting areas – shapes as well as tonal contrasts – both as dark and/or light negatives, and as silhouettes to indicate the profusion of growth. Some areas have been shown in detail to emphasize the simplicity and variety of the shapes that work together to make up the whole.

Line and Form

A series of lines drawn directionally can indicate form. A wandering line, where the pen, pencil or brush remains in contact with the paper's surface throughout the drawing, can be equally effective in finding form – this is demonstrated on pages 6 and 101.

Form is also created tonally, as shown on page 79, and within this theme tonal areas describe form in various ways, using different media.

Brush pen exercises

In the study of an amaryllis on page 83 the brush pen strokes follow the direction of the petal forms; the illustrations here demonstrate the use of a single contoured stroke that is followed by a series of varied contoured strokes describing the curve of one of those impressive petals. This kind of line application can be accompanied, or replaced, by dots and dashes, which can also indicate form.

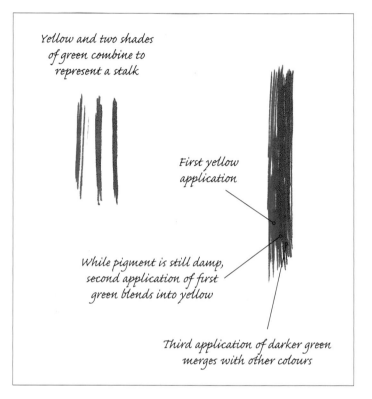

Yellow and two shades of green combine to represent a stalk

First yellow application

While pigment is still damp, second application of first green blends into yellow

Third application of darker green merges with other colours

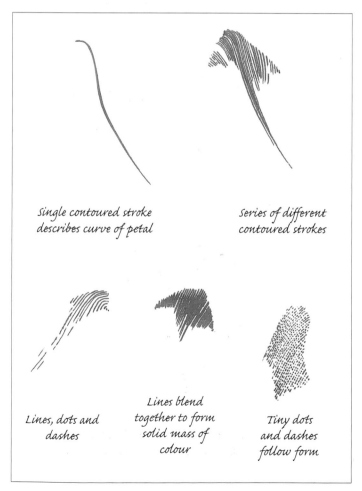

Single contoured stroke describes curve of petal

Series of different contoured strokes

Lines, dots and dashes

Lines blend together to form solid mass of colour

Tiny dots and dashes follow form

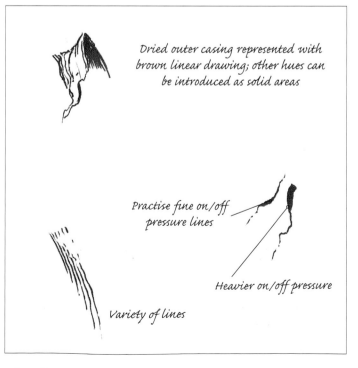

Dried outer casing represented with brown linear drawing; other hues can be introduced as solid areas

Practise fine on/off pressure lines

Heavier on/off pressure

Variety of lines

Graphitint pencil exercises

The subtle shades of Graphitint pencils were used to enhance the foxglove image on page 81. Here, I have suggested a few simple dry-and-wet exercises to help you practise the sweeping clear water strokes that can be placed over this pigment to blend it.

Watersoluble pencil exercises

Derwent Inktense pencils can be used in a similar way to Graphitint pencils, and were used for the rose on page 79. Here a simple dry application image is followed by a second image that demonstrates the pigment's response to the addition of water. In the latter, note the description of form, indicated by arrows to show the direction in which the clear water was applied as a wash to activate the pigment.

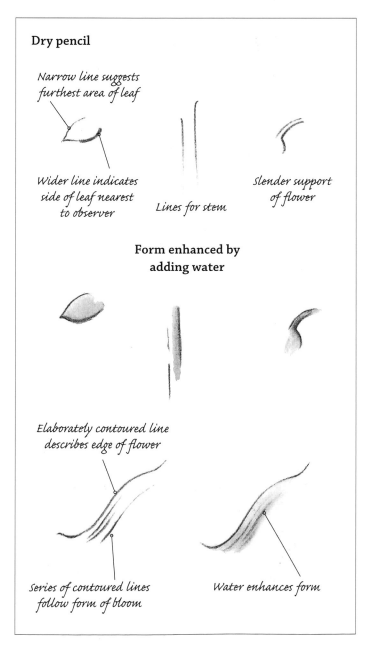

Dry pencil

Narrow line suggests furthest area of leaf

Wider line indicates side of leaf nearest to observer

Lines for stem

Slender support of flower

Form enhanced by adding water

Elaborately contoured line describes edge of flower

Series of contoured lines follow form of bloom

Water enhances form

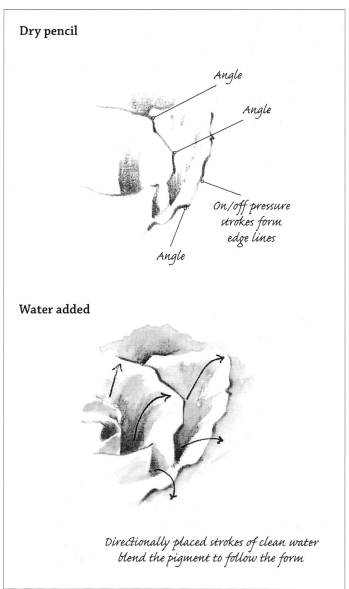

Dry pencil

Angle

Angle

On/off pressure strokes form edge lines

Angle

Water added

Directionally placed strokes of clean water blend the pigment to follow the form

Painting with pencils

For the clematis flower representation on page 77 I combined Derwent Inktense pencils with watercolour paint for the background leaf painting.

The following exercises are intended to help you combine the blending of hue and tone with linear representation to describe form.

Another combination to consider is that of materials: try using a larger brush for sweeping strokes than you would for the finer lines required to depict veins on petals and leaves, and choose a paper surface that will enhance this method – I used Saunders Waterford CP (NOT) paper here.

Line

Practise using a very fine pointed brush for the delicate representation of lines that indicate shadow vein shapes.

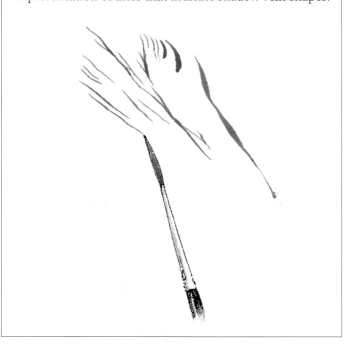

Form

Cut in dark shadow recess shapes up to light edge

Sweep background hue stroke away from light edge

Pull down shadow tone stroke from light edge

Line and form

Paint the edge line first, then sweep the hue away from the edge, adding more water to dilute and blend as necessary.

Inktense colours

Apple green Poppy red Chilli red Bark Mustard Tangerine Sun yellow Ink black

Watercolour pencil exercises

In the demonstration on pages 84 and 85, watercolour pencils were used upon a rough-textured surface to give a bolder approach. It is the direction in which the initial pencil (and later the brushstrokes) are placed that is so important in defining form; rather than applying the pencils as flat areas of tone, I used them in a linear way to follow the vein contours of petals and leaves.

Try to be bold as you apply the sweeping strokes on the leaves and parts of the flower petals to ensure that your interpretation benefits from the intensity of hue achieved by the addition of water.

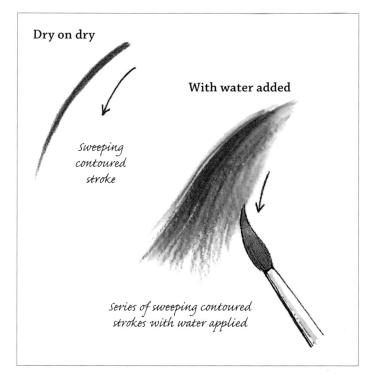

Dry on dry

Sweeping contoured stroke

With water added

Series of sweeping contoured strokes with water applied

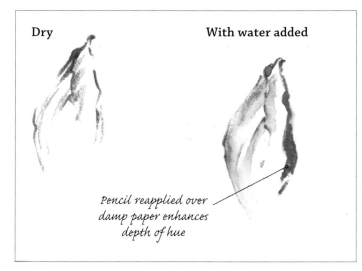

Dry

With water added

Pencil reapplied over damp paper enhances depth of hue

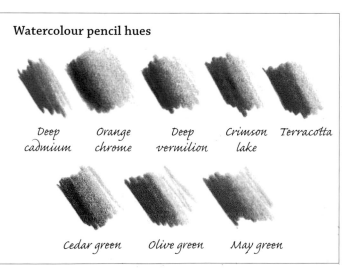

Watercolour pencil hues

Deep cadmium *Orange chrome* *Deep vermilion* *Crimson lake* *Terracotta*

Cedar green *Olive green* *May green*

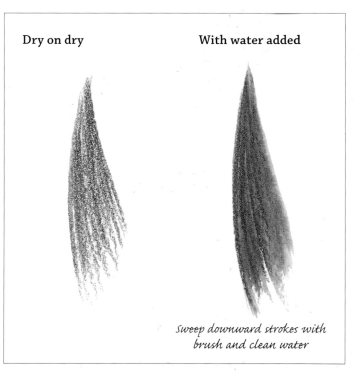

Dry on dry

With water added

Sweep downward strokes with brush and clean water

Problems

Clematis

watercolour and Inktense pencils

Climbing up walls or scrambling through trees, shrubs and undergrowth, colourful varieties of clematis are seen in gardens for most of the year. Beginners find depicting the dark veins on the petals a problem, and this may be due to an unsuitable brush as much as to heavy-handedness.

Effective blending out into the white paper can also cause problems if insufficient water has been used. When more water is added to solve this problem, it helps considerably to use a paper that enhances these effects – Saunders Waterford CP (NOT) is very useful in this situation.

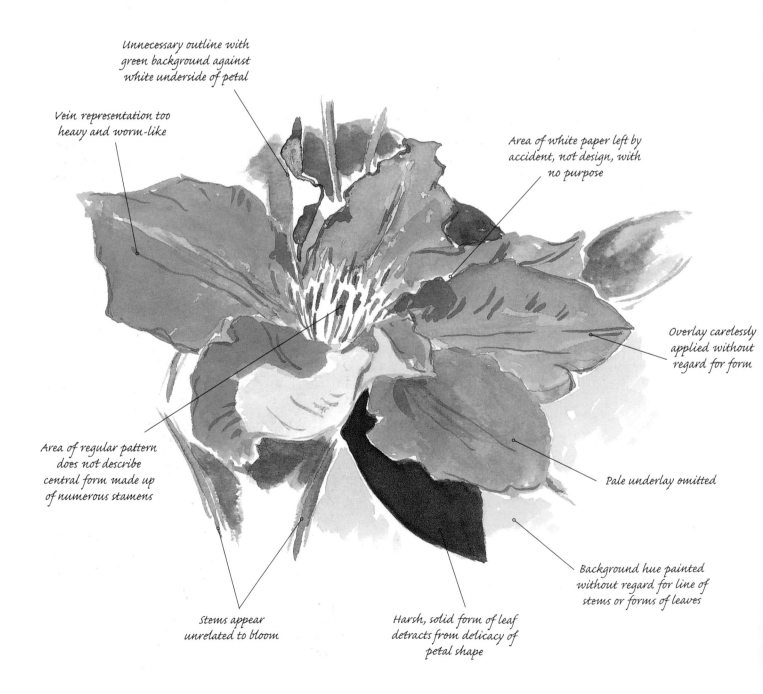

Unnecessary outline with green background against white underside of petal

Vein representation too heavy and worm-like

Area of white paper left by accident, not design, with no purpose

Overlay carelessly applied without regard for form

Area of regular pattern does not describe central form made up of numerous stamens

Pale underlay omitted

Stems appear unrelated to bloom

Harsh, solid form of leaf detracts from delicacy of petal shape

Background hue painted without regard for line of stems or forms of leaves

Solutions

For a plant of this type, with such rich colours and large blooms, retaining light via white paper at the edges of the undulating petals not only helps to differentiate between the different petals but also enhances the contrast with a leafy, stem-divided background.

Inktense watersoluble pencils were used for the flower head and watercolour paints for the background hues, suggesting leaves and stems. Hue and tone were overlaid using directionally placed brushstrokes to create form, and delicate, thread-like lines were placed to indicate dark veins.

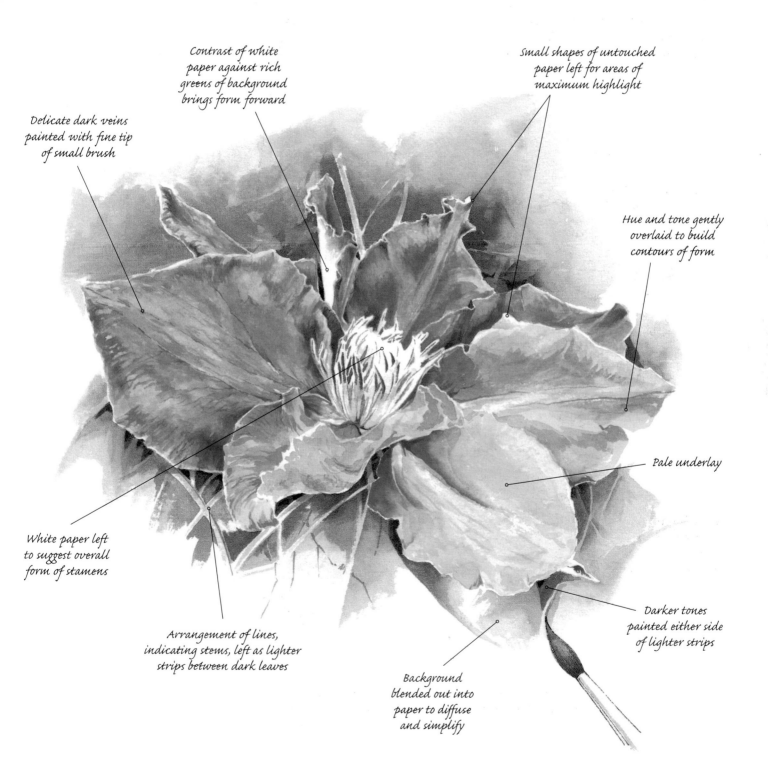

Contrast of white paper against rich greens of background brings form forward

Small shapes of untouched paper left for areas of maximum highlight

Delicate dark veins painted with fine tip of small brush

Hue and tone gently overlaid to build contours of form

White paper left to suggest overall form of stamens

Pale underlay

Arrangement of lines, indicating stems, left as lighter strips between dark leaves

Background blended out into paper to diffuse and simplify

Darker tones painted either side of lighter strips

Problems

Rose

Inktense pencils

The crisp, angled, edges of delicate rose petals offer an opportunity to use straight edge lines from one angle to another in the interpretation of this type of form. Problems can arise when these considerations are omitted; the things to remember are: the use of angled lines; lines that 'find form'; directionally applied pencil and brushstrokes; background relationships resulting in the inclusion of rich, dark, negative shapes that provide essential areas of contrast.

Forms too heavy and rounded, with no regard for angled edges

Drawing executed too heavily

Superficial marks applied without regard for form

Disjointed images floating in space

No contrasts between dark and light hues and tones

No shadow recess toning

No dark negative shapes painted here to bring light forms forward

Images painted without regard for relationship to background appear flat

Solutions

Angles give strength to structure, and curved/contoured lines can be drawn over initially angled lines to make the image more convincing. While considering this, it is also helpful to be aware of form direction when applying pencil and brushstrokes. Using watercolour pencils allows a drawing to be incorporated within the painting, both as an initial undercoat and with subsequent overdrawing where needed.

It is important to retain some untouched paper to indicate the lightest highlights and to include areas of rich dark hue and tone in other areas for maximum contrast. Here, dark green pencil was introduced to the orange/red pigment to achieve dark negative shapes.

Delicately drawn shapes receive directionally placed washes of clean water to blend hue

Dark cut in against light to encourage light forms forward

Tiny shadow recess shape

Some background areas need no more definition in order to recede

Images drawn directionally, using suitable colour

Tiny positive shapes of leaf tips in shadow

Rich dark negatives of background bring light leaves forward

Untouched paper retained for extremely light highlights

Clear water washed delicately over drawn images before overlaid washes

Looking for angles

Edge lines that define petals are firmly drawn in this preliminary sketch to show how they travel from one angle to another.

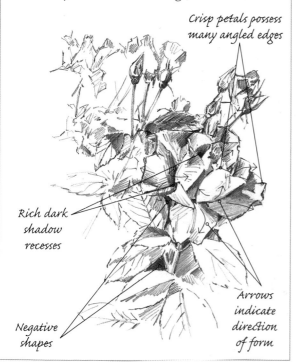

Crisp petals possess many angled edges

Rich dark shadow recesses

Negative shapes

Arrows indicate direction of form

Problems

Foxglove

Graphitint pencils

Working mainly or exclusively in monochrome helps to concentrate more fully upon tonal values, but in these drawings I have introduced an outline in many areas to demonstrate that this is not always detrimental. The way an outline is used in this type of study should be a primary consideration, and a sharp pencil throughout the execution is vital. Problems can arise through lack of concentration when observing outlines of leaves and blooms, and through continually using pencil strips that are no longer sharp enough for the job.

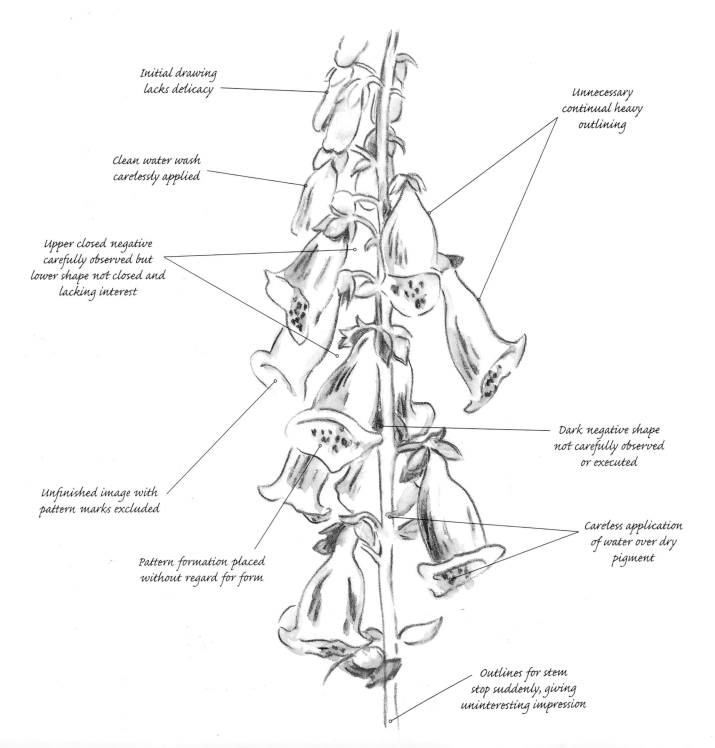

Initial drawing
lacks delicacy

Clean water wash
carelessly applied

Upper closed negative
carefully observed but
lower shape not closed and
lacking interest

Unfinished image with
pattern marks excluded

Pattern formation placed
without regard for form

Unnecessary
continual heavy
outlining

Dark negative shape
not carefully observed
or executed

Careless application
of water over dry
pigment

Outlines for stem
stop suddenly, giving
uninteresting impression

Solutions

For illustrative representation, where outlining may be desired, the gentle medium of watercolour pencils is ideal: choose the nearest colours to those of the flower you wish to depict and treat the study as almost monochrome. Here I have used two greens, ivy and green-grey, to emphasize shadow areas.

Line drawing combined with the use of clear water washes gives line and form representation that can be botanical in approach. Most of the tonal areas result from placing a series of contoured lines that enable the transition from line into form to be natural, gradual and comfortable. It is important to make smooth, directional movements with both pencil and brush.

Practising delicate strokes

It is a good idea to familiarize yourself with a medium before embarking upon your final artwork. These exercises suggest ways to practise delicacy of line application and to overlay directional clear water washes.

Ivy pencil

Area of dry tone will blend readily when water added

First delicate line drawing

Water brushed directionally over image

Water added

Dry

Green-grey for shadow areas

Port pencil

Heavy line

Delicate line

Clean water washed directionally over image to blend dry colours

Water added

Dry

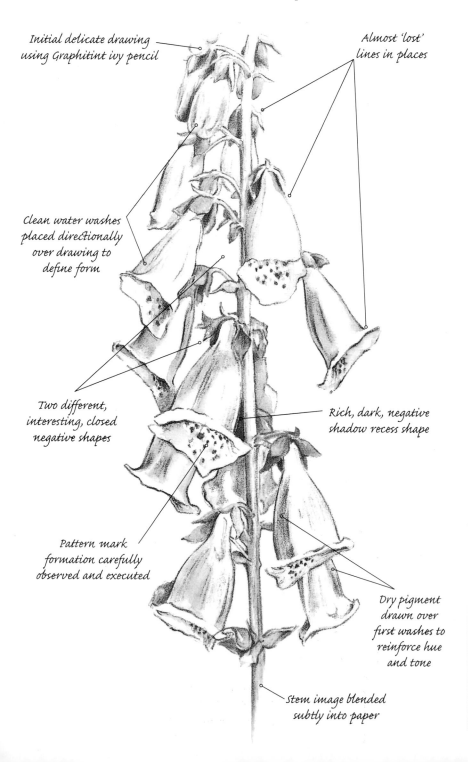

Initial delicate drawing using Graphitint ivy pencil

Almost 'lost' lines in places

Clean water washes placed directionally over drawing to define form

Two different, interesting, closed negative shapes

Rich, dark, negative shadow recess shape

Pattern mark formation carefully observed and executed

Dry pigment drawn over first washes to reinforce hue and tone

Stem image blended subtly into paper

Problems

Amaryllis

`brush pens`

The problem of using too much outlining is quite a common one, and it can be solved in one of two ways – either by drawing in pencil lightly first and subsequently working inwards from this edge line with a series of directionally placed strokes, or by applying interesting on/off pressure lines around the edges. Some areas can be blocked in solidly, while others retain lighter strips that can subsequently be blended when the overlay is applied.

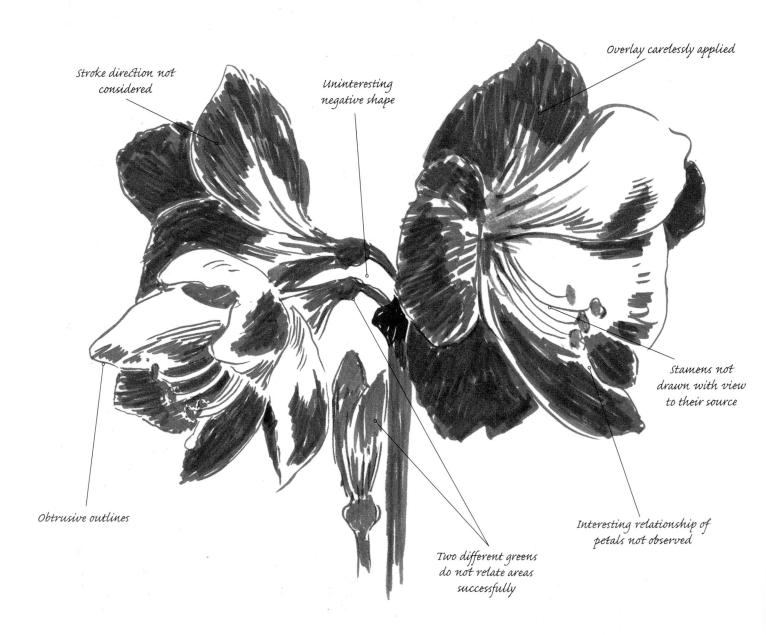

Stroke direction not considered

Uninteresting negative shape

Overlay carelessly applied

Obtrusive outlines

Two different greens do not relate areas successfully

Stamens not drawn with view to their source

Interesting relationship of petals not observed

Solutions

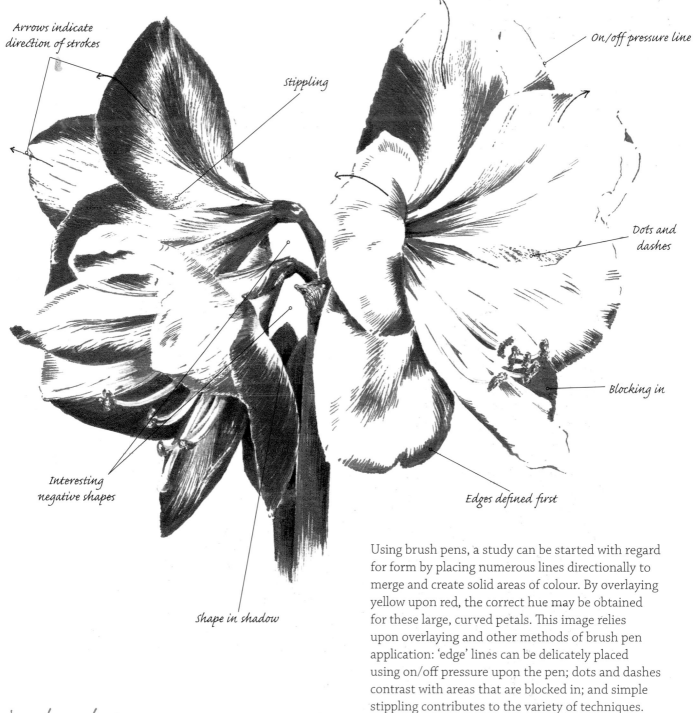

Arrows indicate
direction of strokes

Stippling

On/off pressure line

Dots and
dashes

Blocking in

Edges defined first

Interesting
negative shapes

Shape in shadow

Using brush pens, a study can be started with regard for form by placing numerous lines directionally to merge and create solid areas of colour. By overlaying yellow upon red, the correct hue may be obtained for these large, curved petals. This image relies upon overlaying and other methods of brush pen application: 'edge' lines can be delicately placed using on/off pressure upon the pen; dots and dashes contrast with areas that are blocked in; and simple stippling contributes to the variety of techniques.

Using brush pens

The examples here show how colours can be overlaid wet on dry to change the resulting hue. If you apply the initial strokes in a way that keeps them slightly separate from each other, and then place a solid overlay of a lighter hue, you will change the shade of the base colour and see the overlay glinting through where it has covered the white paper.

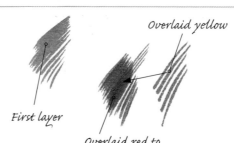

Overlaid yellow

First layer

Overlaid red to
increase intensity

Overlaying yellow
and greens

Iris

`watercolour pencils`

A large iris plant with its showy flowers and sword-shaped leaves is splendid when seen in isolation. However, within a group, viewed at unfamiliar angles, the artist is presented with numerous opportunities to observe line and form within an exciting composition. Add the rich darks that are seen in negative shapes between the forms – to throw the petals forwards from background structures – and you only need colour to complete the picture.

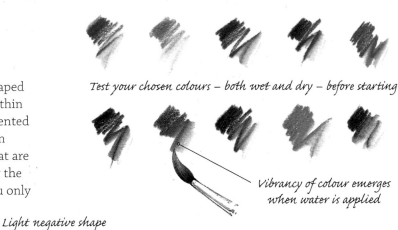

Test your chosen colours – both wet and dry – before starting

Vibrancy of colour emerges when water is applied

Light negative shape between leaves and petals

Rich dark negative shapes encourage light petals to come forward

Direction of petals describes form

Direction of veins gives feeling of movement

Preliminary drawing

A preliminary sketch using watersoluble graphite enables you to practise the directionally applied overlaid brushstrokes prior to working with colour. I drew the bloom on the left-hand side first, placing it at an angle to turn into the centre of the paper. This was followed by the other bloom, placed at a more unusual angle, then the mass of the stem structure and leaves positioned behind as a 'support' for the main images. Although the two flowers, picked from my own garden, were drawn as individual studies (relating to each other), the background leaves resulted from an impression sketched from the growing plant.

Tracing the image

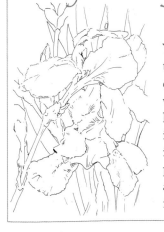

You can place the preliminary drawing at a window or lightbox, trace it and transfer it to watercolour paper. I used a 0.3 Profipen for this tracing.

*Delicate 'edge' lines
lost in some areas*

*Background hue
intensified in some areas*

*Purple placed over green
intensifies dark negative shapes*

*Blend clean water over
dry pigment directionally
to follow form*

*Texture will
disappear after water
has been added*

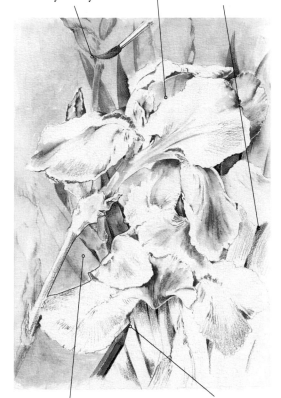

*Background
structure visible
through negatives in
foreground images*

*Overlay pencil dry
on dry to increase
intensity of hue before
applying water*

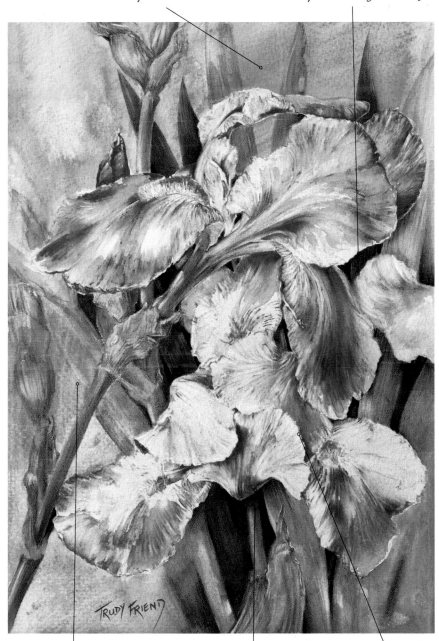

Lost edges

*Retention of strips of reflected light
to bring forms forward*

*Cutting in dark
against light*

First colours and washes

I used watercolour pencils and kept the background (beyond petals and leaves) as a simple pale yellow wash; I achieved this by touching the tip of the yellow pencil with a large brush dipped in clean water and transferring the diluted pigment to the paper in sweeping strokes. The traced image was gently built up dry on dry, prior to the addition of clean water washes. When these were completely dry, further drawing was added where necessary, with a limited amount of water, to intensify tones.

Final stages

The white paper remains visible in some areas to enhance the contrasts of highlights against the rich darks of the petals and background hues. This is where the preliminary drawing is essential – to consider where these need to be retained. It is also a good idea to test your chosen colour range and discover how the colours may change when water is applied.

theme 6:

Colour

This theme features comparisons between pencil toning and watercolour painting, and linear toning in pen and ink with the introduction of watercolour washes. I have also included the use of counterchange and the way a neutral background hue helps to bring forward areas painted in colour. In each of these examples we are considering hue and tone.

Many people produce paintings in colour without an understanding of tonal values, so I have included monochrome representations to help build an awareness of the importance of consideration for tonal values, not only in monochrome drawings and paintings, but also in colour representations. Inability to understand the use of tone can lead beginners to rely upon outlines as they try to differentiate between forms, instead of creating tonal contrasts to separate the images.

In some instances, for example botanical illustration, the use of outlines is desirable, but even in this situation care needs to be taken that they do not appear too heavy or 'wire-like' and detract from the delicate treatment necessary when executing this type of study.

The colours of green

Many beginners experience problems with the mixing of suitable greens. Whether these are to represent areas of background foliage or for the larger leaves of the plant itself, the correct hues and tones are very important.

When mixing greens, take time to recognize and mix the correct green for the foliage you are depicting. Experiment with various mixes and match colours with care and consideration, rather than approximating in your excitement to start the painting.

These exercises demonstrate colour mixing with named hues as well as showing how the addition of just a small amount of other colours added to those mixed can give many interesting variations.

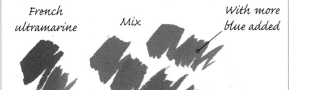

French ultramarine

Mix

With more blue added

Lemon yellow

With more yellow added

Cobalt blue

With more blue added

Mix

Lemon yellow

With more yellow added

By adding a little burnt umber to this mix a different green is obtained

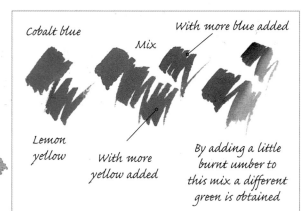

Cobalt blue and lemon yellow mix

Cobalt blue, lemon yellow and burnt umber mix

Create a silhouette image of foliage to get an idea of how the mix will appear in your paintings

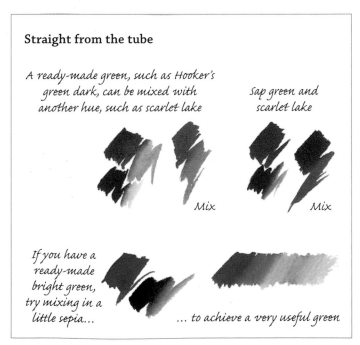

Straight from the tube

A ready-made green, such as Hooker's green dark, can be mixed with another hue, such as scarlet lake

Sap green and scarlet lake

Mix

Mix

If you have a ready-made bright green, try mixing in a little sepia...

... to achieve a very useful green

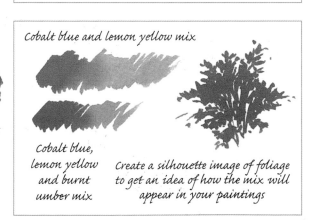

Counterchange

If you are particularly interested in ways of avoiding too many outlines, this exercise, which relates to the poppy image on page 95, can be helpful.

Dark image against light background – image appears to be in front of background

Dark background behind light part of image also brings image forward

Light against dark, followed by dark against light, ensures image appears separate from background

Using the white paper surface

Working in monochrome, whether using the dry medium of graphite or wet watercolour painting, requires you to make use of the white paper among your tonal values in order to achieve maximum contrast when placing the darkest dark tone against the lightest light. This can take the form of a flower that is actually white – where the shadow tones are the primary consideration – or a flower or leaf that has a colour but on which you wish to indicate strong highlights. In this case you need to retain some untouched paper surface to depict the highlights. White paper can also be retained as slender strips in order to represent divisions between one hue or tone and another. Some of the methods used to paint the camellia on page 91 are explored here.

Petals

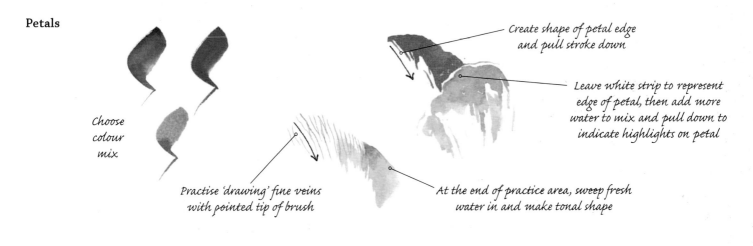

Choose colour mix

Practise 'drawing' fine veins with pointed tip of brush

Create shape of petal edge and pull stroke down

Leave white strip to represent edge of petal, then add more water to mix and pull down to indicate highlights on petal

At the end of practice area, sweep fresh water in and make tonal shape

Leaves

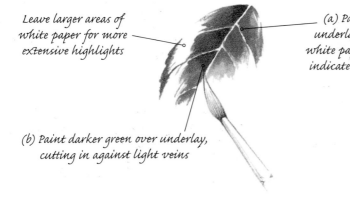

Leave larger areas of white paper for more extensive highlights

(b) Paint darker green over underlay, cutting in against light veins

(a) Paint pale underlay, leaving white paper strips to indicate slim veins

Practise same movements in pencil

'Blend away'

'Up to' light vein to be retained

Incorporating white paper

The honeysuckle study on page 97 demonstrates the advantages of retaining white paper strips between painted forms. These are not only retained to help define the edges of leaves and flowers, to encourage them to stand forward from a background area, but also help in the definition of slender stems.

The latter, seen among a profusion of blooms and foliage, can be highlighted by painting up to and away from either side of them, using the darker background hue. 'Up to and away' strokes enable the slimmest of stems to be depicted, and their clarity can be retained by keeping them as untouched white paper.

For delicate plants of this sort it is useful to practise the application of sweeping strokes that define the forms. The study here shows the first basic strokes prior to building the overlays that will intensify hue and tone.

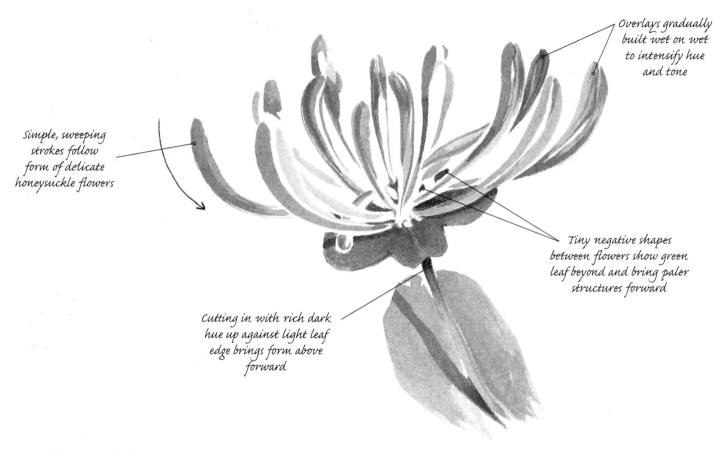

Simple, sweeping strokes follow form of delicate honeysuckle flowers

Overlays gradually built wet on wet to intensify hue and tone

Tiny negative shapes between flowers show green leaf beyond and bring paler structures forward

Cutting in with rich dark hue up against light leaf edge brings form above forward

Understanding tone

Without knowledge of tonal values and how they may be used to create the all-important contrasts within your artwork, you will be at a disadvantage. These colour swatches show a scale of tonal values in one of the flower hues and another in a useful green.

A rich crimson lake or similar hue produces a variety of tonal values: each tonal block is produced by adding a little more water to the concentrated hue

Lemon yellow and French ultramarine mixed produce useful greens

Vibrant colours

The images of the antirrhinums on page 93 and the sunflower on page 99 demonstrate Inktense watersoluble pencils applied as overlays – over pen and ink on page 93, and over 'outliner' pencil on page 99.

Working with outliner pencil on a rough watercolour paper surface produces an interesting textured tonal base upon which to overlay hues. Because it is a soft pencil, the outliner is also capable of producing rich, dark tones that contrast effectively with the more vibrant hues of the Inktense range of pencils.

Establishing forms in a monochrome medium prior to applying exuberant washes of colour can be an exciting way to work, and with this method, as with many others, the direction in which you apply the brushstrokes is another important factor.

In the exercises on this page I have drawn a series of arrows to indicate the directions in which the strokes were placed – both for the execution of the brushwork and for the pen and ink underlay.

Derwent Inktense pencils were used to colour the ink drawing...

Touch tip of pencil with wet brush and pull pigment down into palette, diluting as required

To create rich dark areas, move pen gently while remaining in same area

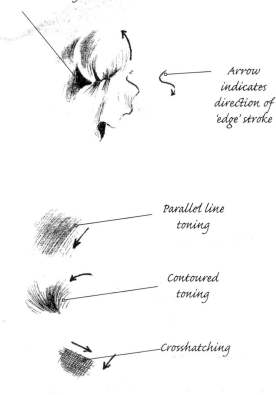

Arrow indicates direction of 'edge' stroke

Parallel line toning

Contoured toning

Crosshatching

Use directional stroke application of pen and brush

Arrows indicate direction of strokes

...and Saunders Waterford CP (NOT) paper was used to create the textured effect of strokes as the pen was gently grazed across the surface.

Problems

Camellia

pencil and watercolour

A burst of colour early in the year is a welcome sight. The impressive camellia, with its bright blooms and rich green shiny leaves, provides an excellent opportunity to observe tonal values as well as colour.

The solid forms of dormant buds resting throughout the winter months allow form to be represented by careful pencil toning. Delicate veins, which indicate direction and structure, require close observation and careful treatment, and this often proves to be a problem. A brush with a fine point is required for these areas in order to define veins, as well as cutting in dark shadow recess areas crisply against white petal edges.

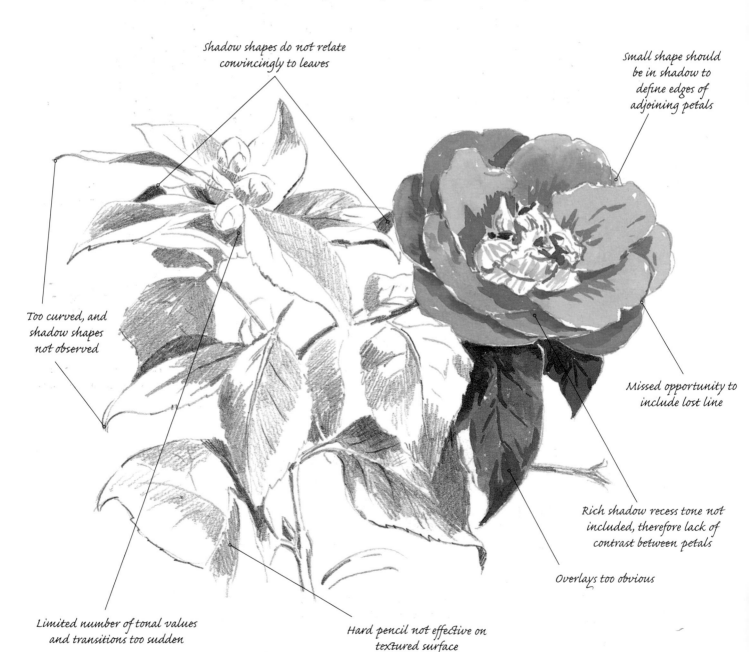

Shadow shapes do not relate convincingly to leaves

Small shape should be in shadow to define edges of adjoining petals

Too curved, and shadow shapes not observed

Missed opportunity to include lost line

Rich shadow recess tone not included, therefore lack of contrast between petals

Overlays too obvious

Limited number of tonal values and transitions too sudden

Hard pencil not effective on textured surface

Solutions

When blooms burst into colour, observation and understanding of tonal values helps the depiction of overlapping petals and the achievement of all-important contrasts. Light petal edges can enhance this effect.

The forms of buds, leaves and petals are defined by the way the light hits them, and it is important to be aware of how to incorporate the white paper surface – in order to achieve the effect of strong highlights, it may be necessary to leave large areas of unmarked paper to contrast with shadow shapes and cast shadow areas.

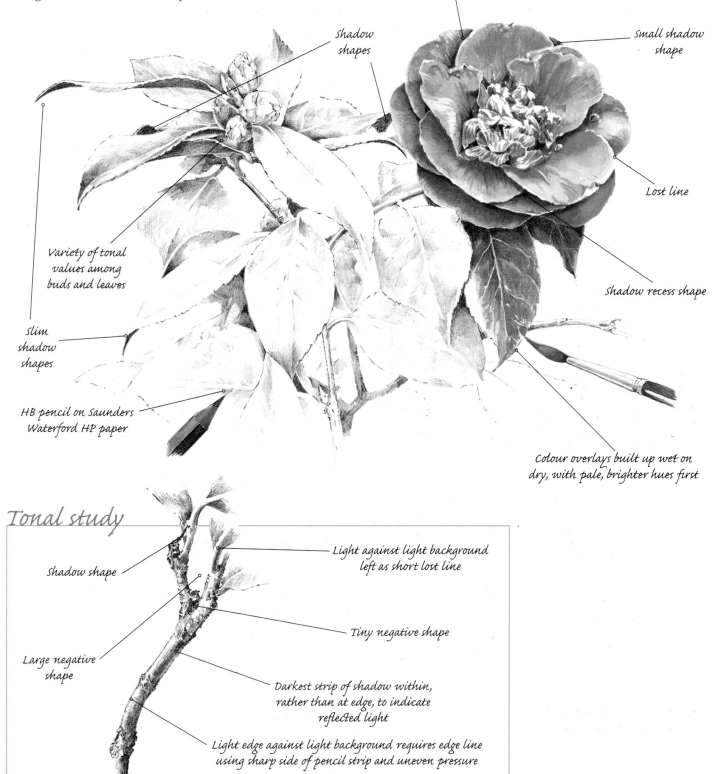

Cut in crisply and leave light edges to petals

Shadow shapes

small shadow shape

Lost line

Shadow recess shape

Variety of tonal values among buds and leaves

Slim shadow shapes

HB pencil on Saunders Waterford HP paper

Colour overlays built up wet on dry, with pale, brighter hues first

Tonal study

Shadow shape

Light against light background left as short lost line

Tiny negative shape

Large negative shape

Darkest strip of shadow within, rather than at edge, to indicate reflected light

Light edge against light background requires edge line using sharp side of pencil strip and uneven pressure

Problems

Antirrhinums

Inktense pencils and pen and ink

When drawing or painting closely massed plants, such as antirrhinums, trying to visually separate one from another can sometimes prove to be problematic: recognizable shapes of blooms, leaves and stems become lost as a result of too much linear and tonal activity. You may draw what you see, and what you know to be there, but when it is confronted with numerous lines and tonal areas, the inexperienced eye can become confused.

Another problem experienced by beginners when confronted by a complicated arrangement is that they panic – fear of making mistakes or of having to give up in frustration often prevents them from even making a start.

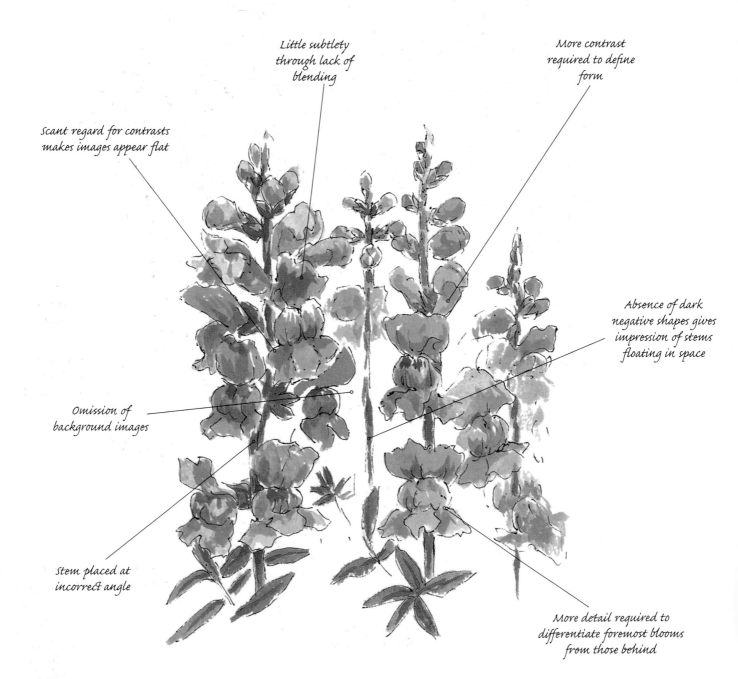

Little subtlety through lack of blending

More contrast required to define form

Scant regard for contrasts makes images appear flat

Absence of dark negative shapes gives impression of stems floating in space

Omission of background images

Stem placed at incorrect angle

More detail required to differentiate foremost blooms from those behind

Solutions

The best way to start is to do just that! Find a shape that you can clearly define, understand and manage – then draw it. Relate this image to its neighbour, noting the shape of the negative between them, then continue to work out and away from the original image on either side.

When you gradually introduce gentle colour washes to complement areas of tone, the image will become clarified. Colour can bring pen and ink drawings to life: the effective addition of colour separates one image from its neighbour, and the problem is solved.

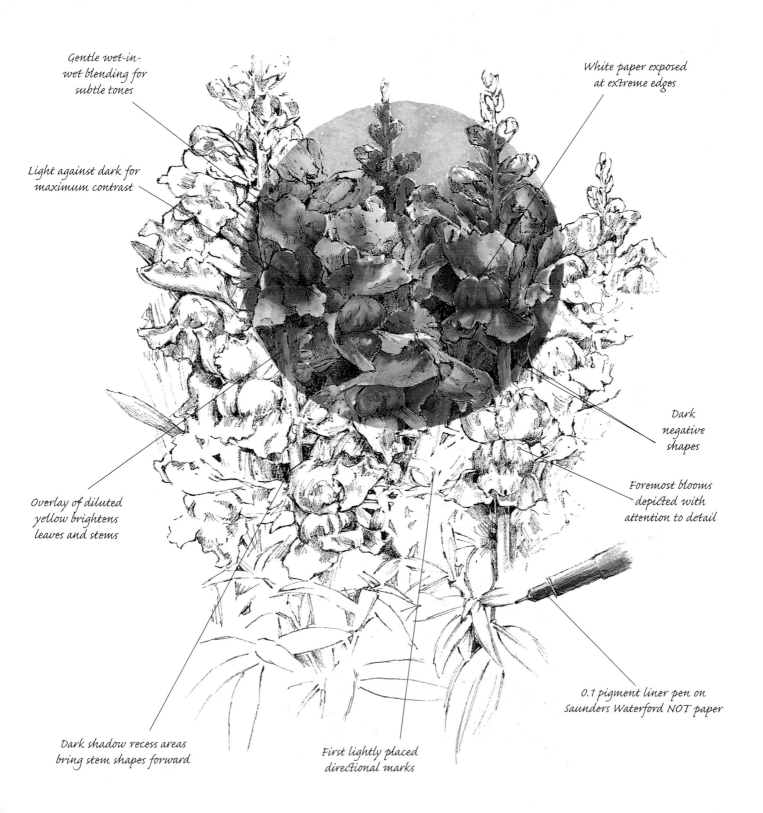

Gentle wet-in-wet blending for subtle tones

Light against dark for maximum contrast

Overlay of diluted yellow brightens leaves and stems

Dark shadow recess areas bring stem shapes forward

First lightly placed directional marks

White paper exposed at extreme edges

Dark negative shapes

Foremost blooms depicted with attention to detail

0.1 pigment liner pen on Saunders Waterford NOT paper

Problems

Poppies

watercolour

Different poppy varieties present us with numerous tonal contrast considerations – some possess an array of pale stamens against the rich dark hues of the pattern on the petals, while others have dark stamens that contrast with petals of a lighter colour.

The technique of counterchange, using contrasts of hue and tone, effectively separates components and background areas from each other. When using this method, care must be taken that transitions work smoothly in order to produce the desired result and to make the whole image visually acceptable. Beginners who are unaware of the counterchange method often resort to outlining the forms, but this presents a flattened image rather than the three-dimensional representation they desire.

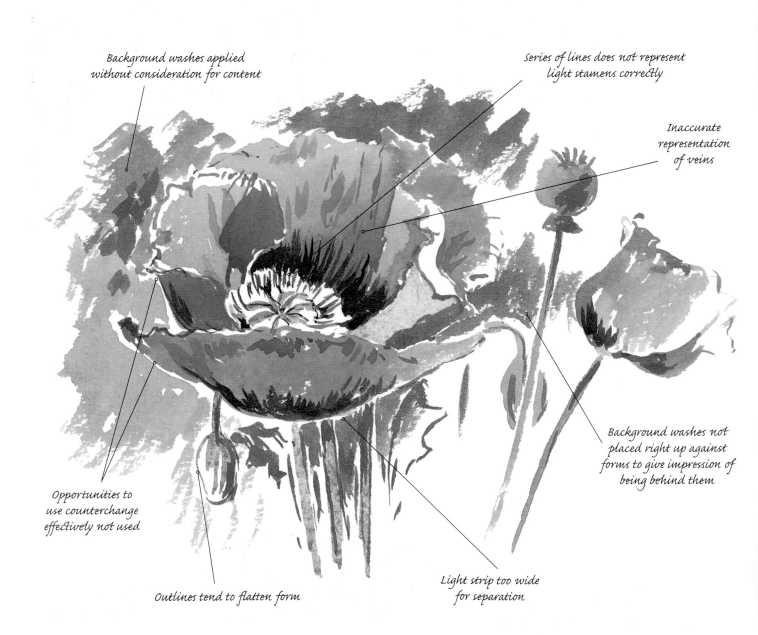

Background washes applied without consideration for content

Series of lines does not represent light stamens correctly

Inaccurate representation of veins

Opportunities to use counterchange effectively not used

Background washes not placed right up against forms to give impression of being behind them

Outlines tend to flatten form

Light strip too wide for separation

Solutions

Subtle yellow glaze brightens and unifies area

Effect of light stamens achieved by cutting in between and around them with darker hue

Raised, highlighted veins receive dark hue on either side of lighter strips

With two dark hues together, very narrow light strip of paper retained to separate form from background

Background painted loosely with criss-cross strokes to suggest leaf masses behind main form

Counterchange: light form against dark background and dark form against light background

Some images unfinished in light areas where highlights merge

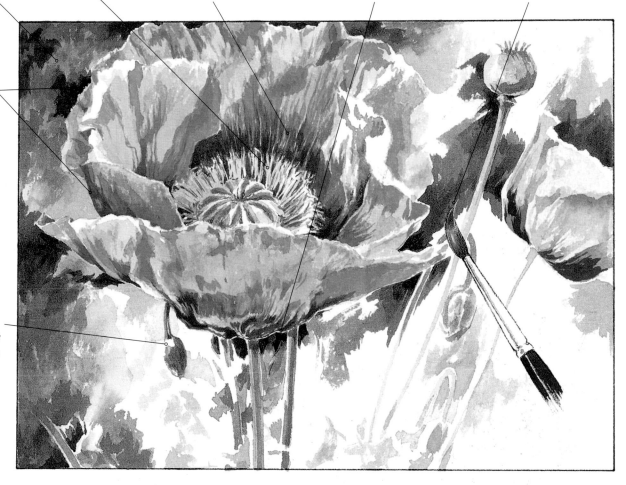

This painting shows how dark hue cuts in up to the edge of the stamens and, to some extent, within their mass. The value of contrasts in achieving a three-dimensional impression has been mentioned in other themes, and this demonstrates how counterchange also plays an important part in the process, both in colour and in monochrome representations.

In order to take full advantage of contrasts – whether this is in watercolour or pencil work – you need to incorporate the white paper support as an integral part of your representations. Areas of white paper are often there because the artist is unsure how to use the area, rather than by choice. You need to decide where white paper will be effective – for example on areas where you wish to suggest the lightest highlights.

Tonal counterchange in monochrome

This pencil study gives an example of overlaying dark over lighter tones.

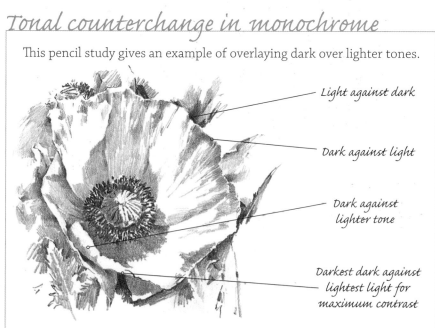

Light against dark

Dark against light

Dark against lighter tone

Darkest dark against lightest light for maximum contrast

Problems

Honeysuckle

watercolour

The sweet-smelling honeysuckle, with its numerous tendrils and thicker supporting stems intermingled with flowers and leaves, can appear very complicated when viewed en masse. Inexperienced painters sometimes draw with a brush in outline or are tempted to exclude much of what they see, being unsure how to depict all the visual activity of the components.

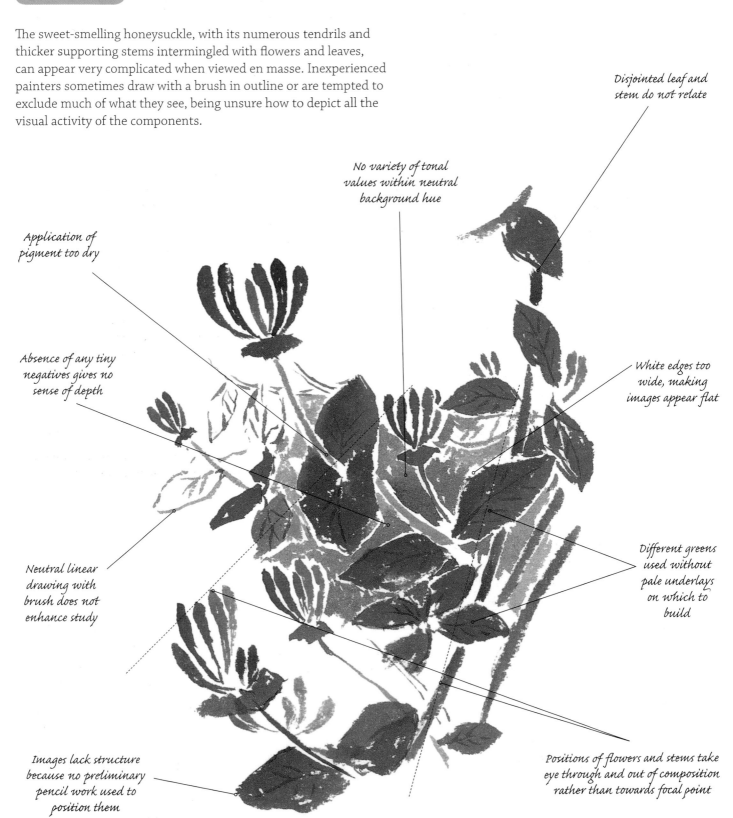

Disjointed leaf and stem do not relate

No variety of tonal values within neutral background hue

Application of pigment too dry

Absence of any tiny negatives gives no sense of depth

White edges too wide, making images appear flat

Neutral linear drawing with brush does not enhance study

Different greens used without pale underlays on which to build

Images lack structure because no preliminary pencil work used to position them

Positions of flowers and stems take eye through and out of composition rather than towards focal point

Solutions

One way of addressing the problem is to treat the background areas in a neutral hue, incorporating various tonal values. This has the effect of bringing the colours of the main flowers, leaves and stems to the fore. If these positive shapes are painted first, in the palest of colours to establish their positions, the negative shapes between them can be established in pale neutral hues. In this way both the main plant shapes and the background shapes can be built up together and related to each other as the painting progresses.

Areas in this study have been left unfinished to show how overlaying of hue and tone builds the images. The first, very pale underlay washes are used to position flowers, leaves and stems; the latter are mainly created by applying a neutral tone either side of slim areas of white paper.

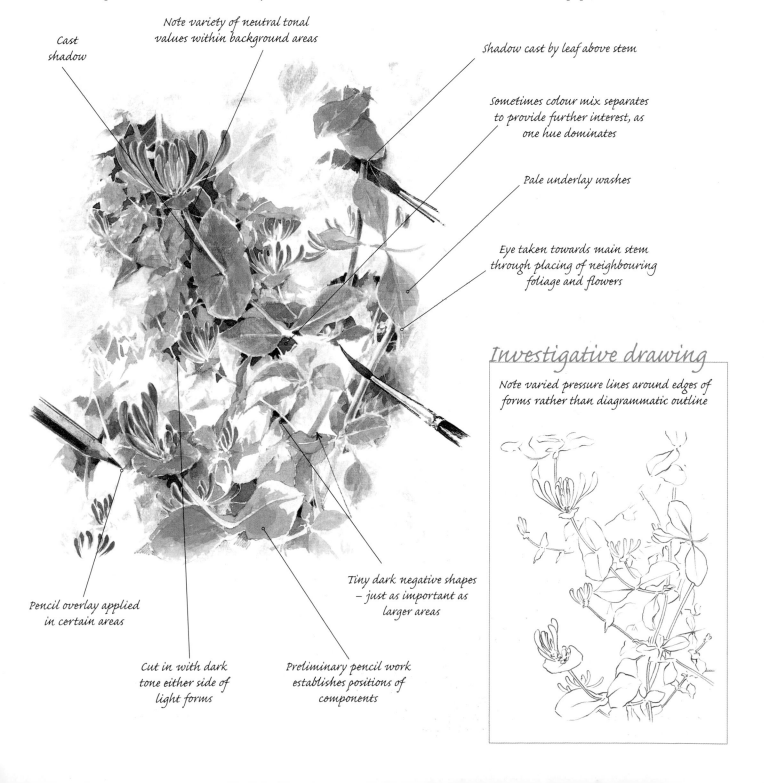

Cast shadow

Note variety of neutral tonal values within background areas

Shadow cast by leaf above stem

Sometimes colour mix separates to provide further interest, as one hue dominates

Pale underlay washes

Eye taken towards main stem through placing of neighbouring foliage and flowers

Investigative drawing

Note varied pressure lines around edges of forms rather than diagrammatic outline

Pencil overlay applied in certain areas

Cut in with dark tone either side of light forms

Preliminary pencil work establishes positions of components

Tiny dark negative shapes – just as important as larger areas

Sunflower

Inktense pencils

When not growing en masse in fields, sunflowers can be viewed against the sky, towering above many other garden plants. These large blooms lend themselves to bold treatment; I used the Derwent Inktense range of watersoluble coloured pencils for this demonstration.

Drawing and first colour stages

The useful, soft 'outliner' pencil, when used upon a rough surface watercolour paper, produces some exciting lines and textures. The former defines forms with interesting edges and the latter provides a base texture upon which the vibrant hues of the Inktense range may be applied as translucent washes. This illustration shows step-by-step stages of development, annotated from (a) to (k).

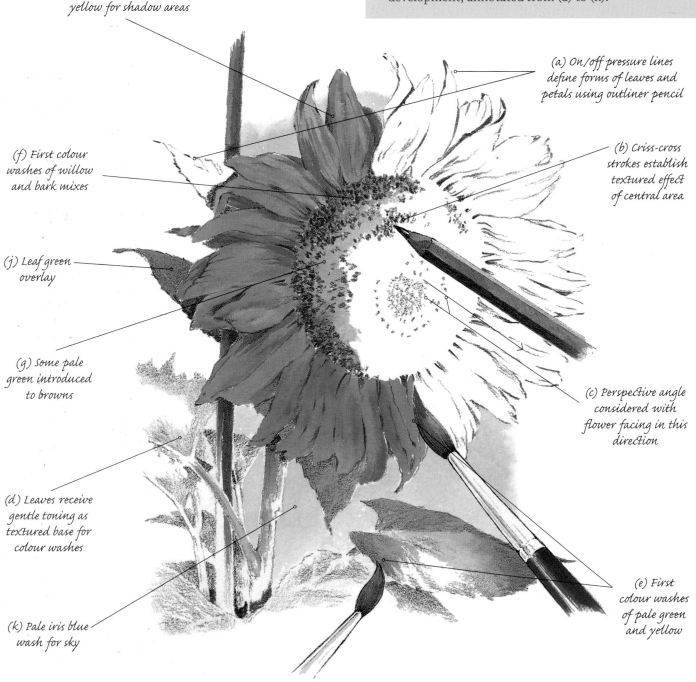

(h) Bark mixed with sun yellow for shadow areas

(f) First colour washes of willow and bark mixes

(j) Leaf green overlay

(g) Some pale green introduced to browns

(d) Leaves receive gentle toning as textured base for colour washes

(k) Pale iris blue wash for sky

(a) On/off pressure lines define forms of leaves and petals using outliner pencil

(b) Criss-cross strokes establish textured effect of central area

(c) Perspective angle considered with flower facing in this direction

(e) First colour washes of pale green and yellow

Completed study

I have kept this image clear and simple in representation to conclude this theme with one of the most cheerful of garden flowers. The colours used are shown at right.

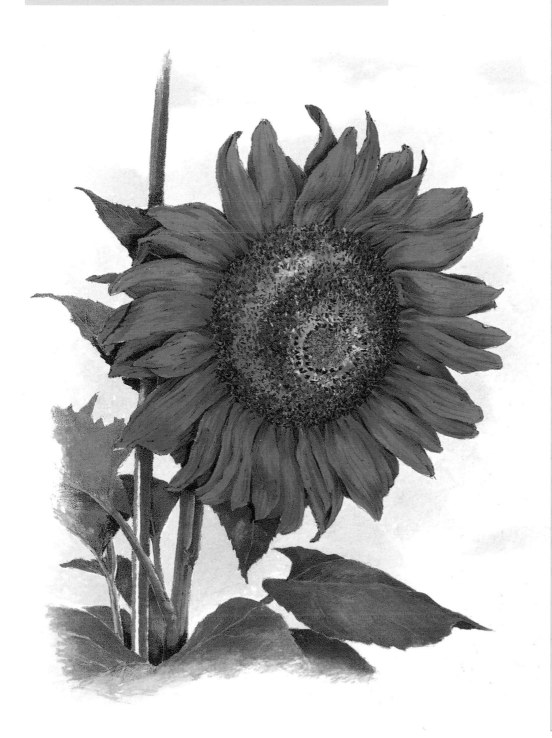

Apple green | Apple green underlay

Leaf green

 | Hint of sun yellow over greens

Sun yellow

 | Sun yellow underlay

Tangerine

 | Tangerine mixed with sun yellow for darker areas

Willow

Baked earth

 | Willow washed over central area

Iris blue

Dilute wash of iris blue for sky | Stem with baked earth wash

Composition and Arrangement

Finding the focus

Because composition and arrangement are such important considerations, this theme starts with a detailed drawing that contains many of the elements conducive to creating a successful study.

On page 111 you can see a preliminary sketch for the detailed drawing below. In the quick sketch – which was executed in order to compose the arrangement – there are many areas of the drawing that receive the same type of treatment, whether in the foreground or background images. In the drawing below more thought has been given as to how the foreground and background areas can appear separate, and how to enhance the focal point – which is different in the study on page 111.

Here, the observer's eye is directed towards the focal point and anchored there by introducing a strong contrast on the left. I also reduced the tonal values of distant images on the right, encouraging them to remain in recession.

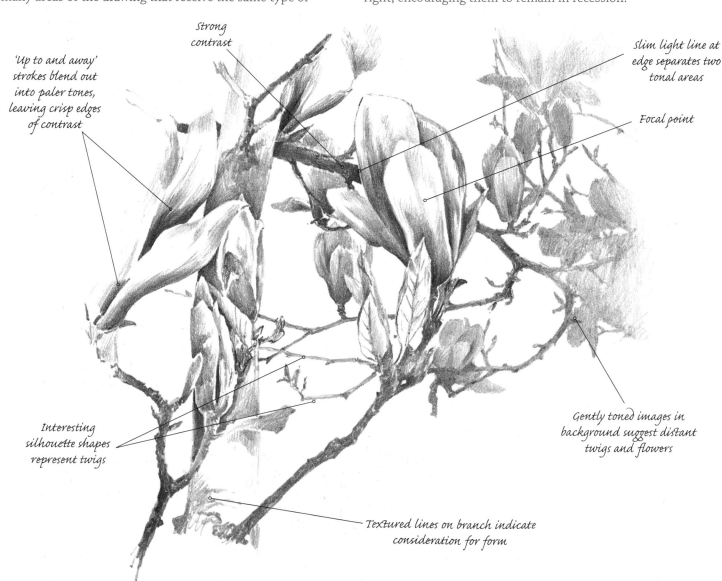

Strong contrast

'Up to and away' strokes blend out into paler tones, leaving crisp edges of contrast

Slim light line at edge separates two tonal areas

Focal point

Interesting silhouette shapes represent twigs

Gently toned images in background suggest distant twigs and flowers

Textured lines on branch indicate consideration for form

Composing with massed foliage

Another study containing many components can be seen
on page 107. Here are a few exercises to try, relating to that
pencil and wash study of primroses. Instead of light negative
shapes helping to hold the composition together (as in the
drawing opposite), the dark negative shapes have come into
play in this sketch.

In these studies I used a wandering line to find and position
the forms, retaining pencil contact with the paper as much as
possible throughout the drawing.

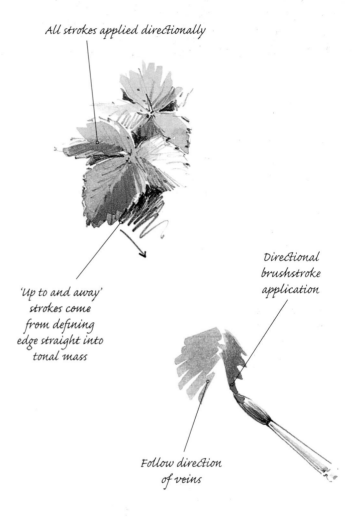

All strokes applied directionally

*'Up to and away'
strokes come
from defining
edge straight into
tonal mass*

*Directional
brushstroke
application*

*Follow direction
of veins*

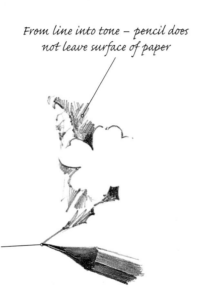

*From line into tone – pencil does
not leave surface of paper*

*Lightly applied wandering
line travels over the paper,
defining form*

*Pencil remains in
contact with paper's surface
throughout most of initial
'placing' drawing*

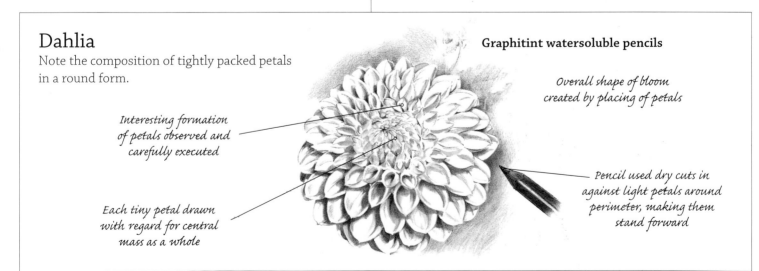

Dahlia

Note the composition of tightly packed petals
in a round form.

Graphitint watersoluble pencils

*Overall shape of bloom
created by placing of petals*

*Interesting formation
of petals observed and
carefully executed*

*Each tiny petal drawn
with regard for central
mass as a whole*

*Pencil used dry cuts in
against light petals around
perimeter, making them
stand forward*

Moving in closer

A colourful poppy is observed in close-up on page 105, and demonstrates how you can edit in insects to add interest to your composition. That study was executed in Inktense pencils, and the following exercises are to help you practise the execution of three different areas in the composition.

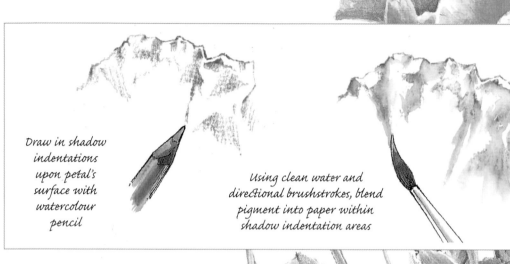

Draw in shadow indentations upon petal's surface with watercolour pencil

Using clean water and directional brushstrokes, blend pigment into paper within shadow indentation areas

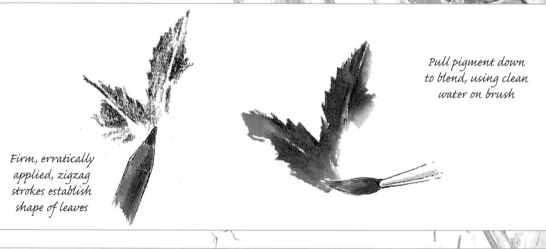

Firm, erratically applied, zigzag strokes establish shape of leaves

Pull pigment down to blend, using clean water on brush

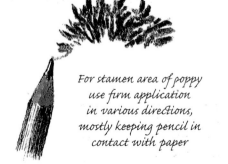

For stamen area of poppy use firm application in various directions, mostly keeping pencil in contact with paper

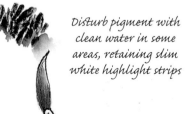

Disturb pigment with clean water in some areas, retaining slim white highlight strips

Complicated formations

Close observation is essential when depicting plant forms and formations. The complex arrangement of elegant agapanthus blooms upon slender stems emanating from a single main supporting stem is the subject of the demonstration on pages 112–13.

Agapanthus flowers are worthy of close study, and practice drawings of the individual flowers and buds, using pen, ink and wash, are included here. These small ink studies help you to understand the structure of the flowers when seen from different angles.

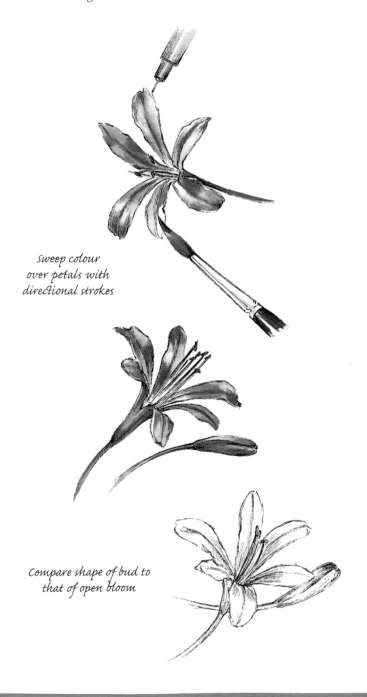

Sweep colour over petals with directional strokes

Compare shape of bud to that of open bloom

Working in monochrome

Penwork is also ideal for monochrome representation, especially where a looser interpretation is enjoyed. I used a fine 0.4 coloured watersoluble pen here, which is ideal for sketchbook studies. These exercises relate to the drawing of a greenhouse interior on page 109.

Place tip of pen on paper and move in different directions to give impression of tiny leaves

single lines grazed across paper

Erratically placed up-and-down strokes create angled interpretation

Parallel lines for flat tonal areas

Light leaves against darker background

Tiny flower shapes kept light by washing water between images to disturb ink

For light stems against darker background: (a) draw lines either side of form; (b) fill in areas between with penwork; (c) wash clean water over penwork

Problems

Poppy

watercolour pencils and Inktense pencils

In this study, the expanse of petal to the right, among an array of other petals, lends itself to the addition of an extra component. A hovering bee has been added, and this leads the eye towards the focal point of massed stamens in the centre of the flower. Combined with the dark pattern on the petal just below the insect and that seen in the inverted

V shape above, this adds a feeling of movement to the arrangement. When making additions of this kind, beginners may experience problems that arise from not being sure of scale and lack of knowledge concerning the additional components. In this case it is advisable to seek reference from other sources in order to make comparisons.

Overlays not used to create intensity of hue and tone in shadow recess area

Initial guideline trespasses on to adjoining petal

White paper used just for areas untouched by colour

Loosely washed water and outline do not give impression of massed foliage

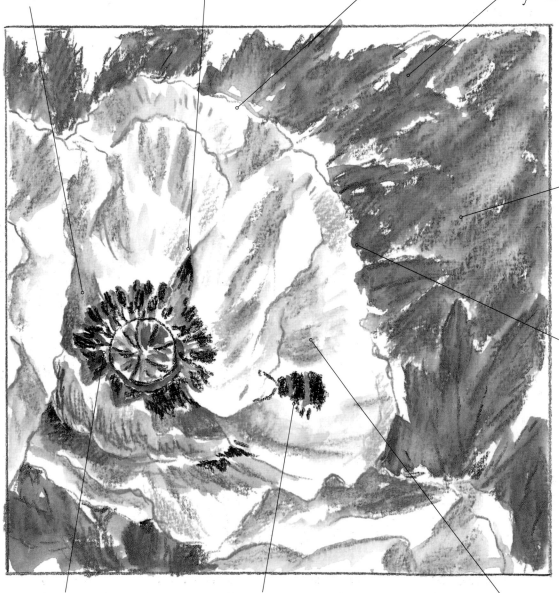

Clear water blending placed uniformly and diagonally without regard for images

Colour for soil not rich enough for sufficient contrast

White paper left by accident, rather than design

Vertical stripes do not consider contours of body

Strokes not placed with regard for form

Watercolour pencils and Inktense pencils have been combined here to build layers of dry application, followed by clear water blending and more dry-on-dry work. The Inktense orange and yellows were used sparingly and applied as overlaid translucent washes to add vibrancy and glow.

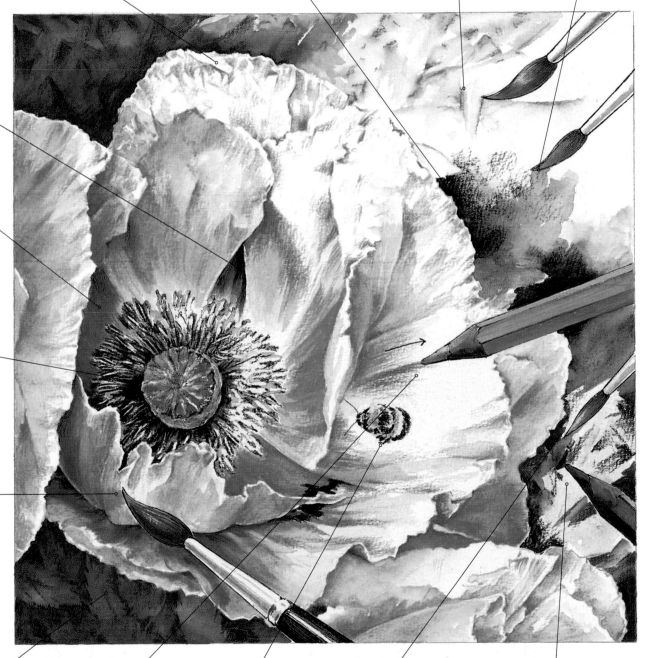

Clear water wash over lightly drawn background shapes gives impression of massed leaves

Clear water blended over colour as underlay

Highlighted creases in petals achieved by retaining white paper

Rich soil hue cut in against crisp light edge of petal

Shadow recess shape

Overlays of different hues built to increase intensity of hue

Shadow shapes used in addition to intricate drawing

Glazed with yellow pencil wash

Shape between part of flower and edge of painting considered

Directional pencil strokes follow form of petal

Additional components enhance composition

Clear water washes applied with criss-cross movements

Criss-cross pencil strokes represent shadow recess shapes between background leaves

Problems

Primroses

pencil and watercolour

When confronted by a profusion of flowers and foliage, you may find the prospect of portraying so many positive and negative shapes rather daunting. One of the problems often experienced by beginners is that of how to arrange blooms and leaves in irregular, natural presentations, and to show the relationships between the positive and negative shapes. When left without consideration for why they have been retained, such as for highlights, white paper areas tend to flatten the forms and give a disjointed appearance.

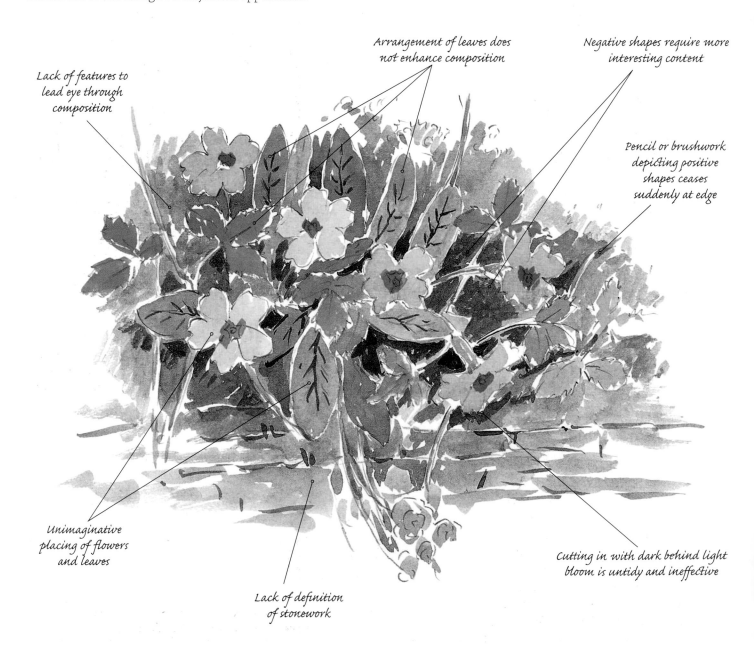

Lack of features to
lead eye through
composition

Arrangement of leaves does
not enhance composition

Negative shapes require more
interesting content

Pencil or brushwork
depicting positive
shapes ceases
suddenly at edge

Unimaginative
placing of flowers
and leaves

Lack of definition
of stonework

Cutting in with dark behind light
bloom is untidy and ineffective

Solutions

For the study here, I started by relating the primroses and their leaves. This was followed by the wild strawberry leaves and trailing plant with grasses. The whole arrangement rests above a shallow stone wall. In some areas I edited in a few extra negative shapes to provide contrasts and, in turn,

edited out various leaves that did not help the composition Using pencil and watercolour together on smooth white paper can work well: place the images in pencil first, before washing over with appropriate colours. When this is dry, you can add further pencil drawing to enhance the contrasts.

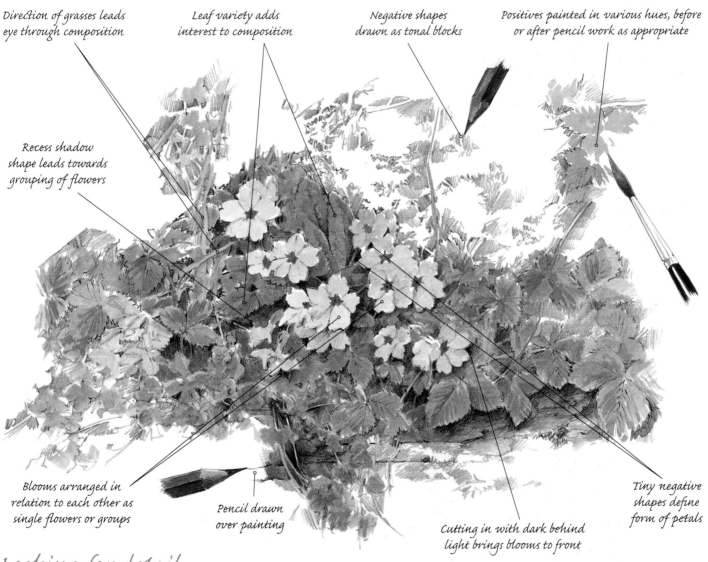

Direction of grasses leads eye through composition

Leaf variety adds interest to composition

Negative shapes drawn as tonal blocks

Positives painted in various hues, before or after pencil work as appropriate

Recess shadow shape leads towards grouping of flowers

Blooms arranged in relation to each other as single flowers or groups

Pencil drawn over painting

Cutting in with dark behind light brings blooms to front

Tiny negative shapes define form of petals

Looking for detail

These two studies were also executed in pencil and watercolour. For the full-on view I started with the central area and worked outwards, grazing the pencil gently over the paper's surface. The darker central area was then painted, followed by the pale petal hue. Finally a pale neutral background hue was painted up to the petal edges. As the second image was to be presented against white paper, I used a heavier, on/off pressure edge line to define the forms.

Holding blooms in one hand and drawing or painting with the other enables close observation of the form.

Problems

Greenhouse

pen and watersoluble ink

Positioning yourself comfortably in an area where you can take your time – for example, in a greenhouse – gives you the opportunity to execute a variety of sketchbook studies. Including an area of floor, panes of glass and visible parts of flowerpots provides contrasts to the profusion of foliage.

Relating shapes of positive and negative forms within these masses can present problems for beginners unsure how to fill the spaces. Too much untouched paper remains, and the relationships between components in the composition are lost. Perspective angles can also cause problems.

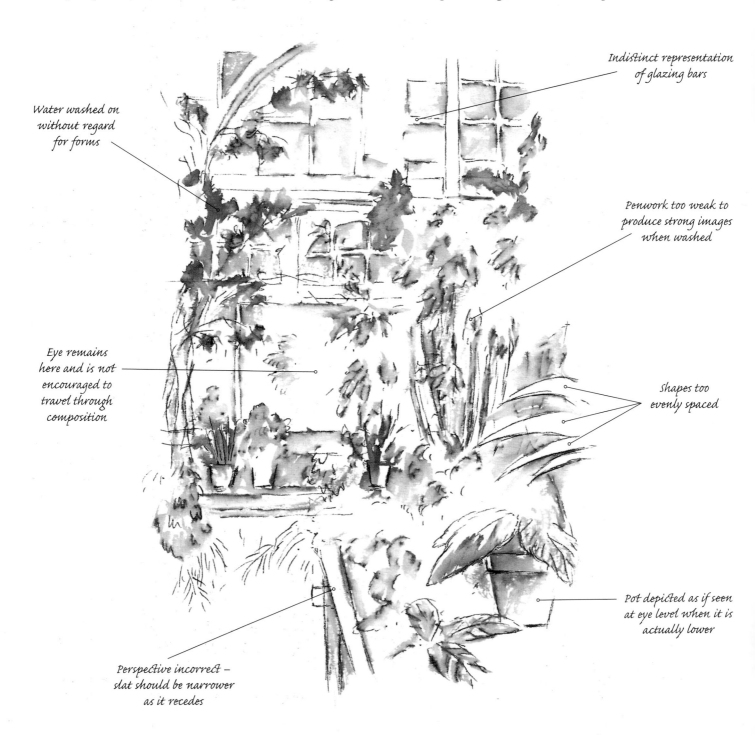

Water washed on without regard for forms

Eye remains here and is not encouraged to travel through composition

Perspective incorrect – slat should be narrower as it recedes

Indistinct representation of glazing bars

Penwork too weak to produce strong images when washed

Shapes too evenly spaced

Pot depicted as if seen at eye level when it is actually lower

Solutions

Try to sketch from an angle where certain lines, such as those of the supporting slats on which pots of plants are placed, can take your eye into the composition. Look for areas that rest the eye, in contrast to the busy foliage masses.

Working on a textured surface, such as Saunders Waterford CP (NOT) paper, will enhance your penwork and encourage subsequent washes to work successfully, as long as they are applied with care and consideration.

Series of vertical parallel lines simplifies background as contrast to busy foliage areas below

Fine 0.4 coloured watersoluble pen

Clean water washed over watersoluble ink gives variety of tonal values

Varied shapes in series of flower pots along shelf, in relation to foliage

Strong shapes break through vertical growth

Overall shapes of prolific plants considered

Arrows show how eye is taken through composition

Slat narrows as it recedes

Simple, uncomplicated shapes

Note perspective angle at base of pot, below eye level

Problems

Magnolia

pencil

By observing and drawing a single section of a magnolia tree we are editing out quite an extensive area of the rest of the plant. It is therefore important to consider the arrangement of flowers, leaves and twigs in relation to the main branch supporting them.

One of the problems experienced by beginners is that of how to apply tone in a way that describes form effectively, such as long, sweeping on/off strokes to tone flower petals, and shorter, erratic strokes to indicate tonal texture on twigs (seen as silhouettes) and branches.

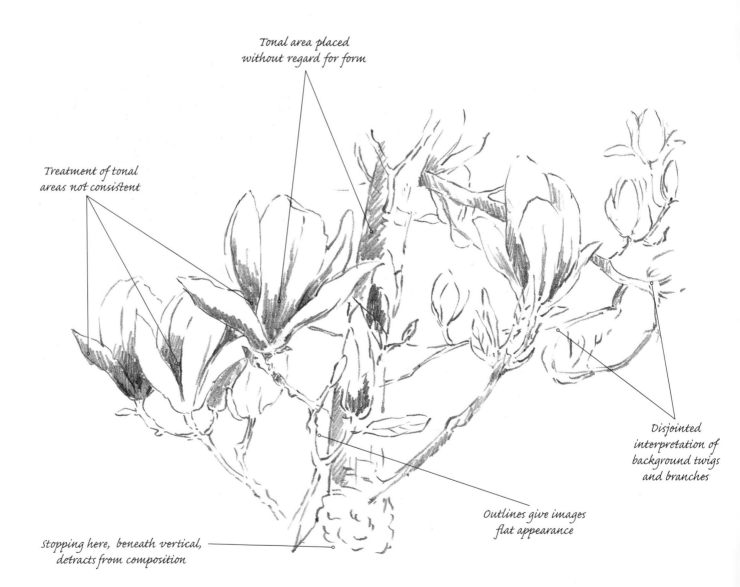

Tonal area placed without regard for form

Treatment of tonal areas not consistent

Disjointed interpretation of background twigs and branches

Outlines give images flat appearance

Stopping here, beneath vertical, detracts from composition

Solutions

Here, I have chosen an S-shaped composition to take the observer's eye through this little study, by working on an area where the angles of the flowers concentrate that effect. This is a preliminary sketch, using a 4B pencil, which could be used for a painting or a more detailed drawing (see page 100).

Keeping the pencil sharpened throughout the execution of the drawing enables rich dark tonal areas to be quickly established. When depicting twigs of this nature as silhouettes, it is important to consider the uneven appearance of the edges, as this helps to define the species.

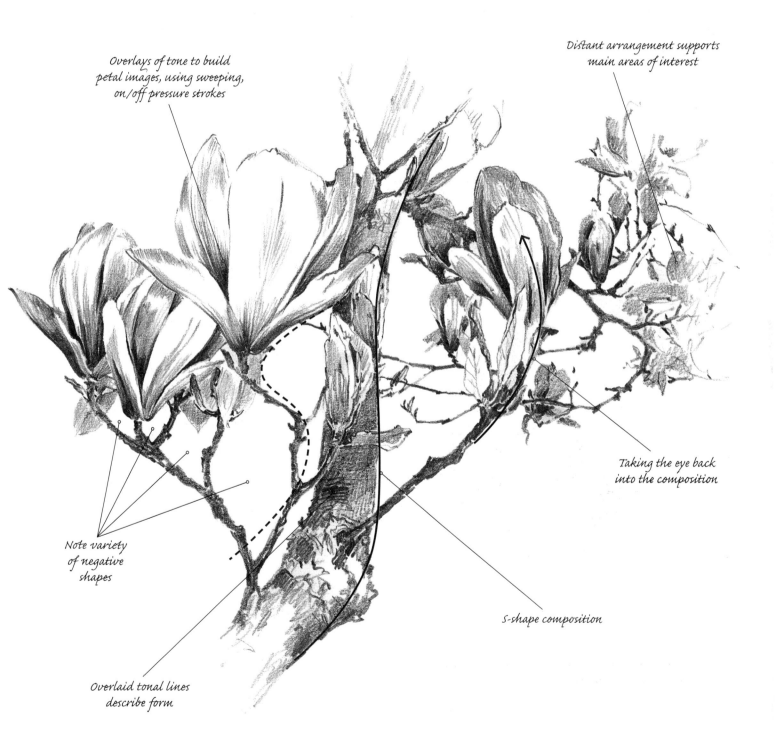

Overlays of tone to build petal images, using sweeping, on/off pressure strokes

Distant arrangement supports main areas of interest

Note variety of negative shapes

Taking the eye back into the composition

Overlaid tonal lines describe form

S-shape composition

Agapanthus

watercolour

The elegant agapanthus plant has a long flowering season and can grace borders in a garden or be grown in pots. In the preliminary investigative sketch I chose the latter and included the cascade of leaves; however, for the demonstration study I concentrated on the natural arrangement of flowers, in the form of buds and open blooms emerging from the single main stem.

Preliminary drawing

By turning the pot and sketching the arrangement from different angles you can decide which viewpoint offers the most interest of presentation. Always look for a variety of negative shapes, as well as the positive blooms and buds with their supporting slender stems. This preliminary sketch was made to understand the structure of the complete plant.

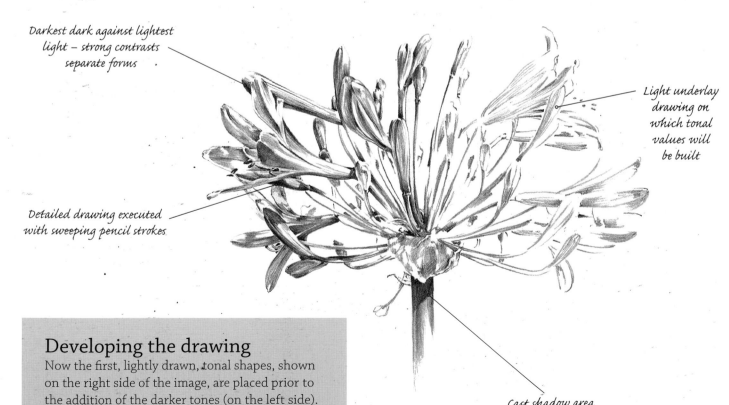

Darkest dark against lightest light – strong contrasts separate forms

Light underlay drawing on which tonal values will be built

Detailed drawing executed with sweeping pencil strokes

Cast shadow area helps to achieve three-dimensional impression

Developing the drawing

Now the first, lightly drawn, tonal shapes, shown on the right side of the image, are placed prior to the addition of the darker tones (on the left side). Various tonal values, contrasting with areas of white, untouched paper, help to define the forms.

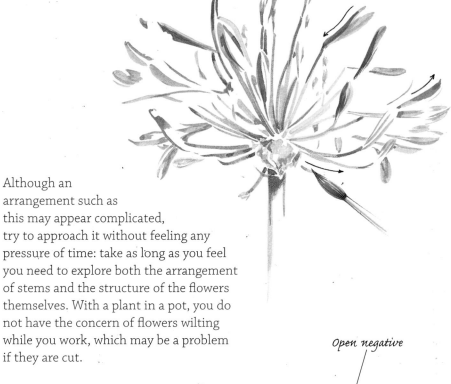

First colour washes

After carefully tracing the arrangement on to good paper, use the first directional brushstrokes to position the components, prior to erasing the pencil lines after these washes have thoroughly dried. You will then be ready for the final stages of building up the hue and tone by carefully overlaying washes using a fine, pointed brush.

Practise delicate strokes on separate pieces of paper, allowing your brush or pencil to sweep along the contours with on/off pressure for the flower and buds, and to sweep with more even pressure for the slim stems.

Although an arrangement such as this may appear complicated, try to approach it without feeling any pressure of time: take as long as you feel you need to explore both the arrangement of stems and the structure of the flowers themselves. With a plant in a pot, you do not have the concern of flowers wilting while you work, which may be a problem if they are cut.

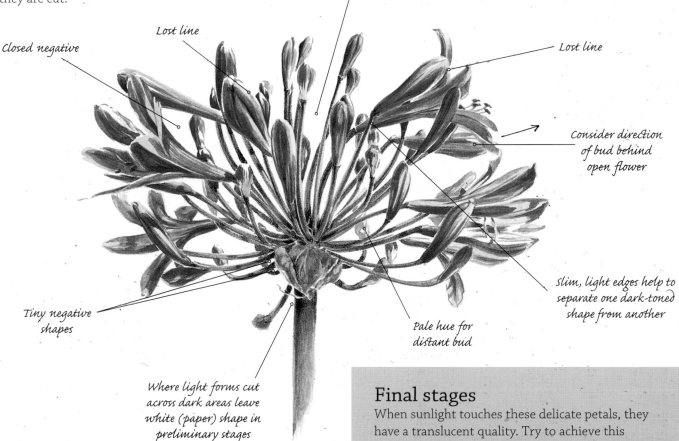

Open negative

Lost line

Closed negative

Lost line

Tiny negative shapes

Consider direction of bud behind open flower

Where light forms cut across dark areas leave white (paper) shape in preliminary stages

Pale hue for distant bud

Slim, light edges help to separate one dark-toned shape from another

Final stages

When sunlight touches these delicate petals, they have a translucent quality. Try to achieve this delicacy with swift strokes that are not disturbed after application. Be aware of areas that receive cast shadows as well as areas that are naturally in shadow.

Colour

With such a diversity of plants to choose from, it can be difficult for beginners to know where and how to start. There is so much to learn regarding methods and techniques, arrangement and composition, colour mixing and tonal values, to name but a few considerations.

One way of starting is to choose a flower of a colour you find attractive and which you feel you may be able to mix from your existing palette. If the plant is growing in a pot or is placed in a vase of water you do not have the problem of it wilting or changing position too quickly while you work, but there are also advantages to holding a specimen between your fingers in order to study it closely and represent fine detail.

Try to familiarize yourself with the relationships of leaves to stem, stem to blooms, and petals arising from the central area. Look at the flower from many different angles and try to understand all the complexities. Then start drawing. Try to make everything look 'believable' – for example, a stem disappearing behind a leaf should reappear at the correct point on the other side and butt on, rather than just hovering in empty space.

Practise the pencil strokes and marks shown throughout the book, both as abstract exercises and as part of your plant drawings. They will help you get to know your pencil and the most effective way of using it.

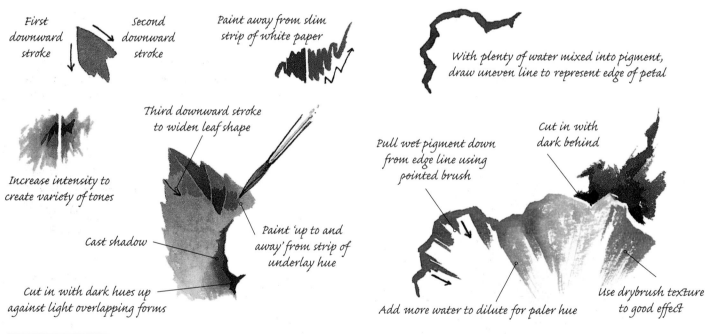

First downward stroke

Second downward stroke

Paint away from slim strip of white paper

With plenty of water mixed into pigment, draw uneven line to represent edge of petal

Increase intensity to create variety of tones

Third downward stroke to widen leaf shape

Pull wet pigment down from edge line using pointed brush

Cut in with dark behind

Cast shadow

Paint 'up to and away' from strip of underlay hue

Cut in with dark hues up against light overlapping forms

Add more water to dilute for paler hue

Use drybrush texture to good effect

Brush exercises

Use these brush exercises to help with your preparations for painting. I used watercolour for them, but they are also applicable for gouache and when using a brush to lift the pigment from watercolour pencils.

Work 'on your toes' – with brush held vertical to paper – to achieve very slim lines

Practise effect of tiny veins

Gradually widen strokes

These strokes can also be used to depict certain leaves in their entirety

Mixed media

Pencil and watercolour can work well together if the colours and paper used lend themselves to this treatment – Saunders Waterford CP (NOT) paper works well for this combination.

I have chosen a yellow begonia with warm red edges on some of its petals as this watercolour hue is a good base for delicate pencil drawing. The colourful petal edges provide contrasts, and by placing a blue wash behind the images you can practise many aspects of painting in this exercise.

Leaf

First pale underlay to establish silhouette shape of leaf

Colourful first edge shape to petal

Pull down from edge line while still wet

When first colour has dried, overlay second hue

Second underlay, painting up to and away from veins

Blooms behind main flower mass can be depicted in much paler hues

Contrasting hue behind forms brings images forward

On rough surface paper gently criss-cross strokes over surface to blend pigment out smoothly as brush dries

Drop in darker hue while second underlay still damp, to enhance light veins

Include shadow recess shapes

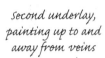

Define edges of shapes and petals using very sharp pencil such as HB

Practise creating veins without having to establish a leaf shape – this also helps practise blending into paper

Texture

When referring to texture I include three things: a regard for the texture of the paper's surface; the textured effect achieved by dry pencil shading; and the textured effect within coloured areas using overlaid washes and stippling. The slight 'bleeding' that can occur on some paper surfaces often enhances the effect, and you can see this happening on this demonstration of a cyclamen leaf.

In this study I have indicated the stages of development and, in addition to using the bleeding effect to soften the edges of the patterned areas, I have overlaid the drawing with muted colours using stippling to convey the texture of the leaf's surface.

Graphitint colours used on Saunders Waterford HP paper

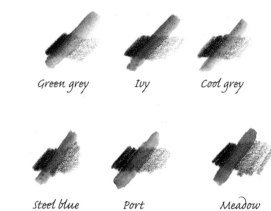

Green grey *Ivy* *Cool grey*

Steel blue *Port* *Meadow*

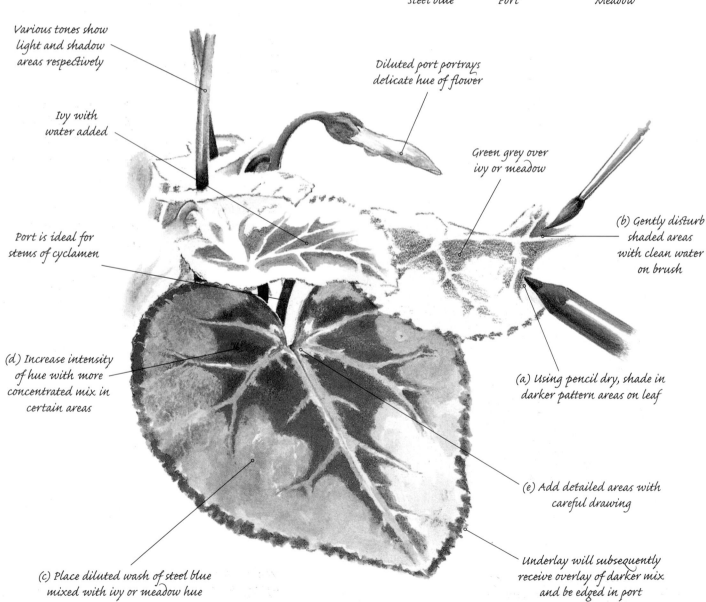

Various tones show light and shadow areas respectively

Ivy with water added

Port is ideal for stems of cyclamen

(d) Increase intensity of hue with more concentrated mix in certain areas

(c) Place diluted wash of steel blue mixed with ivy or meadow hue

Diluted port portrays delicate hue of flower

Green grey over ivy or meadow

(b) Gently disturb shaded areas with clean water on brush

(a) Using pencil dry, shade in darker pattern areas on leaf

(e) Add detailed areas with careful drawing

Underlay will subsequently receive overlay of darker mix and be edged in port

Line and Form

Whether depicting the simple, clean lines of an arum lily or one of the more flamboyant varieties with crinkled petals and slender, contoured stamens, lily flowers are ideal subjects for practising directional on/off pressure lines.

The lines of a lily

This drawing concentrates on the interest of line, with continuous varied pressure strokes, twists and curves, wide and narrow tapering lines, and so on. A 'lost' line can be achieved by lifting pressure and pencil from the paper while continuing the flowing movement, and reapplying pressure to complete the shape.

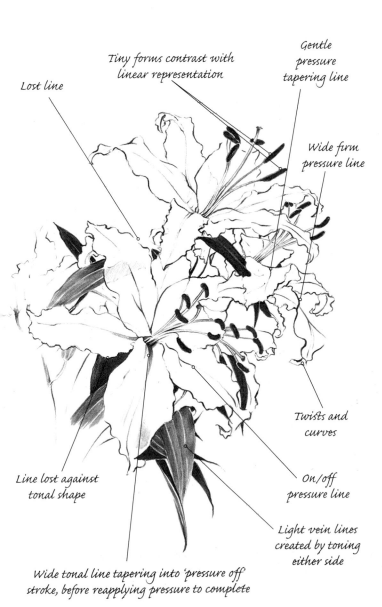

Lost line

Tiny forms contrast with linear representation

Gentle pressure tapering line

Wide firm pressure line

Twists and curves

On/off pressure line

Line lost against tonal shape

Light vein lines created by toning either side

Wide tonal line tapering into 'pressure off' stroke, before reapplying pressure to complete

Arum lily

Give thought to the form the lines are representing. Comparing the shape to something like a delicate wine glass can help you create an awareness of the form.

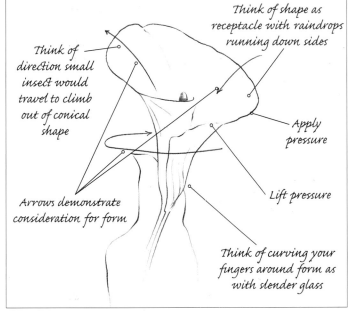

Think of direction small insect would travel to climb out of conical shape

Think of shape as receptacle with raindrops running down sides

Apply pressure

Lift pressure

Arrows demonstrate consideration for form

Think of curving your fingers around form as with slender glass

Practice lines

Here I have suggested a few practice lines to try, using an HB pencil on smooth white paper.

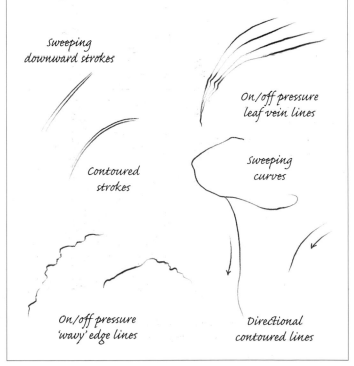

sweeping downward strokes

On/off pressure leaf vein lines

Contoured strokes

sweeping curves

On/off pressure 'wavy' edge lines

Directional contoured lines

And with an artist's eye

To see the world with an artist's eye is to look more closely at and give more thought to your surroundings: noting how cast shadows can enhance a composition; being aware of tonal values and the excitement of strong contrasts; feeling a thrill at spotting where a lost line is apparent and deciding how to depict that area without losing sight of the image; and taking advantage of the existence of both large and small negative shapes and their arrangements, in order to position components.

Flowers that possess slender petals grouped together present many considerations, including how to interrelate the blooms, how to represent background areas and how to treat the central areas of the blooms.

When interrelating flowers, try not to think of the positive shapes in your preliminary (investigative) drawing. Look at the negatives – the shapes between petals.

Start by placing the positive shapes in the palest of hues – if you position any incorrectly you can, at this stage, alter the positioning without this being obvious in the final painting. Now look for the shapes between – the negative shapes. If these are occupied by other petals (perhaps in shadow) you need to still paint in pale hues, slightly darker than your initial strokes, so that the darkest negatives will contrast with lighter shapes. Then you can add the final overlays to unify the painting and maximize contrasts.

Loose interpretations for background foliage treatment can be achieved in various ways – for example, criss-cross stroke application achieves crisper edges to suggest images more representational of leaf forms.

The central areas of flowers, which often possess minute details, are best observed under a magnifying glass. You can then draw these areas in detail to understand them.

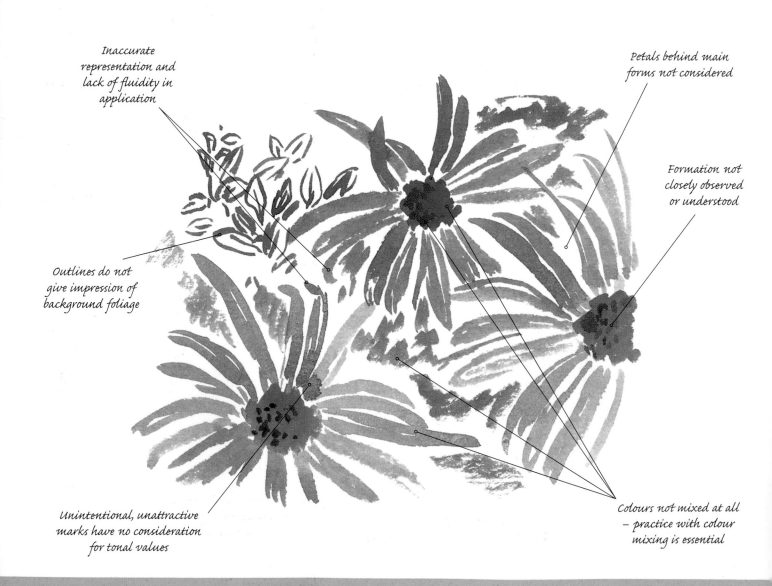

Inaccurate representation and lack of fluidity in application

Petals behind main forms not considered

Formation not closely observed or understood

Outlines do not give impression of background foliage

Unintentional, unattractive marks have no consideration for tonal values

Colours not mixed at all – practice with colour mixing is essential

Five stages to consider

In this study an arrangement of small negative shapes interrelates a number of delicate blooms. This shows how an artist's eye looks for negative shapes in order to place components in the correct relationships with each other.

Step 1: Choose your colours and practise the mixes. Mix plenty of pigment and add enough water to the mix to achieve fluidity. The water may evaporate to some extent as you work, so you may need to add extra water during the painting process.

Step 2: Try out various paper surfaces and practise your brushstrokes. Make sure your paper is not too textured for this type of execution and that you do not unintentionally achieve a drybrush effect when you are actually aiming for smooth strokes.

Step 3: Look at one small area of the group (use a viewfinder if it helps) and practise establishing the relationships in this area so you understand the order in which you intend to work your washes.

Step 4: Choose the paper best suited to your approach and map out the whole study using very pale hues. Take your time – if you rush this stage, inaccuracies may occur.

Step 5: Slowly build overlays wet on dry, remembering to cut in up against the positive shapes with a darker hue/tone behind for your negatives.

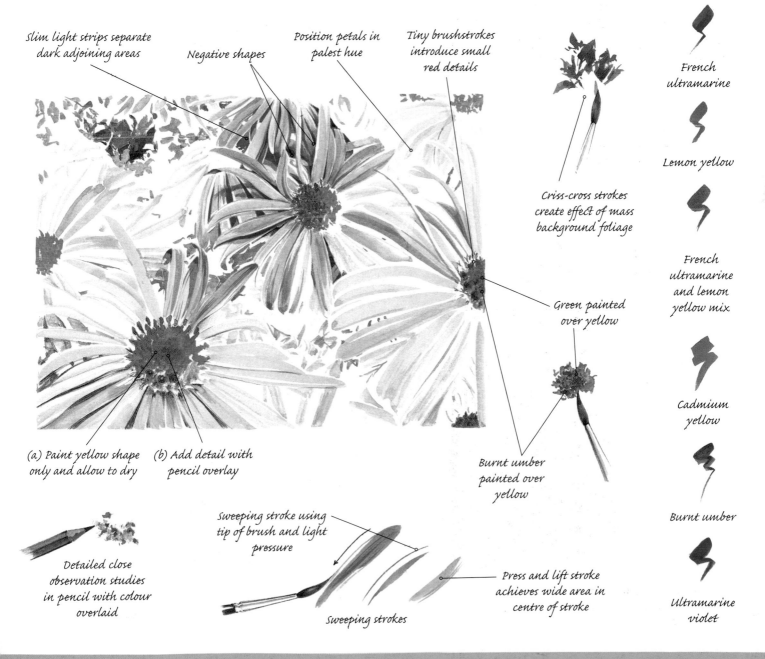

Slim light strips separate dark adjoining areas

Negative shapes

Position petals in palest hue

Tiny brushstrokes introduce small red details

French ultramarine

Lemon yellow

Criss-cross strokes create effect of mass background foliage

French ultramarine and lemon yellow mix

Green painted over yellow

Cadmium yellow

Burnt umber painted over yellow

Burnt umber

(a) Paint yellow shape only and allow to dry

(b) Add detail with pencil overlay

Detailed close observation studies in pencil with colour overlaid

Sweeping stroke using tip of brush and light pressure

Sweeping strokes

Press and lift stroke achieves wide area in centre of stroke

Ultramarine violet

Conclusion

Although it may be the case that it is their colours that make flowers such a popular choice of subject matter for artists, there is much to be gained from working in monochrome as well. If you do not do so already, I hope this book will inspire you to use pencil and other monochrome media alongside your colour studies.

Without regard for tonal values and their exciting contrasts, you may find that your flower studies fall short of your expectations. However, it is not only use of tone that makes drawing such an important part of a journey into colour, but also understanding of structure. Close observation and detailed drawings resulting from an awareness of form are, I feel, the foundation upon which we can build our knowledge and artistic skills as flower painters.

If you can be patient with yourself in the early stages of learning, and accept that it will take time to develop your drawing and painting skills, you will certainly find that

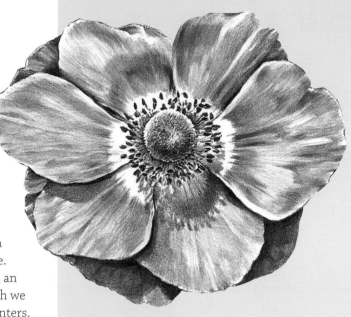

Red anemone

This final study demonstrates the use of tone to indicate that the flower is actually a colour (rather than white) as well as the tonal overlays that depict areas of cast shadows. I never cease to be excited by monochrome – where strong tonal contrasts bring drawings to life – or by the way observational drawing gives strength to resulting paintings.

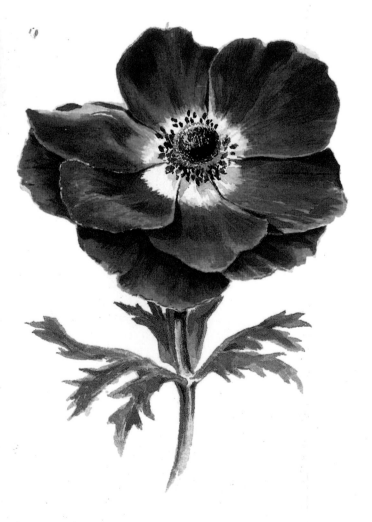

discipline leads to freedom. Good, sound observational drawing and attention to detail provide the firm base upon which you can build and from which you will be able to choose the direction in which you wish to proceed. This may be detailed botanical representation, formal design, a personal representational style or a loose, free approach – perhaps even moving towards abstraction. Many of the studies within the themed sections are drawn and painted in detail. This is done with the intention of encouraging you to look closely and understand structure, and not necessarily to influence your style or to demonstrate mine.

Pencil and brush exercises present an opportunity to make mistakes and learn from them without spoiling your drawings and paintings. Also, by observing individual specimens closely, you may be able to develop your own series of exercises (in the way that I have done) relating to the specific flowers you choose to depict.

I hope you have found within this book inspiration to help you with your own drawings and paintings of the exciting world of flowers.

Index